WALLACE STEVENS

Two American Poets

WILLIAM CARLOS WILLIAMS

TWO AMERICAN POETS – WALLACE STEVENS & WILLIAM CARLOS WILLIAMS

From the collection of

Alan M. Klein

THE GROLIER CLUB

New York 2019

Catalogue of an exhibition held at The Grolier Club
January 16 – February 23, 2019

ISBN 978-1-60583-079-7

Table of Contents

Acknowledgments

This catalogue, and the exhibit it accompanies, is truly the work of many hands and these collections would not have seen the light of day without the encouragement, support and assistance of many friends over the two decades during which these collections were accumulated.

First and foremost, Sarah Funke Butler is without question the co-author, co-editor and co-curator of this catalogue and the exhibit. I realized when the Grolier Club accepted my exhibit proposal that I needed professional assistance and guidance. Little did Sarah realize that my seemingly casual request for her help would result in a two year journey for her. But there would be no catalogue or exhibit without her work. I cannot more greatly express my gratitude. Sarah and I have been ably, and extensively, supported by Katie Vagnino, whose research and writing are evident in virtually every entry in the catalogue. Her appreciation and affection for both poets has greatly added to this catalogue.

Jerry Kelly is the master of creating beautiful and elegant examples of the printed word. I am tremendously appreciative of his design and printing of this catalogue. Thanks are due to Robert Lorenzson and Dominique de Meijer for the extraordinary photography throughout the catalogue. I thank Barbara Suhr for her design of the exhibit, which has added much to the enjoyment and understanding of its content.

Conrad Harper was the first person to tell me about the Grolier Club and the person who encouraged me to apply to join it. This exhibit is the culmination of a road that started with that conversation. Carolyn and Ward Smith and Cheryl Hurley have been friends and mentors at the Grolier. Their many kindnesses cannot begin to be enumerated. Carolyn and Ward were gracious enough to include items of mine in their Seamus Heaney exhibit and to suggest that I ought to propose a Stevens/Williams exhibit to the Club. Cheryl has been a source of encouragement throughout my time at the Club. Without their support this exhibit would not have taken place.

Eric Holzenberg, Jennifer Sheehan and the entire staff at the Grolier Club have been tremendously supportive and professional in help-

ing put this exhibit and the associated programs together. Thanks as well to Fern Cohen and Chris Loker for their guidance in the process of preparing the catalogue and the exhibit and to Susan Flamm for her help in making sure that information about the exhibit has reached a broader audience.

Becoming a collector, and creating a collection, does not take place without guidance and help. My friend of forty years, Alexander Neubauer, explained to me two decades ago how to take some random first editions I had acquired of a few poets I liked and to start to turn them into a collection. I continue to rely on his connoisseurship and his insight. I have been fortunate over the last twenty years to develop relationships, and friendships, with a number of book dealers, without whom it would have been impossible for me to learn how to think about books and build my collections and without whom getting access to these materials would not have been possible. In particular, the inimitable Glenn Horowitz has been essential in creating these collections. James Jaffe, Rick Gekoski, Tom Goldwasser, James Goldwasser, and Ralph Sipper have taught me much about books and greatly facilitated my collecting. Each of these gentlemen has been thoughtful and kind for many, many years.

My concept for the exhibit of my collections of Wallace Stevens and William Carlos Williams has been greatly enhanced by my conversations with Professors Joan Richardson and Paul Mariani, who have authored the definitive biographies of Stevens and Williams, respectively. Professor Mariani has also written a recent insightful biography of Stevens. His unique depth of perspective on each poet is evident in the piece he graciously contributed to this catalogue. Daniel Halpern's many conversations with me about poetry, and that of Stevens and Williams in particular, have been a privilege for me and I greatly appreciate his contribution to the catalogue regarding his feelings for Stevens's work. Nicole Sealey is an exciting young voice in contemporary poetry and I am greatly honored that she has contributed her thoughts on Williams to this catalogue.

Finally, I thank my remarkable wife Lauren. She has always been supportive of my book collecting and has never faltered in that support or

in her support of my efforts to put together this exhibit and this cata-logue. My cherished children Charlotte and Sam have seemed to enjoy my appearances in their classrooms over the years to show off some books and manuscripts of poets they happen to be studying. I hope that perhaps presages another generation of collectors, but at the very least another generation of poetry lovers.

ALAN M. KLEIN Two American Poets –
Wallace Stevens &
William Carlos Williams

Wallace Stevens (1879-1955) and William Carlos Williams (1883-1963)
are widely recognized as two of the towering giants of mid-twentieth
century American poetry. They are rarely thought of together, however,
despite their mutual admiration and personal relationship spanning
over forty years.

 This is not just a catalogue, or an exhibit, about two well-known
poets but rather something that is intended to go deeper than that. My
hope is that readers and viewers will be drawn in to see two poets, com-
ing of age in the late nineteenth century, meeting and maturing as part
of a unique circle of writers and artists at the time of World War I amid
the explosive effect of the war on the culture, immersed in startling in-
novations in modern art and grappling with radical changes in science
and technology such as Einstein's theory of relativity. Each grew up in
a period when electricity was just becoming commonplace in the home
and automobiles and airplanes were new innovations. By the time of
their passing the world had entered the atomic age and, in the case of
Williams, the space age. Through this catalogue and the accompany-
ing exhibit, the influence of these stunning changes to their world will
be seen on their work and their overlapping output over the course of
their careers they struggled for and achieved recognition as two of the
most influential writers in American literature by mid-century.

 Almost exact contemporaries, Stevens and Williams met in New
York City in 1914 at a formative point in their development as poets.
They wrote in very different idioms, although each strove to be unique-
ly American. Stevens worked in a very cerebral and often abstract
language and Williams wrote in a very direct and down to earth style,
trying consciously to emulate the rhythms of American speech. Often,

Stevens's work is described as "difficult" and Williams's as almost too accessible. And yet, they were supporters and readers of each other from their first meeting until Stevens's death in 1955.

Quite unusually, in addition to their literary careers, they both pursued successful professional careers. An important part of Stevens's mythology is his work as a lawyer and insurance executive in Hartford, Connecticut. Williams was a respected physician and the people and circumstances he encountered in his medical practice in New Jersey greatly influenced his literary work.

Both Stevens and Williams were also active participants in the world of poetry of their time. They each published in many of the same literary journals and carried on an active correspondence with a wide range of their contemporaries. Each mentored younger poets, both directly and indirectly. Stevens's work first became a touchstone for American poets to study and be inspired by during the period prior to World War II, and remains so today. During his lifetime he was recognized and revered. Williams's experiments with form and his choice of subject matters similarly inspired the American surrealists of the 1930s and the Beats of the 1950s. His personal relationships with the Beats, particularly Allen Ginsberg, were noteworthy. Appreciation of his poetry has only grown since his death.

Their writings on poetry in general and regarding one another reflect that in many ways they viewed each other as embarking on a similar project in their poetry. Each was consciously trying to create poetry that would be recognizably "American," that didn't simply emulate the themes and subjects of the English and European poets they had studied as youths but which grappled with the world that had been created on this continent. At the same time, each felt that part of what their poetry needed, and what was lacking in their poetic inheritance, was to bridge the gap between "reality" and the words they used to describe that reality. Advancements in science, much of which drew on Einstein's work, had demonstrated that reality was a slippery concept. New techniques in literature and art that arose during the World War I period were part of the response to the radical developments in the understanding of the physical world then taking place and to the inferno of the war itself.

Stevens's version of the project was to create a poetry that itself in many ways seems as fractured and often as impenetrable as the abstract art being created at the same time. Of course, his work evolved considerably both in technique and subject matter, from the urbane poses of the poems collected in his first book to the many lengthy meditations and ruminations on the nature of poetry and art in his later poetry. Williams's work evolved as well, beginning with the imagist pieces of the nineteen teens and twenties and developing into his experiments with what he called the "variable foot" and with the pattern of the words on the page while also creating the amalgams of prose, poetry and found text best exemplified by his magnum opus "Paterson." The divergence of their efforts was certainly well understood by each of them, but Stevens and Williams also understood the foundation of each other's work. They kept tabs on each other's progress more assiduously than on the work of any other peer save, perhaps, Marianne Moore.

<center>* * *</center>

This catalogue is first an effort to reflect the course of the individual lives and careers of Stevens and Williams. I began collecting Stevens and Williams first editions twenty years ago simply because I liked their poetry. I was neither a seasoned collector nor a student of their work and lives. I had a general understanding that Stevens had been a lawyer and insurance company executive and Williams a local doctor, in addition to crafting literary work of astonishing resonance. I am certainly not an academician, critic or poet. Over the last two decades, these collections took greater form and achieved greater depth as my interest and knowledge deepened and collecting opportunities grew.

By its very nature, though, a private collection of two such writers is in many ways a reflection of market availability. In the case of these poets, much of their personal libraries, letters and manuscripts are in institutions, along with those of many of their correspondents and publishers. I am particularly lucky that in recent years some material from the families of Stevens, Williams and Ezra Pound (Williams's friend from college onward), have become available, as well as materials from their personal and professional inner circles – in particular that of the publisher of the Alcestis Press, the influential poetry press of the

mid-1930s and that of Henry and Barbara Church, the closest friends of Stevens's later years.

My Stevens items begin with letters and works from his undergraduate years at Harvard, and continue from his earliest contributions to literary journals and throughout his career, to his published books, both through commercial houses such as Knopf and small literary presses – notably the Alcestis Press and the Cummington Press – many with inscriptions to individuals such as his daughter, his work colleagues, his friends the Churches and other individuals with whom he formed relationships from which he drew inspiration for his work. Some of this material is from his own library, including two family history projects which Stevens had privately printed in excruciatingly small runs: Only a half dozen or fewer of each are known. There are letters from Stevens to a wide variety of contemporary poets, such as Conrad Aiken, Allen Tate and Delmore Schwartz as well as letters to his publisher Alfred Knopf, to his editor and to his publicist at Knopf. Also present are his marriage certificate and several personal photographs.

My Williams collection begins with books given to him as a child by his mother and inherited from his father, some of his school books from a prep school in Geneva, Switzerland and some high school textbooks from the Horace Mann School in New York City. His earliest publications in literary journals are present continuing throughout his career in a range of genres; along with his first commercially published book inscribed to his mother-in-law, his second commercially published book inscribed to his wife, a complete set of his magnum opus *Paterson* inscribed to his son, and many other books inscribed to Ezra Pound, some of which have Pound's annotations, as well as books inscribed to friends and colleagues such as Man Ray, Malcom Cowley and Martha Graham. The many letters of Williams included here range from his thoughts on Albert Einstein to correspondence with publishers, editors, friends and fellow poets. Ephemera includes a train schedule belonging to Williams from Rutherford, New Jersey, his home, to New York City, illustrating the worlds that he bridged.

<div align="center">* * *</div>

As I continued collecting and researching, there emerged a strong sense of the intersection and overlap of the poetic lives of Stevens and Williams, and through a subset of the collection an over-arching theme became apparent. There is Stevens's own copy of the second issue of the 1915 journal *Others*, published by Alfred Kreymborg, which Williams helped edit, with the first appearance of Stevens's iconic "Peter Quince at the Clavier" as well as four poems by Williams; a copy of *Poetry* magazine from 1917 with Stevens's play "Carlos among the Candles," whose title character is almost certainly named after Williams; the first edition of Stevens's first book, *Harmonium*, from 1923, with the poem "Nuances on a Theme of Williams," in which Stevens reprints Williams's short poem "El Hombre" and then elaborates on it; a first edition of Williams's book *Kora in Hell* from 1920 in which Williams reprints a portion of a letter from Stevens and then responds to Stevens's critique of Williams's work; the first edition of the Objectivist Press's *Collected Poems 1921-1931* of Williams, published in 1934, with an introduction by Stevens; celebrations of Stevens's work and career in the Harvard *Advocate* and the *Briarcliff Quarterly* in the 1940s with contributions by Williams; letters by Stevens in the late 40s to Vivienne Koch, author of the first book length assessment of Williams, in which Stevens almost tenderly discusses Williams and his mother's influence on him and Williams's growing reputation; and, poignantly, the memorial that Williams wrote for *Poetry* magazine upon Stevens's death in 1955.

Manuscript material for both poets is scarce in private hands, but through a trove of material acquired from the family of Alcestis Press founder Ronald Latimer I acquired manuscript copies of poems copied out by both Stevens and Williams for that publisher, as well as lengthy inscriptions to him in their books that he published - and even Stevens and Williams editions from Latimer's collection brought out by other publishers. This material is a unique addition to the biographies of both poets (not to mention of Latimer).

Stevens was the stolid son of Pennsylvania Dutch farmers, as he viewed it, who went off to Harvard and developed an exquisitely sensitive ear and eye. He never visited Europe and indeed he left the United States only twice, once to go to Havana and once on a Carib-

bean cruise. Yet his work reflects a cosmopolitan encounter with the most difficult themes of his time. Williams, by contrast – the son of an English father raised in the Caribbean and a mother of Spanish descent raised in Puerto Rico – grew up speaking Spanish at home in New Jersey, studied at a Swiss boarding school, had medical training in Leipzig and spent time in Paris in the '20s. Yet his work employs the American vernacular to convey the sights and sounds of the immediate world in which he lived. They published in the same journals and with the same publishers, read and wrote about each other. Although they lived just a state or two away, after Stevens moved to Hartford in 1916 there are only perhaps fewer than a handful of documented meetings between them in person. The intellectual engagement between them never ended, however. Both poets, dead for over sixty years and fifty years respectively, still speak to readers today, each in a unique, and uniquely American, idiom.

My hope is that this still-growing collection and this catalogue, with contributions from Paul Mariani – the biographer of both Williams and Stevens – and poets Daniel Halpern and Nicole Sealey will help elucidate the lives and works of both Stevens and Williams in a way that adds to the understanding and appreciation of both of them.

PAUL MARIANI The Abiding Literary
Friendship Between William Carlos
Williams and Wallace Stevens

Williams and Stevens met for the first time at Walter and Louise Arens-
berg's studio on Manhattan's West 67th Street sometime in mid-1915, two
years after the Armory Show which had featured the work of Marcel
Duchamp, whose "Nude Descending a Staircase" helped revolution-
ize the way artists and poets now saw the world around them. By then,
the thirty-year-old Williams had already published *The Tempers*, while
Stevens, though four years older than Williams, was still eight years
away from publishing his first book of poems. By then, however, both
poets had seen their work appear in the pages of *Poetry* (Chicago), as
well as another *avant garde* magazine, this one published right there in
Manhattan, aptly called *Others,* because it meant to provide a forum for
those others, like New York's Jewish intellectuals, including its editor,
the indefatigable Alfred Kreymborg, along with a much more radical
feminist element which included Mina Loy, Helen Hoyt, and Marianne
Moore. What began then in an apartment on West 67th Street was an
interchange of ideas which would carry on for the next forty years . . .
and which continues, really, into our own time.

Wallace Stevens hailed from Reading, Pennsylvania, where he'd
grown up, the second of five siblings, whose parents were of Pennsyl-
vania Dutch stock. He'd gone to high school there and, being six two
– had played on the football team. From there he'd gone on to Harvard,
graduating in three years in the summer of 1900. Then it was down to
the Greenwich Village area of Manhattan, where he tried his hand at
cub reporting for a year, before going on to law school. After that, he
tried his hand in a private law firm and, when that didn't work out,
began legal work for several insurance companies in the Wall Street
area. In the summer of 1904, while back in Reading for a visit, he met a

stunning-looking young woman who had grown up just a few blocks away – Elsie Moll Kachel – and fell in love at once. The courtship went on for five years until the summer of 1909, when Stevens felt he finally had enough money to marry his sweetheart, and both settled into an apartment on West 21ˢᵗ Street, where they would live until the spring of 1916, when Stevens secured a job at the Hartford Indemnity Insurance Company and the couple moved to Connecticut's capital, where they would live for the rest of their lives.

William Carlos Williams, the son of an English father and a Puerto Rican mother in a household where French and Spanish were spoken as much as English, was born in Rutherford, New Jersey, in the Meadowlands, just a few miles across the Hudson from Manhattan, in September of 1883, and would live out his entire eighty years in that same town. He went to Horace Mann in Manhattan with his brother, Edgar, and then attended the University of Pennsylvania, where he studied dentistry for a year, before settling on medicine. He interned at two hospitals in the city: the French Hospital at 330 West 30th Street, and then Child's Hospital further uptown. Soon, however, he left the city behind and opened a practice back in Rutherford, first in his parents' home and then after his marriage in December 1912, at 9 Ridge Road, where he and his wife, Florence – Flossie – would live for the next half century and more.

But, in spite of their professional lives, in which they both excelled in their own ways, poetry was always both men's passion. Williams published his first thin book with the help of a local printer in 1909. It was called – simply – *Poems*. And while his poems had begun very much in the same vein of formal verse as Stevens's, Williams, searching for the new, had already undergone a transformation, and with the help of his friend Ezra Pound and others, was already heralding the new forms of free verse that were gaining traction, especially in New York and London. And though he and Stevens were already heading on different verse trajectories, they took to each other from the start, watching each other's progress like hawks in the decades to come.

What brought them together was the salon held at the Arensbergs, which featured the work of Marcel Duchamp, who had set up a studio there. "You always saw Marcel Duchamp there," Williams would

recall thirty-five years later, featuring Duchamp's "Large Glass, or The Bride Stripped Bare by Her Bachelors, Even," as well as several of his earlier works, along with paintings by Cézanne and Gleizes. When Williams made the mistake of telling Duchamp that he admired one of his paintings, which, he admitted, both "disturbed and fascinated" him, Duchamp merely shrugged Williams off. The truth was, he had to confess, that in 1915 he – like the other Americans invited to the salon, including Stevens – were mere beginners, bunglers, in fact, "unable to compete in knowledge with the sophisticates of Montmartre." And because French was the preferred language at the Arensbergs', there was the language barrier as well, though Williams, who had spent a year in Switzerland as a boy, could speak French, although not the witty Harvardian kind which Stevens and Arensberg preferred. Still, forty years on, Stevens would confess that he'd always felt Duchamp was in fact "an intense neurotic" whose "life was not explicable in any other terms." Still, both Williams and Stevens understood that Duchamp and the other French artists were on to something radically new, something that the New York literati were trying to articulate in their own work.

There was also of course, Harriet Monroe's *Poetry* (Chicago). And then there was *Others: A Magazine of the New Verse*, founded by Alfred Kreymborg in July 1915, thanks to Arensberg's deep pockets. The magazine, whose motto was "The old expressions are with us always, and there are always others," sold for twenty cents a copy and would run erratically for the next four years. And, while it never had more than 300 subscribers, *Others* helped launch the careers of both Williams and Stevens, as well those of Marianne Moore, Mina Loy, Ezra Pound, T. S. Eliot, Amy Lowell, H.D., Djuna Barnes, and Lola Ridge, among others.

Among the innovations that Williams, a primary force behind *Others*, introduced in his poems was the elimination of capital letters at the beginning of lines, something which Harriet Monroe at *Poetry* felt had gone perhaps too far in terms of experimentation, an innovation which Stevens assiduously avoided. Williams's was a demotic idiom: the language of New Jersey and New York City, open to the politics and mores of the Greenwich Village crowd. And while Stevens's was a far more elevated diction, more "cultured," more ironic and distant, in the

Anglo-French manner, he remained one with Williams in sharing a deep emotional core in his poems.

The second issue of *Others*, published in August 1915, saw the publication of Stevens's "Peter Quince at the Clavier" and "The Silver Ploughboy," along with four poems by Williams, including "Pastoral" and "The Ogre," about a doctor's sexual fascination with a little girl in the course of a routine physical examination. The March 1916 number included seven of Stevens's poems on as many pages, including "Six Significant Landscapes," and "Domination of Black," which evokes darkness encroaching on a solitary speaker who sits before the flickering peacock flames of a fireplace, aware that there is no stay against what will eventually swallow the light and, with it, the poet himself, along with everyone.

Within a year of its founding, however, *Others* – like so many other experimental magazines of the time – was ready to fold, until Williams, along with F.S. Flint and Maxwell Bodenheim, stepped in to keep it going for the next three years, before the poets it had featured moved on to other magazines, like Scofield Thayer's *The Dial*. The little magazines didn't die, both Williams and Stevens knew. Instead, they morphed into new little magazines. So, in the summer of 1916, Williams was editing *Others* from his home in Rutherford when he wrote to Stevens, who had just left Manhattan for Hartford, about a batch of poems Stevens had sent him. Among them was a draft of Stevens's unfinished "For an Old Woman in a Wig," written in rhymed terza rima. It was a nod to his friend, Arensberg, who was translating *The Divine Comedy*. Stevens's fragment was mostly scrawled in pencil with many erasures, and he would soon abandon the form, though he would work and rework Dante's themes for decades to come. Williams liked the final lines of the fragment especially, he told Stevens, because there Stevens had allowed himself to "become fervent for a moment," something Williams would tweak Stevens about all their lives, for it was there especially that the two poets differed. Forget the epic poetry of sky and sea, Stevens had confessed in his unfinished poem. Better to push into the "unknown new" around one to discover what was there: poems which actually addressed the world as it was at that particular and unique moment.

A week later Williams wrote Stevens again, congratulating him "on

winning 'ARRIET's prize!" [Harriet Monroe] for his play, *Three Travelers*. He was keeping a copy of Stevens's "The Worms at Heaven's Gate" for the July issue of *Others* because it was "a splendid poem," though "a change or two" would no doubt "strengthen the poem materially." The first edit Williams suggested was changing the second line from "Within our bellies, as a chariot" to "Within our bellies, we her chariot," because, Williams explained in bold letters, "THE WORMS ARE HER CHARIOT AND NOT ONLY SEEM HER CHARIOT," He also urged Stevens to remove two lines from another poem he thought too sentimental. "For Christ's sake," he wrote, "yield to me and become great and famous," which was precisely what Stevens did.

In his "Prologue" to *Kora in Hell* (1920), Williams quotes at length from a letter Stevens wrote him, dated April 9, 1918. Stevens had written to thank him for a copy of his just-published *Al Que Quiere!*, explaining that he had decided to send his letter, even though it was "quarrelsomely full of my own ideas of discipline." Williams included the letter in his "Prologue" because it spoke – in Stevens's own words – to how the two differed in their approaches to the poem. What troubled Stevens about Williams's poems was "their casual character," so that the two volumes of poetry Williams had by that point published struck Stevens as reading like a miscellany, rather than as a unified book of poems.

It was an approach Stevens deeply disliked, and the main reason he'd yet to publish a book of his own, and would not for several more years. "Given a fixed point of view," Stevens insisted, everything eventually "adjusted itself to that point of view." But to keep playing with points of view, as Williams did, trying this and that, led "always to new beginnings and incessant new beginnings lead to sterility." What Williams lacked, he explained, was "a single manner or mood thoroughly matured and exploited." The new, the fresh: that was what poetry should always be in search of. The real Williams, the essential Williams, Stevens pointed out, was to be found in those lines about "children / Leaping around a dead dog." A book of that, Stevens urged Williams on, would "feed the hungry." In any event, a book of poems was "a damned serious affair," and a book by Williams should contain only what was distinctive in Williams and nothing else. And while that

essential quality Stevens found everywhere in *Al Que Quiere!*, it was "dissipated and obscured" by poems which did not add to that essential sense of Williams. The truth was that there were "very few men who have anything native in them or for whose work I'd give a Bolshevik ruble," Stevens closed. Follow that search for the American idiom and those New Jersey landscapes, and leave off fiddling with anything else.

Williams fired back. He'd done that, he insisted; had mastered that approach, like Ulysses mastering that witch, Circe. Now it was time to move on to new beginnings, new worlds still unexplored.

That Christmas Eve, Williams wrote Stevens again. His father was dying there in his bed, and had already slipped into a coma. "Three Amens!," Williams managed. "It might be three blackbirds or three blue jays in the snow – but it is three Amens!" At the moment, Flossie downstairs trimming the Christmas tree and their two small sons, Bill and Paul, were asleep in the room next to him. But "what in God's name" could "a man say to Christ these days?" he wondered, close to despair. Christmas morning he added a postscript to thank Stevens for his poetic criticism of his poem in the latest *Little Review*. He was referring to "Nuances of a Theme by Williams," Stevens's take on Williams's four-line poem "El Hombre." "It's a strange courage / you give me ancient star," Williams had written, one more poet among many remaking Modern poetry. No matter, finally, Williams had said, if his own poems did not survive. What did matter was that – like the morning star – he continue to "shine alone in the sunrise" toward which he lent no part. Stevens had seen the chance to point out some of the differences between what Williams was up to and what he himself would have added to Williams' spareness. "Shine alone, shine nakedly," Stevens wrote:

> Be not chimera of morning,
> Half-man, half-star.
> Be not an intelligence,
> Like a widow's bird
> Or an old horse.

It was the last time the two men actually edited one another's poems, though they would keep watching each other across their horizons to see what the other was up to.

In November 1920, on the road for the umpteenth time for the Hartford and away from New York now for the past four years, Stevens wrote his friend, Ferdinand Reyher, about what he saw as the current state of American poetry. What indeed were the most significant magazines being published in the United States at the moment? It was impossible to answer that question, Stevens explained. Williams, for instance, had recently teamed up with a young man named Robert McAlmon to bring out something called *Contact*. But McAlmon was in Europe now, married to a millionaire heiress and "bicycling with Wyndham Lewis in southern France," typing out the manuscript of *Ulysses* for James Joyce, and busy starting up his own Contact Press in Paris, which would publish Ernest Hemingway's first book as well as Williams's *In the American Grain*, among others. With McAlmon away, *Contact* had ceased publication, which was too bad, Stevens thought, since the idea behind Williams's *Contact* made very good sense. True, there was a great deal of free verse still being written in the States these days, though none of it, Stevens thought, had any "aesthetic theory back of it." Besides, most of the poetry wasn't very good because those who wrote it didn't "understand the emotional purpose of rhythm any more than they understood the emotional purpose of measure." To make his point, he mentioned that he'd just read Williams's third book of poems, *Sour Grapes*, just published, and had found it "very slight – very. Charming but such a tame savage, such a personal impersonal."

In August 1922, Williams, now thirty-eight, drove up to his in-laws' farm in southern Vermont with his son Paul and their dog, Bobby. Driving up through Hartford, he stopped to pay a visit with the Stevenses at their apartment at 210 Farmington Avenue. It had been a pleasure to see Williams, Stevens wrote Harriet Monroe afterwards, "although we were both nervous as two belles in new dresses." But the fact was that the forty-two-year-old Stevens was more uncomfortable than ever with guests, especially with his reclusive wife around, and in very short order he managed to find a hotel room for Williams and told him he hoped to see him "on his way back to New Jersey." What the two spoke about is unrecorded, though Stevens probably mentioned to Williams that his first book of poems, *Harmonium*, was going to be published by Knopf in

a year's time. As for Williams, the only thing he recalled Stevens telling him was just how much he enjoyed getting a box of candied violets from a friend each Christmas.

Three years later, in October 1925, Williams, who had just published yet another book – this one his collection of essays, *In the American Grain*, which spanned the history of American literature from the Vikings through Poe and Lincoln, wrote Stevens again, this time asking if he had any new poems available for an issue of *Contact*. But by then Stevens had a baby in the house, and had to confess that for the last year or so he'd "read very little and written not at all." The truth was that his Little Holly kept him and Elsie "both incredibly busy." Moreover, he'd "been moved to the attic" so as to keep out of the way. One consolation for his dismissal, at least, was that at least there he could "smoke and loaf and read and write," though all he did these days was turn in early. He confessed that he'd always found in Williams that "live contact," that vitality with the actual world which still seemed to elude him. Later, when Marianne Moore, now editor of *The Dial*, invited Stevens to review *In the American Grain*, Stevens told her that what Columbus had discovered was nothing to what Williams was looking for, and however much he might like to "evolve a mainland from [Williams's] leaves, scents and floating bottles and boxes," there was a baby at home, which meant all lights were out at nine."

It was the same a year later when, in 1926, Moore invited Stevens to present that year's Dial Award to Williams for *In the American Grain*. "Carlos the Fortunate," Stevens called him. And yet he had to decline even this opportunity, explaining that he was still so "incessantly and atrociously busy." Belatedly he would write Williams to say how much he regretted not having been at the award ceremony in New York. "Your townsmen must whisper about you," he winked, "and, as you pass the girls, they surely nudge each other and say 'The golden boy!'"

In mid-1927, Williams wrote Stevens again, this time with a request that had come directly from "the Pound" himself, who was now living in Rapallo, asking for something for an issue of *Exile*, a new magazine Pound was editing. It took Stevens three weeks to get back to Williams, and when he did, his answer was – once again – no. "Believe me, signor,"

he wrote, I'm as busy as the proud Mussolini himself. I rise at day-break, shave etc.; at six I start to exercise; at seven I massage and bathe; at eight I dabble with a therapeutic breakfast; from eight-thirty to nine-thirty I walk down-town [to the Hartford]; work all day [and] go to bed at nine. How should I write poetry, think it, feel it? Mon Dieu, I am happy if I can find time to read a few lines, yours, Pound's anybody's. I am humble before Pound's request. But the above is the above. "Undecipherable letter from Wallace Stevens," Williams told Pound. "He says he isn't writing any more. He has a daughter!"

Half a dozen years later, when the young New York poet, Louis Zukofsky, decided to publish a volume of Williams's *Collected Poems 1921 to 1931* for his Objectivist Press (five hundred copies at two dollars each), he asked Williams whom he should ask to write the preface. Stevens, Williams told him, for personal as well as for professional reasons, for they'd known each other's work now for the past twenty years. This time Stevens agreed, and that November he wrote something he must have thought would surely please his friend. Williams, who had just turned fifty, was still an incurable romantic, though calling his friend that would no doubt horrify him. By romantic, he explained, he meant someone who had "spent his life in rejecting the accepted idea of things as they were," which for Stevens was very high praise indeed.

True, Williams had his sentimental side, but it was his reaction to sentimentality which so vitalized his work. The truth was, Stevens explained, that Williams had a passion for the antipoetic that kept him grounded in reality, and real poetry – poetry of the actual – was the result of a constant tension between the sentimental and the real. This was 1933, and the harsh fact was that Americans were now in the midst of the Great Depression. The romantic now, therefore, had to be someone who dwelt in an ivory tower but who insisted "that life there would be intolerable except for the fact that one has, from the top, such an exceptional view of the public dump and the advertising signs of Snider's Catsup, Ivory Soap and Chevrolet Cars." In other words, the true poet was a "hermit who dwells alone with the sun and moon, but insists on taking a rotten newspaper." Williams, in fact, was our Laocoön: "the realist struggling to escape from the serpents of the unreal." But Williams

was also our Diogenes, a poet who was continually seeking to find the truth inherent in poetry. Stevens was speaking, of course, of the tension one is constantly finding between the real and the imagined in Stevens's own poems as much as in Williams.

At first Williams was delighted by Stevens's preface, but in time he became increasingly discontent with Stevens's depiction of him as the antipoet, so that fifteen years later he would confess that he was "sick of the constant aping of the Stevens's dictum that I resort to the antipoetic as a heightening device," even though it was Williams who had described himself in just those terms as far back as *Spring and All*. The fact, he'd insisted there, was that the common vulgate should come from as much below Fourteenth Street as it did from Dante and those footnotes T. S. Eliot had appended to *The Waste Land*.

Then, in 1933, Stevens, who had been a sleeping giant for ten years while he bought a spacious house – the only one he would ever own (at 118 Westerly Terrace in Hartford) – and gardened and continued to raise his little daughter, began publishing again, and with a vengeance. In 1935 he published *Ideas of Order*, followed by *Owl's Clover* in 1936, both in handsome limited editions under the imprint of the Alcestis Press, by a publisher who went by several names, two of them Latimer and Leippert. Alcestis would also publish two volumes by Williams: *An Early Martyr* in 1935 and *Adam and Eve and the City* the following year.

In a letter to Stevens in May 1936, Williams wondered who this elusive Latimer really was. Since neither poet had ever actually met Latimer, Williams wondered if the man could be trusted. "Dear Sherlock Holmes," Stevens wrote back. No doubt there was something odd about this all-too-elusive Latimer, but, really, that was no concern of his. "What Latimer is is nothing to me so long as he does not involve me," he told Williams, as long as the books he published showed the discipline they did. In any event, Stevens's most extensive correspondence with anyone during the mid-1930s would be with this phantom editor who intrigued him, but whom he did trust, inasmuch as Stevens trusted anyone.

Moreover, by then, Stevens seems to have shifted his interest away from Williams to Marianne Moore. When the editor of *Life and Letters Today* wrote Stevens in March 1935, asking if he might review Moore's

Selected Poems, Stevens replied enthusiastically. Moore, he believed, was a real poet, "not only a complete disintegrator" like too many contemporary poets, but "an equally complete reintegrator," someone whose poems were "a good deal more important than what Williams does." Williams, he believed more strongly than ever, represented an "exhausted phase of the romantic," whose major attraction was its form. Moore, on the other hand, represented a new phase of the romantic, whose particular break with traditional forms was what he himself was after: an attempt to free oneself to discover "what a fresh romanticism might look and sound like."

And there it was: Stevens with his idea of the Modern Romantic Poet, and Williams with his own idea countering that. "The story is that Stevens has turned of late definitely to the left," Williams noted in his review of *The Man with the Blue Guitar* in *The New Republic* in mid-November 17, 1937, six weeks after the book appeared. But that would be a misreading. Stevens, now approaching sixty, was "merely older and as an artist infinitely more accomplished." And here was the blessed catch: Stevens had turned out to be a poet "in defense of the underdog." The title poem was one of Stevens's best, which revealed "a troubled man who sings well, somewhat covertly, somewhat overfussily at times, a little stiffly but well," but at his best "thrumming in four-beat time." Unfortunately, that had not been enough for Stevens, who had felt the need "to make a defense of the poet . . . facing his world." And so, as far as "Owl's Clover" went, though it had "its old woman very effectively balanced against the heroic plunging of sculptured horses," the poem had failed to get under way.

The trouble there lay in Stevens's use of the blank-verse line, which had a "strange effect on a modern poet" because it made a poet think he had to think, with the result that Stevens had created a "turgidity, dullness and a language" no one "alive today could ever recognize – lit by flashes, of course," because Stevens was "always a distinguished artist." This time, however, he'd let his blank verse meter run the language. Actually, Williams pointed out, diagnostician that he was, the best poem in the collection turned out to be the collection's final poem, "The Men That Are Falling," because it was "the most passionate." It

was, in fact, "one of the best poems of the day," because Stevens had finally allowed himself to show through the poem, and there was a lesson there "for us all."

In July 1942 the critic Harvey Breit wrote Stevens asking to interview him for *Harper's Bazaar* in his dual roles as poet and insurance executive. Breit added the carrot that Williams had already signed on to be interviewed in his roles as poet and physician. Williams also wrote Stevens, pleading with him to come aboard, but Stevens, being Stevens, and already having been stung in giving an earlier interview, simply refused. "Wallace Stevens is beyond fathoming," Marianne Moore confided to Williams in November 1944. She'd been reading and reviewing his poetry for twenty years now, in spite of which she still found him strange, "as if he had a morbid secret he would rather perish than disclose and just as he tells it out in his sleep" – by which she meant his poems – "he changes into an uncontradictable judiciary with a gown and a gavel and you are embarrassed to have heard anything."

When, in late 1945, Williams read Stevens's long poem, "Description without Place" in the pages of the *Sewanee Review*, he saw it as an attack on his own poetry, which often began with something he'd seen or heard on the streets of New York City – the same streets where he and Stevens used to meet thirty years earlier. Who had Stevens been pointing to when he spoke of the way in which men made themselves by their speech? Was he the "hard hidalgo" Stevens had spoken of, the poet who had shaped, as much as Stevens had, the "invention of a nation in a phrase"?

Resistance to the direction Stevens's poetry had assumed had been on Williams's mind for decades now. How he missed that "lamb-like urban talent" in *Harmonium*, a tone long since gone now: that "metropolitan softness of tone, a social poetry that Chaucer had long ago [brought] to such perfection," as he confided to Marianne Moore. Even as early as 1943 Williams had written his editor, James Laughlin, at New Directions about the long poem he was cobbling together. If Stevens could speak of "Parts of a World," he had said then, his long poem "Paterson" would consist of "'Parts of a Greater World' – a looser, wider world where 'order' is a servant not a master."

* * *

By 1950 both poets, now in their late sixties, were going strong. That year, Williams was awarded the first National Book Award for Poetry in recognition of the publication of his *Selected Poems* and *Paterson III*. The following year Stevens was presented with that same award for his *Auroras of Autumn*. Williams and Stevens were going to meet up again that April at Bard, where Williams was scheduled to give a talk on poetry. Instead, he lay in the intensive care unit at Passaic General Hospital, capable of no more than a weak stutter, having just suffered a severe stroke. Still, he'd insisted on talking on the telephone to Ted Weiss, the organizer of the event, trying to explain why it would not be possible for him to be there to greet Stevens. When Weiss broke the news to him, Stevens quipped that, though he was four years older than Williams, he'd managed to outlast his friend.

But Stevens, feeling guilty for his remark, wrote Williams three weeks later. While the Bard affair had been extremely pleasant, the news of Williams's illness had "saddened and disturbed everyone." Bill had worked too hard getting to the top to be deprived now of a leisurely old age. Then he caught himself. "As the older of the two of us; I resent those words more than you do. If a man is as young as he feels, you are, no doubt, actually twenty-five and I am say twenty-eight. . . . I still come to the office regularly because I like to do so and have use for the money, and I never had any other reasons for doing so." He wished he could see Williams when he was in New York, but his days always seemed to be taken up with errands to run – buying shoes, socks, and so on – so that there was "rarely time to meet people." Stevens's poetry, of course, had already told Williams as much.

As soon as he felt strong enough, Williams wrote back. It was the first letter he'd been able to peck out on his typewriter since his stroke, and he told Stevens he was thrilled to be writing at all, especially to a friend he'd known for close to forty years. The stroke, he admitted, had caught him by surprise, "for though I know I am far from invulnerable I didn't expect THAT! . . . It seems to have resulted from trying to write a book in three months while carrying on a practice of medicine. Just couldn't bring it off," though he'd almost "had the book finished

at that." He was referring to his *Autobiography*, which he was now back to working on. And, yes, though either of them might "croak at any moment," they weren't really old, were they? He was even looking forward to a whole "new way of life," hoping to "hobnob" with his few real friends, among whom he counted Stevens. What he could not know was that the two would not meet again on this side of the Great Divide.

Williams was in worse shape than Stevens had thought, having suffered not one but three strokes, which had left his right side paralyzed. Worse, though Williams had been "invited to act as consultant in poetry to the Library of Congress" rumors had begun circulating that he was a Communist because he'd contributed to several leftist magazines during the 1930s, so that – in this frigid cold war era – Washington had decided to play it safe and strip him of the honor they had bestowed on him.

Stevens of course had no idea whether or not Williams was a Communist. Since Williams had always been on the cutting edge of things, chances were that he probably had associated with Communists in the past, though, as Stevens wrote his young Cuban friend, José Rodríguez Feo, Williams was "the least subversive man in the world." And what was he to make of Williams's new poems, with their triadic structures and Calderesque mobile-like lines? Were those the things readers preferred these days? And if so, what would the next generation favor? The bare page? "For that alone would be new," the equivalent to the bare canvases the New York School of painters seemed to prefer these days. He could only hope that someday there might really be a new world for the poem, and not mere variations of the old.

On the evening of January 25, 1955, Stevens, now seventy-five, was in New York to receive his second National Book Award in four years, this time for his *Collected Poems*. Williams had also been a finalist that year, but it was Stevens who won, as he would also win the Pulitzer later that same year, sharing the evening with William Faulkner, who received the award for his novel *A Fable*. Then, less than three months later, Stevens was diagnosed with stomach cancer, and died on August 2nd.

It was left to Williams to write Stevens's eulogy for *Poetry*, where both had started out forty years before. "To me there was something in the dogged toughness of his thought that gave it a Germanic quality," Wil-

30

liams wrote that October. "He always reminded me of Goethe, in his youth," when "lemon trees filled his dreams, before the devastations of the moral sense had overcome him." In the beginning there had been that New York dandy, the Stevens he had known most intimately, before he assumed the New England conscience of a Hawthorne.

There had always been a cryptic quality to Stevens's verses, a ritualistic quality, really, as if he were following a secret litany he revealed to no man. "Over and over again, as he reached his later years and . . . began to be recognized for what he was, . . . even in such a late book as *The Auroras of Autumn*, he could be detected, to the surprise of the world, in this secret devotion." The truth was that, "in the midst of a life crowded with business affairs," Stevens had become "a veritable monk."

By then he had "seen and possessed what he wanted in this world," Williams concluded. "Henceforth contemplation, vividly casting its lights across his imagination, sufficed for him." In his last years, Stevens had "earned an undeserved reputation for coldness if not sterility," a judgment which only time would rescue him from. Though Williams had "no confidence" that anyone would read Stevens (or himself) in the years to come, what Stevens offered, if one took the time to read him carefully, was "something to cure our neuroses and make us whole again in the face of much that is sordid and cheap in the world." In any event, one went back to Stevens for the sheer pleasure of his lines. Somehow, the man had managed to write an English as no Englishman had ever written it. For centuries poetry had forgotten how to dance. And then along had come Stevens to change all that, for good.

In spite of his debilitating strokes, Williams would manage to soldier on. Stevens had always been in awe by how a man who had delivered over 2,000 babies could write so much. There would be *Journey to Love* published the same year Stevens died, followed by his *Selected Letters* in 1957. In 1958 *Paterson V* would follow, and then, in 1959, the book he'd worked on years before with his mother, *Yes, Mrs. Williams*. In 1961 his collected stories, *The Farmers' Daughters*, appeared, followed in 1962 by his collected plays and *Pictures from Brueghel and Other Poems*. And then all of *Paterson* (I – V) in 1963. In May of the year he died, 1963, he was posthumously awarded the Pulitzer for *Pictures from Brueghel*, followed by the

Gold Medal for Poetry from the National Institute of Arts and Letters.

Among the voluminous items in Alan Klein's magnificent collection you will find Wallace Stevens's own copy of the second issue of *Others*, as well as a copy of *The Man with the Blue Guitar* inscribed to his daughter, Holly, with the touching inscription, "From one poet to another, Love, Daddy." There's also a copy of the Knopf edition of *Ideas of Order* which Stevens inscribed to Latimer, as well as a copy of the *Transport to Summer*, which Stevens inscribed to his close friend, Henry Church, just a week before Church died of a heart attack in New York on Good Friday, April 4, 1947. And then there's Stevens's *Collected Poems*, which Stevens inscribed to Church's wife, Barbara, the same evening – November 6, 1954 – he gave his reading at the 92nd Street Y, which bears the inscription "Tom Tom C'est Moi", a line from Stevens's "The Man with the Blue Guitar."

In addition, there are two letters from Stevens to Vivienne Koch, who knew both poets and who wrote the first biography of Williams. Like so many of Stevens' letters, both were written at his office at the Hartford. In the first, written on January 29, 1947, he promises to send her some poems for the next issue of the *Briarcliff Quarterly*, and then praises the Williams number, published by the *Quarterly* the previous October, calling it "one of the best of these Festschriften." And while there are a number of poems and prose pieces by Williams himself, it is a photograph of Williams's mother which has especially touched him, revealing in the mother's face something which "seems to account for a very great deal" of who the poet himself is. And speaking of mothers, it is something which is as true for Stevens himself, as *The Auroras of Autumn* will show.

In the second letter, written to Koch at the Kingsley Hotel in London in mid-February 1950, he tells her how happy he is for Williams now that his friend, having won the National Book Award for *Paterson III* and his *Selected Poems*, has been elected to the National Institute for Arts and Letters, even though, in that distinctive manner of Stevens, while he believes Williams may have no real sense of just how important the award is, it is "a big step toward the acceptance of his work and acceptance is a big step toward understanding and liking."

And then there are priceless items by Williams. Among them are his first book of poems, *The Tempers* (1913), inscribed for his mother-in-law. There's also a copy of *Al Que Quiere!* (1917) inscribed to Flossie, as well as a letter Williams wrote to Latimer to say just how thrilled he was to be published by him. In addition, there are first edition copies of all five books of *Paterson*, which he inscribed to his son Paul as each of those volumes were published. There's also a first edition of *Kora in Hell* (1920) inscribed to Martha Graham when he was working on a project with her. And then there are Ezra Pound's copies of so many of Williams's books, each of them inscribed by Williams. This, friends, is indeed a collection to feast upon.

Paul Mariani, author of *A New World Naked: The Life of William Carlos Williams* and *The Whole Harmonium: The Life of Wallace Stevens*

WALLACE STEVENS

DANIEL HALPERN Why Wallace Stevens?

Who ends a poem,

> Where was it one first heard of the truth? The the.

Wallace Stevens was not the first poet I read. My mother made me
read an old anthology of British and American poetry, edited by Louis
Untermeyer. She pointed me to Lewis Carroll's "Jabberwocky," which I
memorized for a class assignment in grade school. I liked the texture
of the poem and the insanity of the language: *frumious Bandersnatch*,
'twas brillig, and the slithy toves, all mimsy were the borogoves – even a *Jubjub
bird* and a *Tumtum tree*. Then I found a book of love poems by Walter
Benton, *This Is My Beloved*. A book devoid of memorable language and
any indication of crazy – just pure sentiment, which I understood at
ten as romantic love. Then it was on to Rod McKuen, a hipper version
of Benton. And so, many years passed. I wrote some poems of my own,
and eventually found the poets who would speak to me for the rest of
my life. Elizabeth Bishop, Emily Dickinson, Thomas Hardy, T.S. Eliot,
Wallace Stevens and W. B. Yeats. Their collected works, in hardcover,
are never not near my reading chair at home. But only Stevens travels
with me, in paperback and eBook.

The first poem of his I read was not "Thirteen Ways of Looking at
a Blackbird" or "The Emperor of Ice-Cream." It was "The Man on the
Dump," a poem that speaks to the infinities of language and the struc-
tures of poetry. Out of the mundane detritus of the everyday – of the
quotidian, of the passed off, the unwanted, the rejected – a boundless
treasury of images, a pile of the discarded for the poet's imagination to
sort through, assess and reassemble. The opening stanza:

> Day creeps down. The moon is creeping up.
> The sun is a corbeil of flowers the moon Blanche
> Places there, a bouquet. Ho-ho . . . The dump is full
> Of images. Days pass like papers from a press.
> The bouquets come here in the papers. So the sun,
> And so the moon, both come, and the janitor's poems

> Of every day, the wrapper on the can of pears,
> The cat in the paper-bag, the corset, the box
> From Esthonia: the tiger chest, for tea.

I've read Stevens for over 50 years. I've taught him, I've read him
to potential love interests and even had him read to me – by Donald
Trump, but that is another story.

Why Wallace Stevens.

In his own words, his poems are *shiny surfaces full of clouds* – that
continue to shape and reshape themselves over a multitude of read-
ings. The limberness of his associations and transitions, the pastels of
his language, his linguistic unpredictableness, his effortless blank verse
in a poem like "Sunday Morning," whose first stanza reads,

> Complacencies of the peignoir, and late
> Coffee and oranges in a sunny chair,
> And the green freedom of a cockatoo
> Upon a rug mingle to dissipate
> The holy hush of ancient sacrifice.
> She dreams a little, and she feels the dark
> Encroachment of that old catastrophe,
> As a calm darkens among water-lights.
> The pungent oranges and bright, green wings
> Seem things in some procession of the dead,
> Winding across wide water, without sound.
> The day is like wide water, without sound,
> Stilled for the passing of her dreaming feet
> Over the seas, to silent Palestine,
> Dominion of the blood and sepulchre.

The way his poems avail themselves simultaneously of the domes-
tic and exotic, attentive to the requests of the body metabolism, even
when the poem feels bodiless, existing within a darkly intellectual and
cerebral framework. Often it seems, reading him, that he's somewhere
down the hall, but never in my room. Not sure why that is.

His poems have the depth and longevity they do because they re-
quire *your* imagination to engage with *his*. So it's always, and *only*, an
individual understanding of a particular poem, as it should be reading

38

poetry. And as one's imagination evolves, via the experience of age and the foibles of the humdrum, so do the poems of Wallace Stevens. The poems, moving targets in reverse, come back, full volume, at you. And if you're a young poet, a line of his can become a fuse.

Why Wallace Stevens.

Because his poetry, in every season, is like the smell, feel and taste of summer fruit.

So here is this exhibit from Alan Klein's collection, a collection of *paper*. Some of it bound, some unbound or enclosed in envelopes of paper. Paper forever altered by one of our great poets, who has altered the world we, for the time being, inherit.

How remarkable to have such a personal collection of material – paper! As Stevens wrote,

> . . . The dump is full
> Of images. Days pass like papers from a press.
> The bouquets come here in the papers . . .

By Stevens

1 Autograph letter to E.P. Loud, signed, "Wallace Stevens, Secretary" of the Signet Society, Cambridge, MA, 1899.

> Unprinted leaf, 5 ½ x 7"; one page; framed with dried rose.

In this letter, one of very few to survive from his time at Harvard, Stevens congratulates one E.P. Loud on his acceptance into the Signet Society and gives the following instructions regarding the initiation ceremony:

> For your initiation, which will take place Wednesday evening, December 20, 1899, you will be expected to prepare a part of from five hundred to one thousand words.

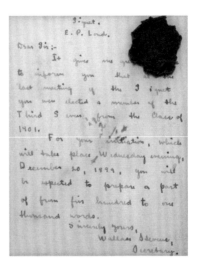

Stevens matriculated to Harvard in 1897, where despite his father's constant reminders that he was there to prepare for a career in business and law, he began publishing poems (mostly sonnets) in the Harvard *Advocate* and the Harvard *Monthly*. The Signet Society was founded in 1870 for students interested in literature and the arts. Membership to the elite club is still by invitation only; Stevens was elected his senior year, to the position of Secretary. In that role, he sent new members a letter of invitation, as well as a rose – a tradition still in place today. Edward Perry Loud preserved his with this acceptance letter from Stevens. Loud served as President of the Harvard *Crimson* and went on to pursue a career in engineering.

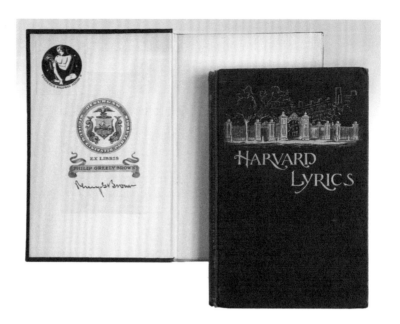

2 Harvard Lyrics and Other Verses. Being selections of the best
verse written by Harvard Undergraduates within the last ten years.
Selected by Charles Livingstone Stebbins of the Class of Ninety-
seven. Boston: Brown and Company, 1899.

> 8vo.; crimson cloth, with the title and a view of Harvard Yard
> stamped in gold on the front cover.

First edition of this selection of works by Wallace Stevens and his
fellow Harvard students. Includes Stevens's first appearance in a
book, "Vita Mea" – and the only book appearance of this poem,
which first appeared in the Harvard *Advocate* (December 12, 1898).
Edelstein B1. Though bearing the bookplate of Frederick Baldwin
Adams, this volume was not itemized in the catalogue of the fa-
mous sale of his collection at Sotheby's London in 2001. Nor did it
appear in the 1935 American Art Association / Anderson Galleries
catalogue of the collection of Philip Greeley Brown, whose book-
plate is also present.

3 Harvard Lyrics and Other Verses. Being selections of the best verse written by Harvard Undergraduates within the last ten years. Selected by Charles Livingstone Stebbins of the Class of Ninety-seven. Boston: Brown and Company, 1899.

> 8vo.; crimson cloth, with the title and a view of Harvard Yard stamped in gold on the front cover.

First edition. Edelstein B1. A presentation copy, inscribed on the front endpaper by the editor: *Frances E. Goddard / from / C. Livingstone Stebbins / Christmas / 1906.*

4 Autograph letter to J.E. Springarn, signed, "W. Stevens," Cambridge, MA, April 9, 1900.

> One leaf of Harvard *Advocate* letterhead; one page.

At the time of this correspondence, Stevens was in his final semester at Harvard and serving as president of the Harvard *Advocate*. Apparently writing in response to a request from Springarn, Stevens notes that he located a copy of volume 60 of the *Advocate*, in which Springarn's "Sonnet for the Centenary of Keats" was published: "I am unable to send you the number in which it appeared but have copied it on inside pages." The complete sonnet appears on the verso in Stevens's hand.

In 1900, Joel Elias Springarn (1875-1939) was teaching comparative literature at Columbia University. It was Professor Springarn who influenced a young Alfred A. Knopf, class of 1912, to go into publishing instead of attending Harvard Law School, a decision which greatly impacted Stevens, as Knopf published the first trade edition of Stevens's first book *Harmonium* in 1923 and every book of his thereafter.¹ Springarn published three volumes of poetry in his lifetime, and edited works of literary criticism. Springarn was also a civil rights activist, and one of the first Jewish leaders of the NAACP, serving on the board in various capacities from 1913 to 1939.

5 Wallace Stevens and Elsie Viola Kachel. **Marriage Certificate.** Reading, PA: September 21, 1909.

> 6 x 8 ½"; with original envelope printed with the return address of Rev. William H. Myers, and docketed by hand, "Cert. Stevens – Kachel / Married Sept. 21. 09 / Rev. Myers."

Together with:

Strunk. **Photograph of Reverend William H. Myers.** Grace Lutheran Church, Eleventh Street.

3¾ x 5¼"; mounted.

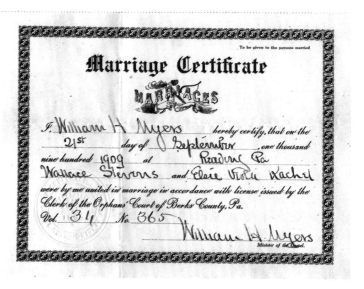

Marriage certificate documenting the union of Wallace Stevens and Elsie Viola Kachel by the Reverend William H. Myers on September 21, 1909 in Reading, Pennsylvania. This marriage certificate is symbolic of Wallace and Elsie's five-year romance as Stevens struggled to establish himself professionally in New York, of the early poems that Stevens wrote as gifts for Elsie, of the rift of Stevens and his parents and, ultimately, of the drifting apart of Stevens and his wife. Stevens's family did not approve of the match – which might account for the long lead-up to their marriage. No one from Stevens's family attended the wedding, after which Stevens broke off contact

with his parents, never seeing his father again. The marriage, which endured for over forty-five years, ultimately became an unhappy one, with Wallace and Elsie living separately under one roof. There is much speculation as to the nature of the rift in their relationship and Elsie's ultimate withdrawal from Stevens and the world at large.

6 **Anthology of Magazine Verse for 1915.** And Year Book of American Poetry. Edited by William Stanley Braithwaite. "Peter Quince at the Clavier," pp. 15-17. New York: Gomme & Marshall, 1915.

> 8vo.; contemporary ink signature on front endpaper ("Louisa Brooke / 'Churchman / 1916'"); tan paper-covered boards; brown cloth spine; printed cover and spine labels.

First edition. Edelstein B5. "Peter Quince at the Clavier" was the first poem by Stevens to receive major attention from editors. A retelling of the Biblical allegory of Susanna and the Elders from the perspective of Peter Quince, a minor comical character from Shakespeare's *A Midsummer Night's Dream*, it first appeared in the August 1915 issue of *Others* (see item #104) and was then included in this anthology that November, as well as in two subsequent volumes soon after: *Others: An Anthology of the New Verse* (Knopf, 1916), edited by Alfred Kreymborg (see item #105), and *The New Poetry* (The MacMillan Co., 1917), edited by Harriet Monroe and Alice Corbin Henderson.

Also present in the anthology are Harriet Monroe, Stevens's Harvard chum Witter Bynner (see also item #14), Amy Lowell, Vachel Lindsay, Edith Wharton, Louis Untermeyer, and dozens more. Occasional pencil ticks throughout the table of contents – including next to Stevens's contribution.

7 **Poetry: A Magazine of Verse.** "Three Travelers Watch a Sunrise. A play in one act," pp. 163-179. VII.4 (July 1916).

> 8vo.; printed wrappers.

First appearance of this play. Edelstein C49. This precedes by several years its book publication in *Fifty Contemporary One-Act Plays* (1921). Stevens was awarded $100 by the Players' Producing Company

for this one-act verse play. The editorial staff of *Poetry* judged the contest and Stevens expressed pleasure at his win, as well as his plans to revise the piece, in a letter to *Poetry* editor Harriet Monroe: "This is a feather in my cap and I make my first bow with it to Chicago. I shall make every effort to get the revised copy in your hands by June 8th . . . What I tried to do was create a poetic atmosphere with a minimum of narration. It was the first thing of the kind I had ever done and I am, of course, delighted with the result. So is Mrs. Stevens." Stevens also jokingly notes a typo in the title in the proof he received – "It should be *Travelers*. The printer appears to believe that travelers are full of l, so that he makes it travellers" (May 22, 1916).[2]

The final draft, which Stevens edited based on feedback from Monroe and poet Max Michelson (also on staff at *Poetry*), is included in *Opus Posthumous* (1957). One of their suggestions was to eliminate a hanging corpse on stage, described in the opening stage directions, which they found to be distasteful. In the revised version, a character sees a "dark swaying object" offstage and hears a creaking limb, but the body is never seen by the audience.[3] *Three Travelers Watch a Sunrise* premiered at the Provincetown Playhouse in New York on February 13, 1920. Stevens did not attend the performance. This play marked Stevens's third appearance in Harriet Monroe's influential *Poetry* magazine.

8 Poetry: A Magazine of Verse. "Carlos among the Candles," pp. 115-123. XI.3 (December 1917).

> 8vo.; printed wrappers.

First publication of this play which appeared in book form only much later in *Opus Posthumous* (1957). Edelstein C52. After his success with "Three Travelers Watch a Sunrise," Stevens wrote another one-act, this time in prose. The play, essentially a monologue for one actor, was written for the Wisconsin Players, but closed after only one performance, on October 20, 1917 at the Neighborhood Playhouse in New York. The production was disastrous according to both Stevens and theater critics. As Stevens explained, "The principal character forgot three pages of the text, which only contained, as I

remember it, ten or twelve pages."[4] Stevens sent Monroe the nega-
tive reviews to dissuade her from publishing the piece in *Poetry*, but
she was undeterred: "Indeed, I can't help laughing over what almost
any actor might do with Carlos (Nijinsky might dance him). But I
am not in the least discouraged from desiring to see him in print."[5]

At least one commentator has speculated that "Carlos" may be an
homage to William Carlos Williams.

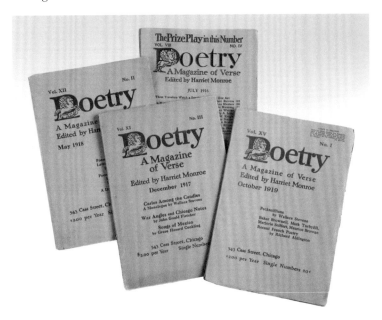

9 Poetry: A Magazine of Verse. "Lettres d'un Soldat," pp. 59-65.
 XII.2 (May 1918).

 8vo.; printed wrappers.

First appearance. Edelstein C54. This appeared decades later in *Opus
Posthumous* (1957). This sequence of World War I poems originally
numbered thirteen, but Monroe decided only to publish nine of
them, none of which appear in the 1923 edition of *Harmonium*. The
1931 edition of *Harmonium*, however, includes three of the poems
from the set that Monroe chose ("The Surprises of the Superhu-
man," "Negation," and "Life contracts and death is expected") and

one that she did not ("Lunar Paraphrases").

Each poem in "Lettres d'un Soldat" begins with an epigraph taken from the letters of Eugène Lemercier (1886-1915), a French painter who was drafted in 1914 and killed on April 6, 1915 at the Battle of Les Éparges. Lemercier's letters and postcards to his mother, as well as his journals kept during the war, were preserved in book form, *Lettres d'un soldat (Août 1914-Avril 1915)* (Librairie Chapelot, 1916), from which Stevens presumably found the text he used to introduce each poem in this series. War poems were understandably popular in this period, and Stevens paints a noble portrait of the soldier who accepts the sacrifice he must make and is unsentimental about his own mortality.

10 Poetry: A Magazine of Verse. "Pecksniffiana," pp. 1-11. xv.1 (October 1919).

8vo.; printed wrappers.

First appearance. Edelstein C62. Fourteen poems comprise "Pecksniffiana," for which Stevens won *Poetry*'s Helen Haire Levinson prize. His win was announced in the November 1920 issue of *Poetry*, and the series appeared in *Others for 1919* (1920), *The New Poetry New and Enlarged* (1923) and *Prize Poems 1913-1929* (1930). The title "Pecksniffiana" is an allusion to Seth Pecksniff, an unlikable character from Dickens's *Martin Chuzzlewit* who is known for his hypocrisy, arrogance, and fickle nature.

Concerned about the quality of some of the work he initially submitted, Stevens wrote to Monroe in August of 1919, enclosing an additional five poems as replacements. One poem he asked to withdraw from consideration, "Piano Practice at the Academy of the Holy Angels," was not published until after his death, in 1957's *Opus Posthumous*: "I am uncertain about the Piano Practice – as I recall it, it is cabbage instead of the crisp lettuce intended." Monroe added in all of the new pieces Stevens sent, and took out "Piano Practice" and one other poem. Stevens expressed reservations about "Exposition of the Contents of a Cab," remarking, "I have not yet learned how to do things like the Exposition." Monroe apparently disagreed be-

cause she decided to include it in the series; Stevens included it in 1923's *Harmonium*, but dropped it for the 1931 edition.[6]

The Helen Haire Levinson prize was established in 1914 by Salmon Oliver Levinson ("Sol") in honor of his late wife. Carl Sandburg was the first recipient and was awarded $200. (For a letter from Sandburg, acknowledging receipt of advance sheets of William Carlos Williams's *Al Que Quiere!* in 1917, see item #135.)

11 Harmonium. New York: Knopf, 1923.

> 8vo.; multicolor checkered paper-covered boards; navy cloth spine; printed spine label; red topstain; pressed dried flower loosely inserted.

Together with:

Typed letter to Thomas Graham, signed, "Norman R. Moray," Hartford, CT, October 13, 1926; one leaf of Hartford Accident and Indemnity Company letterhead; one page.

Together with:

Typed letter to Dorothy Hartstall, signed, "Marguerite [] Flynn," Hartford, CT; date neatly excised; one leaf of Hartford Accident and Indemnity Company letterhead; one page.

Together with:

Typed letter to Dorothy Hartstall, signed, "Wallace Stevens," Hartford, CT; date neatly excised; one leaf of Hartford Accident and Indemnity Company letterhead; one page.

Together with:

Four newspaper articles, mentioning Stevens and reviewing books about him, 1975-1980, all clipped from the *New York Times*, the *New York Times Book Review* and the *Washington Post*.

Together with:

Obituary clipping: "D. E. Hartstall; Poet's Secretary." The *Hartford Courant*, n.d. [August 1988].

First edition of Stevens's first book, 1500 copies; this is one of 500

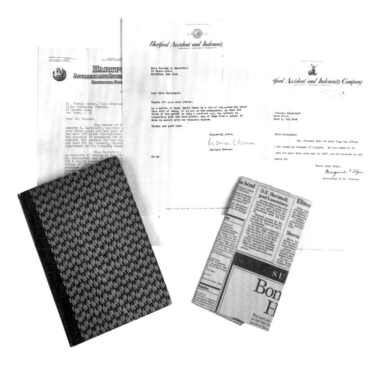

copies in the first binding. Edelstein A1.a. Signed by Stevens on the front flyleaf, and with a small four leaf clover, pressed in the book between "The Snow Man" and "The Ordinary Woman" (pp. 24-25). With related correspondence and clippings.

This copy of *Harmonium* belonged to Dorothy Elizabeth Hartstall (1894-1988), Stevens's secretary, for several years, at Hartford Accident & Indemnity. Also present are three brief typescript letters that connect Hartstall to Stevens well beyond the end of their professional relationship, and newspaper clippings about Stevens that Hartstall collected and saved, indicating her continued interest in his poetic career. Finally, Hartstall's obituary – with the headline: "D.E. Hartstall; Poet's Secretary."

The first letter, written by Norman R. Moray, the Vice President and General Manager of Hartford Accident & Indemnity, describes Hartstall as a "most efficient stenographer" who has worked for the firm for more than seven years, many of which were "in the capac-

ity of secretary for Mr. Wallace Stevens, the counsel for our Surety Claims Department." Moray goes on to explain that Hartstall is relocating to New York City "for personal reasons," but unfortunately their New York Office has no senior stenographer openings. "Therefore, purely as a matter of justice for the splendid services she has rendered this company," he writes, "I am giving her letters of introduction to several of my executive friends in New York, in the hope that one of them may have an opening which will be to their mutual advantage." The letter is addressed to Thomas Graham of Globe Indemnity Company in Manhattan.

The next two letters were written after Hartstall had settled in Brooklyn, and show that Stevens and Hartstall remained in touch and on friendly terms. One is from Marguerite Flynn, the secretary who worked for Stevens after Hartstall left, who reports that Stevens is ill and will be out of the office for a few weeks but wanted to thank her for her "kind note," and the other is from Stevens himself, who writes about an intriguing, but unknown incident:

Dear Miss Hartstall,

Thanks for your nice letter.

As a matter of fact, while there is a lot of rub-a-dub-dub about this sort of thing, it is all in the newspapers, so that the truth of the matter is that I received only two letters in connection with the last affair, one of them from a lawyer to whom we should give our business anyhow.

Thanks and good luck,
Wallace Stevens

This material is in many ways very touching, even moving. Ms. Hartstall apparently never married and moved back to Hartford to be nearer to relatives after her retirement. She held on to her copy of *Harmonium* and her letters during the course of sixty-five years, still clipping newspaper reviews of books about Stevens more than fifty years after leaving his employ. Her letter from him has the date carefully excised, for reasons unknown. The *Hartford Courant* published an obituary upon her passing referring to her as "former secretary to poet Wallace Stevens." Neither her devotion to Stevens's

memory nor her very existence appears in any of his biographies.

Harmonium, the first volume of Stevens's poetry, was published with the help of Carl Van Vechten, whom Stevens presented a manuscript of "Peter Quince at the Clavier" in 1914 upon their first meeting. Knopf had published Van Vechten's first novel in 1922, and Van Vechten was instrumental in Stevens landing this first major book contract. *Harmonium* contains a number of significant poems in addition to "Peter Quince at the Clavier," including "The Snow Man," "The Emperor of Ice-Cream," "Thirteen Ways of Looking at a Blackbird," "Anecdote of the Jar," "The Comedian as the Letter C" and "Sunday Morning," each among the most anthologized poems of the 20th century. Twelve of the poems in *Harmonium* first appeared in the October 1919 issue of *Poetry*, grouped together under the self-deprecating title, "Pecksniffiana" (a nod to the Dickens character Seth Pecksniff). Stevens was awarded the Helen Haire Levinson prize for that selection.

In the months leading up to the book's publication, Stevens corresponded with Monroe, expressing great anxiety: "Gathering together the things for my book has been so depressing that I wonder at *Poetry*'s friendliness. All my earlier things seem like horrid cocoons from which later abortive insects have sprung. The book will amount to nothing, except that it may teach me something" (October 28, 1922); and, "to pick a crisp salad from the garbage of the past is no snap . . ." (December 21, 1922). Stevens changed the title of the manuscript several times – at one point, it was "The Grand Poem: Preliminary Minutiae," which he felt had "a good deal more pep to it" (March 12, 1923) – before he settled on *Harmonium*, finalizing the decision in a telegram to Knopf on May 18, 1923.[7] Though Stevens would not publish another collection for more than a decade, this book marked the arrival of a major new voice in modern American poetry.

Knopf issued a second, revised edition of *Harmonium* in 1931, which included fourteen additional poems, and a third edition (identical to the second) in 1947.

12 Harmonium. New York: Knopf, 1923.

> 8vo.; striped paper-covered boards; navy cloth spine; printed
> spine label.

First edition, 1500 copies; this is one of 215 copies in the second of
three bindings. Edelstein A1.a.

13 Poetry: A Magazine of Verse. "Good Man, Bad Woman," p. 6.
XLI.1 (October 1932).

> 8vo.; printed wrappers.

First appearance; in the twentieth anniversary issue of *Poetry*. Edel-
stein C82. Poems by Stevens are scarce in periodicals from 1931-1933,
a lull after the second edition of *Harmonium* (1931).[8] Presumably not
one of Stevens's own favorite pieces, "Good Man, Bad Woman" does
not appear in a book until *Opus Posthumous* (Knopf, 1957). When he
sent the poem to Harriet Monroe, he wrote, "I am enclosing another
scrap, but it is the best I can do. If it is no use, don't hesitate to say
so" (August 5, 1932).[9]

14 Typed letter to Witter Bynner, signed, "Wallace Stevens,"
Hartford, CT, April 6, 1934.

> One leaf of Hartford Accident and Indemnity Company letter-
> head; one page.

Together with:

Latimer, Ronald Lane (writing under his real name, James Leippert).
Typed note signed, "James Leippert," April 4, 1933; referenced
in the Stevens letter.

> One unprinted leaf, folded; half page.

Stevens's colorful communication to his former *Harvard Advocate*
colleague about James Leippert – best-known as Ronald Lane Lat-
imer – reads in full:

> Dear Bynner,
> To hell with Leippert:
> The only thing from him that I can find is enclosed. The only

reason that I am sending this to you is that, if he offered to bind your manuscript in orange crushed levant, it was wonderfully far seeing of him, considering that you are now in Florida.

I don't see why you should pay any attention to the thing. Ordinarily when one has been played for a sucker one forgets it. Of course, I don't know that Leippert is all that you say he is; I don't know anything at all about him, and don't care.

But I do care about you. Come to see me some time when you are in Hartford. I went through Sarasota the other afternoon, so to speak, on the way from Tampa to Miami, or, rather, on the way from Tampa to Key West. You ought to forsake Santa Fe and put Key West on the map.

Yours,

Wallace Stevens

Latimer's note, headed in type with his 1012 Hartley Hall address at Columbia University, forwarded by Stevens to Bynner, details his plans to publish manuscripts by Stevens, as well as H.D., Pound and Moore, in September. He also tells Stevens he is planning to have his copy bound in orange crushed levant unless Stevens objects to that color.

Ronald Lane Latimer, born James Leippert (1909-1964), was a mercurial figure who made a brief but lasting impression on the literary scene in New York in the 1930s. He founded the Alcestis Press and *Alcestis: A Poetry Quarterly*, and was known by many names (most of-

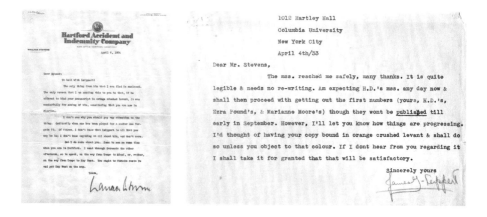

ten Latimer, but also Martin Jay and Mark Jason), leading William Carlos Williams to jokingly address him in one letter as "My dear Anonymous Alcestis." As Mariani explains, Latimer had contacted Bynner expressing interest in publishing his work, but Bynner was "suspicious about the shape-shifting, elusive"[10] editor and conveyed this to Stevens, prompting the above response.

23-year-old Latimer (then still Leippert) first wrote to Stevens in 1933, asking him to submit poems for a new literary journal he was creating to promote modern poetry. Stevens had published little since *Harmonium* ten years earlier, and agreed to submit some new work to *Alcestis: A Poetry Quarterly*. Leippert chose "The Idea of Order at Key West" as the opening poem for the first issue. *Alcestis* featured numerous poems by Stevens and Williams as well as E.E. Cummings, John Peale Bishop, and other modernist poets, in its four issue life from October 1934 to July 1935.

Stevens corresponded with Latimer more frequently than with anyone else between 1934 and 1938. Dozens of letters to him are included in *Letters of Wallace Stevens* (Knopf, 1966), but for unknown reasons, Stevens destroyed all of the letters he received from him. University of Pennsylvania Professor Al Filreis, author of three books of Stevens scholarship (*Modernism from Right to Left: Wallace Stevens, the Thirties, & Literary Radicalism*, *Wallace Stevens and the Actual World*, and *Secretaries of the Moon: The Letters of Wallace Stevens and Jose Rodríguez Feo*), believes Latimer "might have provided the most important literary friendship Stevens ever had."[11]

Witter Bynner (1881-1968) and Stevens were at Harvard together, where they both worked on staff for the *Harvard Advocate*. Bynner was a prolific writer, publishing nearly thirty books (mostly with Knopf) including collections of light verse, satirical plays, and memoirs of his travels in Asia and friendship with D.H. Lawrence. After a brief teaching stint at UC Berkeley, he moved to Santa Fe where he continued to write and entertain visiting authors and artists including Georgia O'Keefe, Robert Frost, Carl Sandburg, Ansel Adams, W.H. Auden, Thornton Wilder, and Willa Cather.

55

15 Alcestis: A Poetry Quarterly. "Seven [ie Eight] Poems." pp. 2-6. I.1 (October 1934).

> 8vo.; printed wrappers.

Together with:

Latimer, Ronald. Typed note signed in type, "Mark Jason" (i.e. Ronald Latimer), n.d. (1934).

> One 16mo. leaf; one page.

"Seven [ie Eight] Poems," in the inaugural volume of Latimer's *Alcestis* quarterly – the volume marking Stevens's return to publishing poetry after a hiatus of a dozen years. One of twenty-five copies on all rag paper. Edelstein C88. An ad hoc review copy, with a typescript note, clipped to the front endpaper, by Latimer, signed in type with a pseudonym, "Compliments of Mark Jason," giving the address of the Alcestis Press as 19 Minetta Lane, New York:

> This is one of 25 copies on all rag paper. We would appreciate your comments and would be glad to know if you would like to receive complimentary copies of succeeding issues. The Alcestis Press. 19 Minetta Lane. Compliments of Mark Jason.

Stevens contributed eight poems to the inaugural issue of *Alcestis* – though Latimer only noted "Seven Poems" in the table of contents: "The Idea of Order at Key West," "Evening without Angels," "Lions in Sweden," "A Fish-Scale Sunrise," "Delightful Evening," "Nudity at the Capitol," "Nudity in the Colonies," and "What They Call Red Cherry Pie."

This compilation of new verse was the most significant outpouring of work by Stevens in well over a decade. Other than gathering up some previously published material and a few new items on old themes for the 1931 second edition of *Harmonium*, Stevens had not had a concentrated series of new poems in many years. These poems marked a new direction, and new energy, for Stevens.

16 Alcestis: A Poetry Quarterly. "Five Poems," pp. 2-6. I.3 (Spring 1935).

> 8vo.; printed wrappers.

The second appearance of Stevens's work in *Alcestis* – in the journal's penultimate issue. Edelstein C98. Includes the following poems: "Sailing after Lunch," "Meditation Celestial and Terrestrial," "Mozart, 1935," "The American Sublime," and "Waving Adieu, Adieu, Adieu." Stevens initially submitted only four poems, then mailed "Sailing After Lunch" separately a week later. In his March 5, 1935 letter to *Alcestis* founder and editor Ronald Lane Latimer, Stevens dictated the order in which the poems should appear and noted that none were "particularly warm or high-spirited."[12]

17 The New Republic. "The Reader," p. 332. LXXXI.1052 (January 30, 1935).

Newsprint excision; poem text, 3 ½ x 5"; framed.

The first appearance of this lesser known poem from *Ideas of Order*, which was published by the Alcestis Press in August 1935. Edelstein C93. Signed by Stevens.

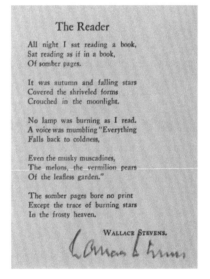

Between *Harmonium* (1923) and *Ideas of Order* (1935), Stevens was submitting work to only a handful of select journals. Of these, *The New Republic* easily boasted a broader and more general readership than the small literary journals where his work usually appeared such as *Poetry*, *Others* and *Contact*. The editor of *The New Republic* at this time was Malcolm Cowley, who had an extended relationship with both Stevens and Williams (see item #143).

"The Reader" is a bleak meditation on the seasonal shifting from autumn to winter:

> No lamp was burning as I read,
> A voice was mumbling, "Everything

Falls back to coldness,
Even the musky muscadines,
The melons, the vermilion pears
Of the leafless garden."

The poem ends with the revelation that the "somber pages" in the book are blank, bearing only the "trace of burning stars / In the frosty heaven."

The New Republic often published reviews and criticism of Stevens's work, including a brief piece by Williams titled "On Wallace Stevens" in November of 1937 in which Williams praises "The Man with the Blue Guitar" as one of Stevens's best poems to date and refers to Stevens as "an artist infinitely more accomplished."[13]

18 Two typed letters to Conrad Aiken, signed, "Wallace Stevens," Hartford, CT, January 31 and April 10, 1935.

> One unprinted bifolium, with his 690 Asylum Avenue, Hartford address in type; one page.

In these letters Stevens reaches out to Aiken – at the time a far more established poet – to recount various publishing endeavors he is considering, over a decade after his first book. In the first letter, Stevens mentions that he is going to submit to the Dent &' Sons half-crown series of poetry books. The April letter suggests that Stevens felt some insecurity about his return to writing:

> Since I have been busy at other things in recent years, it was not easy for me to collect even 50 pages. However, after I had done so I felt that the general tone was low and dreary (like a Brucknor symphony) and I have been trying to do other things to brighten up the general tone, writing new things to replace old ones and trying to write high-spirited things instead of low-spirited ones.

He also asks Aiken for a recommendation of someone who could do "odd jobs" for him.

Conrad Aiken (1889-1973) was a contemporary of Stevens who wrote plays, novels, short stories and poetry. He won the Pulitzer Prize in Poetry for his *Selected Poems* in 1930. He and Stevens shared a Harvard connection (Aiken was in the class of 1911), and he praised

Stevens in his review of *Others: An Anthology of New Verse* (Knopf, 1917), which featured ten poems by Stevens, including the first appearance in book form of "Thirteen Ways of Looking at a Blackbird."

Aiken took credit for successfully urging Stevens to return to regularly writing and publishing.

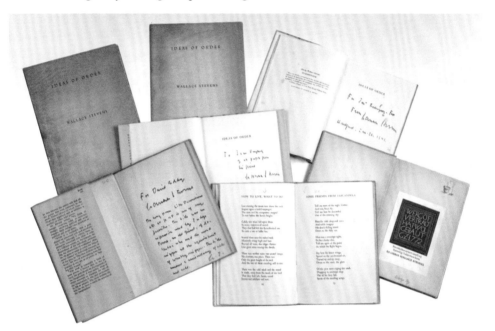

19 Ideas of Order. New York: Alcestis Press, 1935.

> 8vo.; ownership signature on the front endpaper ("Jesse Dean Parkinson"); cream printed wrappers with flaps; original cardboard slipcase, front cover cleanly detached; spine absent.

First edition; the so-called "presentation issue," one of twenty signed copies numbered in roman numerals (this is copy IV), printed on handmade paper; 165 copies, the entire edition. Edelstein A2a. *Ideas of Order* was the first book Latimer published under the Alcestis imprint, which came to be known for producing signed, limited editions of poetry exquisitely printed on rag paper, some of which were bound in parchment and boxed. One year later, Alcestis Press published Stevens's next book, *Owl's Clover*.

Upon receiving his complimentary copies of *Ideas of Order*, Stevens wrote effusively to Latimer, praising the production and refusing royalties so that the book could turn a profit for the new press: "The book has just arrived and gives me the greatest possible pleasure ... You have been generous in sending me ten copies ... don't think of sending me any money. The book is a handsome piece of work ... I should be very glad to go along with you without any royalties or anything of the sort" (August 10, 1935).[14]

20 Ideas of Order. New York: Alcestis Press, 1935.

> 8vo.; cream printed wrappers with flaps; original cardboard slipcase; portion of bottom edge absent.

First edition; one of 135 signed numbered copies (this is copy #13) printed on Strathmore paper; 165 copies, the entire edition. Edelstein A2.a.

21 Contemporary Poetry and Prose. "Farewell to Florida," pp. 52-53. No. 3. (July 1936).

> 12mo.; printed wrappers.

First appearance. Edelstein C105. "Farewell to Florida" was one of the three new poems added to the 1936 Knopf trade edition of *Ideas of Order*, and Stevens placed it first in the collection, suggesting its importance. The narrative of the 40-line blank verse poem is, at first glance, straightforward – the speaker is anticipating leaving Key West. The second stanza concludes:

> How content I shall be in the North to which I sail
> And to feel sure and to forget the bleaching sand.

The South is characterized not as a lush paradise, but as "sepulchral" with "ashen" sands. However, by the opening lines of the fourth stanza, the tone has shifted considerably:

> My North is leafless and lies in a wintry slime
> Both of men and clouds, a slime of men in crowds.

This tension created by the speaker's unresolved ambivalence (neither climate suits him) and the sonically dense lines of iambic pentameter epitomize Stevens's style in this period, making "Farewell to

Florida" the perfect poem to open *Ideas of Order*. From 1924 to 1930, Stevens was not publishing in any journals, but by 1936, he was consistently sending out work to select publications.

This was the only poem of Stevens's to appear in *Contemporary Poetry and Prose*, an avant-garde monthly magazine edited by the communist poet Roger Roughton (1916-1941) that existed for ten issues published between 1936-1937 and featured work by Dylan Thomas and E.E. Cummings, among others.

22 Ideas of Order. New York: Knopf, 1936.

8vo.; multi-color striped cloth; printed spine label; dust-jacket.

First trade edition; in the first binding. Edelstein A2.b. A presentation copy, inscribed on the half-title: *To Ivan Daugherty / of all people from / his friend / Wallace Stevens.* The inscription is undated, but is likely contemporaneous with publication; the second binding was not released until September 1941.

One of the persistent legends surrounding Stevens is that he kept his poetry career hidden from his work colleagues – a belief that is plainly incorrect.

Ivan Simpson Daugherty (1897-1970) worked under Stevens at the Hartford Insurance Company as a lawyer beginning in 1929. While they sometimes enjoyed martinis and lunch together at the Canoe Club and Stevens gifted Daugherty inscribed copies of his books, the two men had a complicated relationship that was not always amicable. Daugherty believed Stevens was singularly responsible for his failure to move up in the company, and wrote a memorandum in January of 1947 detailing a series of exchanges with Stevens. In it, Daugherty describes Stevens as "vindictive and cruel" and expresses frustration at not receiving raises and promotions he felt entitled to based on his work performance. Daugherty's grandson, James, published the memorandum in the *Wallace Stevens Journal*; the concluding paragraph of the memorandum captures his grandfather's conflicting feelings toward his longtime colleague, and reads in part:

Mr. Stevens has not been an easy man to work for. He has a great contempt for his fellow men. He has always felt free to make any

remark that occurs to him, no matter how insulting or what the effect on a man's pride. One must always take whatever he says as though it were a joke and grin like an imbecile. If one talks back, he runs the risk of his lasting dislike and enmity. On the other hand, I have gotten along with Mr. Stevens uncommonly well. He is a brilliant man and has many fine qualities which have drawn me to him.[15]

23 Ideas of Order. New York: Knopf, 1936.

8vo.; multi-color striped cloth; printed spine label.

First trade edition; in the first binding. Edelstein A2.b. A presentation copy marking an important association, inscribed on the title page: *For José Rodríguez / From Wallace Stevens / Hartford, Jan. 26, 1945.* José Rodríguez Feo (1920-1993) was a Harvard-educated Cuban editor, translator, and literary critic who served as the longtime editor of *Orígenes*, a journal that primarily published Cuban, French and Spanish writers along with the occasional American contributor. Four of Stevens's poems, translated by Oscar Rodriguez Feliú, were published in *Orígenes* Vol. II, no. 8, and Rodríguez Feo's own translation of Stevens's "Attempt to Discover Life" ("Tentativa por Descubrir la Vida") appeared *Orígenes* Vol. III, no. 12, which came out in the winter of 1946.

Stevens was pleased with the Spanish translations of his poems – though he did not have a reading knowledge of the language – and the two men struck up an epistolary friendship. Their lively decade-long correspondence (1944-54) is documented in *Secretaries of the Moon: The Letters of Wallace Stevens and José Rodríguez Feo* (Duke University Press, 1986) and Stevens wrote his poem "A Word with José Rodríguez-Feo" in response to one of those letters. The poem, which first appeared in *Voices* in the Spring 1945 issue (see item #45), begins:

> As one of the secretaries of the moon
> The queen of ignorance, you have deplored
> How she presides over imbeciles. The night
> Makes everything grotesque. Is it because

Night is the nature of man's interior world?
Is lunar Habana the Cuba of the self?

Stevens's letters to Rodríguez Feo are uncharacteristically intimate and playful, suggesting a relationship of mutual respect and admiration. This copy of *Ideas of Order* was sent by Stevens to Feo relatively early in their relationship.

24 Ideas of Order. New York: Knopf, 1936.

> 8vo.; rose paper-covered boards; printed spine label; printed dust-jacket.

First trade edition; one of 250 copies in the second binding, bound in September 1941. Edelstein A2.b.

A presentation copy, inscribed to David Eddy on the front endpaper:

> *For David Eddy / Wallace Stevens / The poem Like Decorations / etc at p. 45 is one of my / favorites. The title was an / expression used by Judge / Powell, an old friend, of At-/ lanta.... The title means a miscellany of odds / and ends. W.S.*

David Eddy (1928-2015) was an English major at Princeton when Stevens gave a talk there in 1950, which is most likely when this copy was signed. Eddy's father worked in insurance in Hartford, so it is possible he was an acquaintance of Stevens as well. Stevens says in this inscription that he borrowed the title of the poem "Like Decorations ..." from a phrase used by his friend and business colleague, Judge Arthur Powell from Atlanta. Powell and Stevens both often vacationed in Key West in the winter months, and on a walk one evening by a graveyard, Powell used the expression in conversation. The pair also co-hosted cocktail parties on occasion (including an infamous one that Robert Frost attended, only to gossip later about Stevens's drinking).

In 1966, Helen Vendler described the fifty-part poem as "perversely experimental ... poetry as epigram ... whether *Decorations* is any more than fifty short pieces pretending to be one poem is debatable."[17] Still, Stevens was clearly fond of the work, and the poem is striking in its structure and length compared to other poems in *Ideas of Order*.

25 Ideas of Order. New York: Knopf, 1936.

8vo.; yellow paper-covered boards; printed spine label.

First trade edition; one of 250 copies in the third binding. Edelstein A2.b.

A copy from Stevens's library, with his bookplate reading "Vergot Vertrau Hatwol Gebaut GZ1772 / From the west wall of Trinity Tulpehocken / Ex Libris Wallace Stevens"; later owned by the New England poet and teacher Gladys Ely (1923-2009), whose work appeared in *Poetry*, the *Massachusetts Review, The Nation* and *Poetry Northwest*. Signed by Ely on the front endpaper below Stevens's bookplate, and with a drawing of a potted flower, wilting, above. Ely attended Smith College and Columbia University, and taught English and Latin at the Brearley School from 1951 to 1987. For an additional discussion of Ely and her Stevens books, see "Ghosts in the Collection" on page 123.

Stevens commissioned this bookplate from Austrian painter, sculptor, printer and typographer Victor Hammer, who had fled Europe in 1939, settling in Aurora, New York, where he founded the Wells College Press in 1941. Stevens wrote to Hammer there, sending a photograph of the stone on which he wished his bookplate to be based: a stone set in the west wall of the chapel of Trinity Tulpehocken Church, near Myerstown, Pennsylvania, about thirty feet above ground, given by a member of Stevens's mother's Pennsylvania Dutch family.[18]

After a preliminary exchange, in which each man laid out his initial thoughts and biases about the project, Hammer asked, "Are you the poet Wallace Stevens? I found that name in the latest issue of 'Furioso.'" Stevens sent Hammer a photograph of the stone on December 11, 1946. While he had quite definite ideas about what he wanted, and what he wanted to pay, he sent Hammer a humorously vacillating letter on December 11, 1946, suggesting numer-

ous detailed options for the design but ultimately leaving it up to Hammer, providing he leave in "the words, the initials G.Z. [George Zeller], and the date 1772." In any event, he writes, "I should like to have it signed. In short, I am thinking this time of getting something a little personal from Victor Hammer." He concludes, "Now, I know that at first you are likely to shrink from this, but put yourself in my place."

For information on Hammer's other – very different – bookplate for Stevens, based on a drawing Stevens had previously solicited from English painter James Guthrie, see item #49: another Stevens volume that made its way into the library of Ms. Ely.

26 Ideas of Order. New York: Alfred A. Knopf, 1936.

> 8vo.; rose paper-covered boards; printed spine label.

First trade edition; one of 250 copies in the second binding. Edelstein A2.b.

From the collection of an editor of the Fortune Press, used for choosing material for Stevens's *Selected Poems*, 1953. Along with numerous pencil ticks, underlinings, and occasional comments throughout, the editor – either in two read-throughs, or potentially in league with another editor, based on the weight of pencil and varying notations – left enthusiastic checkmarks and arrows to most poems. At "How to Live. What to Do" (p. 14) there is a pencil question mark. And on the facing page, at "Some Friends from Pascagoula," the editor writes, "Too immaculate for our tastes like a 'Hollywood smoothie'." He left a question mark at "A Fish-Scale Sunrise" (p. 59). The only poem with no markings at all is "The Brave Man" (p. 30).

27 Three typed letters to Alfred A. Knopf, signed, "Wallace Stevens," Hartford, CT, 1936-1951.

> Three leaves of Hartford Accident and Indemnity Company letterhead; each one page.

In the first letter, dated November 27, 1936, Stevens reports that he is "just coming out of a Thanksgiving coma." He thanks Knopf for the recent check he received (presumably for *Ideas of Order*) and the copy of *The Borzoi Reader*, an anthology of novellas, essays, short stories, plays, and poetry selected from books published by Knopf since its founding in 1915. The volume featured two poems by Stevens: "Sunday Morning" and "Peter Quince at the Clavier." Stevens jokes that he hopes the book, a 1,033-page tome that "looks like an eye full," will "find its way under a good many Christmas trees."

The next letter (February 2, 1942) is brief but poignant; Stevens says he is sending a manuscript separately (*Parts of a World*) but laments that "this does not seem a very propitious time for the publishing of poetry." The third letter (March 7, 1951), included a photograph by John Haley that Stevens requests Knopf use for future publicity – instead of "the terribly bad one" circulated at a party held the previous day. (The photo is no longer present.) Lest he seem ungracious, Stevens adds an initialed postscript in pencil: "Thanks to everyone from Knopf for their courtesy and kindness."

When Alfred A. Knopf (1892-1984) started his own publishing house at the age of 22, one of the first books he published was Carl Van Vechten's essay collection, *Music and Bad Manners* (1916). Two years earlier, Van Vechten had come across some of Stevens's poems in the New York magazine *Trend* – the first poems Stevens had published in fifteen years – and reached out to Stevens to see if he had any more. He did, and continued to share work with Van Vechten, who was well-connected in the New York literary scene. It was not until 1922 that Stevens had a book-length manuscript ready, and based on the promise of the earlier poems, Van Vechten convinced Alfred Knopf to read it and meet with Stevens. According to Van Vechten, "Alfred did desire to examine [Stevens's] manuscript and

66

almost immediately agreed to publish it." Thus began a professional relationship that lasted for the rest of Stevens's life, as Knopf went on to publish every volume of his poetry and prose and Stevens became one of his most acclaimed authors.[19]

Stevens worked directly and corresponded frequently with Knopf editor Herbert Weinstock (see item #67), as Knopf himself preferred to oversee the publishing, typography and bookmaking part of the business. Most of the letters exchanged between the two men are relatively brief and cordial, suggesting a collegial, rather than intimate, acquaintanceship. Knopf complained for many years that he did not even have Stevens's home address.

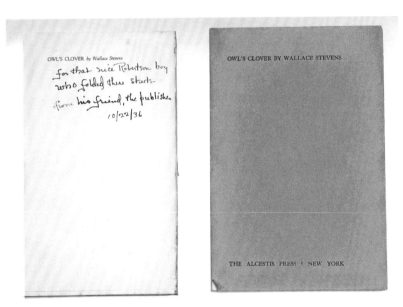

28 Owl's Clover. New York: Alcestis Press, 1936.

> 8vo.; orange printed wrappers with flaps; original cardboard slipcase; spine absent.

First edition; one of twenty signed copies numbered in roman numerals (this is copy IX), printed on hand-made paper; 105 copies, the entire edition. Edelstein A3.

A presentation copy, inscribed by the publisher Ronald Latimer on

the front endpaper two weeks before the official November 5, 1936 publication date: *for that nice Robertson boy / who folded these sheets – / from his friend, the publisher / 10/22/36.*

After their successful collaboration on *Ideas of Order*, which Knopf acquired from Alcestis for the first trade edition, Latimer and Stevens partnered again on *Owl's Clover*. There was some debate over the title. Stevens felt it accurately reflected "the owlishness of the poems" but believed the title "Aphorisms on Society" while "somewhat pretentious . . . brings out for the reader the element that is common to all the poems." *Owl's Clover* is a single 861-line poem broken into five titled sections, and Stevens wrote that his aim was to "make poetry out of commonplaces . . . that the reader may at last hope to find here and there the pleasure of poetry, if not exactly the pleasure of thought."[20]

Stevens struggled to complete the work. He was consciously trying to create a work that was "relevant" to the current political and economic climate. The second section of the poem, "Mr. Burnshaw and the Statue," is a response to the critic Stanley Burnshaw, who in his negative review of *Ideas of Order* attacked what he saw as Stevens's disengagement from fraught current events. *Owl's Clover* was revised and shortened for inclusion in *The Man with the Blue Guitar and Other Poems* (Knopf, 1937), but excluded entirely from *Collected Poems* (Knopf, 1954).

Latimer inscribed this copy to his friend, Charles Robertson, who knew him as James Leippert when they attended Columbia College together, graduating with the class of 1934. Through Latimer, Robertson was also casually acquainted with Stevens. After *Letters of Wallace Stevens* was published in 1966, Robertson contacted both Holly Stevens and the *Wallace Stevens Journal* in the hope of setting the record straight about potential misrepresentations of his eccentric friend in the published letters – in part because Stevens destroyed all his correspondence from Latimer. Robertson also sought to clarify the multiple pseudonyms, explaining the origins of the name Ronald Lane Latimer in a letter to the *Wallace Stevens Journal*: "Ronald" after Ronald Firbank, a writer he admired; "Lane"

after John Lane, a successful publisher he hoped to emulate. Robertson insisted there was nothing "sinister" about his name change, which was legalized: "Besides being fairly unusual, Latimer simply caught his fancy at the time."[21] Additional books from Robertson's library in this collection include *An Early Martyr and Other Poems* (1935) and *Adam and Eve and the City* (1936), both by William Carlos Williams.

29 Owl's Clover. New York: Alcestis Press, 1936.

> 8vo.; orange printed wrappers with flaps; pencil notes on the front endpaper.

First edition; one of 85 signed, numbered copies (this is copy #16) printed on Strathmore paper; 105 copies, the entire edition. Edelstein A3.

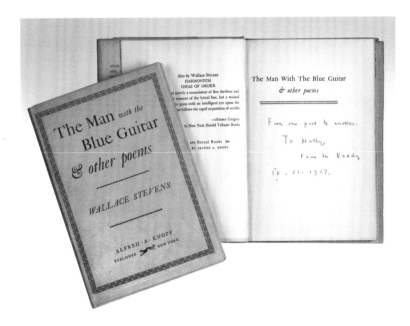

30 The Man With The Blue Guitar and Other Poems. New York: Knopf, 1937.

> 8vo.; yellow cloth, stamped in black; dust-jacket.

First edition; in the uncorrected dust-jacket with the word "conjunctioning": Stevens was displeased and asked that this be changed to "conjunctions," and so a second printing of the dust-jacket was issued; 1000 copies, the entire edition, with fewer than 100 copies believed to exist with the uncorrected dust-jacket. Edelstein A4.a.

An unusually sentimental – for Stevens – presentation copy, inscribed on the half-title to his only child, Holly Stevens, when she was thirteen, nearly two weeks before the official publication date: *From one poet to another / To Holly / From her Daddy / IX.21.1937.*

The front flap of the dust-jacket quotes Stevens on the contents of the book, which consists of two distinct groups of poems: the title poem – a long poem in 33 parts – followed by a section of shortened versions of the five poems comprising *Owl's Clover*. Stevens explains that the two sections of the book are intended to explore conflicting energies: While the "Owl's Clover" group focuses on "the opposition between things as they are and things imagined" in an effort to "isolate poetry" from the real world, "The Man with the Blue Guitar" highlights "the incessant conjunctions between things as they are and things imagined," or the convergence of ideas with the things they represent.

Harold Bloom felt that *The Man With The Blue Guitar* was a return to form after the critical failure of *Owl's Clover*, and wrote that Stevens had "weathered his long long crisis" and that the book signified a "triumph" over his "literary anxieties."[22]

From a young age, Holly Stevens (1924-1992) demonstrated literary leanings, devouring poetry books given to her by her father and at one point considering a career as a playwright. After Stevens's death, she devoted her life to preserving his legacy, compiling the material for *Letters of Wallace Stevens* (Knopf, 1966) and editing a posthumous volume of Stevens's poetry and one play, *The Palm at the End of the Mind* (Knopf, 1971). She also published selections from his journals in *Souvenirs and Prophecies: The Young Wallace Stevens* (Knopf, 1977).

Holly attended Vassar College, but dropped out in 1942 during her sophomore year. She followed in her father's footsteps by

working as an insurance underwriter for Aetna Life and Casualty in Hartford. She also briefly worked as a secretary for Trinity College, and founded the New England Poetry Circuit in 1963 to promote young poets in the area. She married against Stevens's wishes, leading to a break with her father, reminiscent of the falling out Stevens had with his own father when he married. Holly had a son, Peter, divorced and reconciled with her father. After tending Stevens's memory and reputation for over thirty-five years, Holly died of lung cancer in 1992 at the age of 67.

31 The Man With The Blue Guitar and Other Poems. New York: Knopf, 1937.

> 8vo.; yellow cloth, stamped in black; printed dust-jacket; note ("first, a.p. 500"); ownership signatures on the front endpaper ("RR"; "Charles E. Hamilton"); rear endpaper note ("GECX.CX").

First edition; uncorrected dust-jacket; 1,000 copies, the entire edition, likely fewer than 100 in this uncorrected dust-jacket. Edelstein A4.a.

32 Typed letter to Sanders Russell, signed, "Wallace Stevens," Hartford, CT, May 26, 1941.

> One leaf, folded; half-page.

Stevens thanks Sanders Russell for sending him his "unusually interesting" first book of poems, *Poems* (Woodstock: Capricorn Press, 1941). He offers some thinly veiled criticism: "It often happens, in the case of an unusually imaginative person, that his observations of real things give them a peculiar quality. That seems to me to be true in the case of your poems . . . I suppose it ought to be true that the reflections of such men ought to have unusual strength, but here again the truth seems to be that the imagination makes abstractions obscure."

Russell (1913-1982) was a painter and Beat poet who co-founded the *Experimental Review* with Robert Duncan. Together they published work by Henry Miller and Anäis Nin, among others.

33　Furioso. "Four Poems," pp. 34-36. I.4 (Summer 1941).

> 8vo.; printed wrappers; pencil name and address ("Edna
> Stoddard - 470 Mandana Blvd - Oakland Cal") inside front
> cover.

Includes the oft-anthologized "The Well-Dressed Man with the
Beard" as well as "Les Plus Belle Pages," "Poem with Rhythms," and
"Woman Looking at a Vase of Flowers." Edelstein C136. The issue
also features work by Marianne Moore, E.E. Cummings, and W.H.
Auden as well as criticism by Stevens's friend and fellow poet
Richard Eberhart.

Stevens published one other poem in *Furioso* – "The Pastor
Caballero" – in the Fall 1946 issue. *Furioso* was founded in 1939
by two Yale undergraduates and remained in print sporadically
until 1953. One of the founding editors, James Angleton, met
Pound in Italy in 1938, and Pound offered encouragement and
advice, appointing himself the "padre eterno or whatever"[23] of the
journal.[24] Williams contributed three poems to the first issue, and
an elegy, "To Ford Madox Ford in Heaven," to Vol. I.3 (the issue
prior to this one).

Subsequently, Angleton would become one of the founding of-
ficers of the CIA following his intelligence work during World War
II. He served as head of CIA Counterintelligence from 1954 through
1975. During this time he became notorious for his certitude that
the CIA had been infiltrated by a Soviet mole. He was eventually
forced out of the Agency in the wake of scandals regarding domes-
tic surveillance by the CIA of dissident groups in the U.S. and the
belief that Angleton's continual investigations of various CIA of-
ficers had crippled the Agency's effectiveness. His almost fanatical
certitude in Soviet penetration of the Agency and the twenty year
period of his dominance of counterintelligence during the height
of the Cold War has led to Angleton being either depicted or the
basis for characters in countless movies, books and television
shows – a far cry from being the sensitive young editor of a journal
of Modernist poetry.

34 Parts of a World. New York: Knopf, 1942.

> 8vo.; blue cloth, stamped in gold; printed dust-jacket.

First edition; 1000 copies, the entire edition. Edelstein A5.a.1. Stevens was, by 1942, a recognized, respected name in the poetry world and editors regularly solicited work from him. A number of the poems in *Parts of a World* appeared first in national media outlets (the *New York Times*, *The Nation*) and high-profile literary magazines and journals (*Kenyon Review, Poetry*).

This collection features some of Stevens's most beloved poems, including "The Well Dressed Man with a Beard," "Man and Bottle," and several poems contemplating the nature and purpose of modern poetry. In one of those – "Of Modern Poetry" – Stevens declares on a standalone line: "It has to be living, to learn the speech of the place." In his later work, Stevens became increasingly interested in writing philosophically about the uses and limits of poetry as an artistic medium, and poems like "Of Modern Poetry" signal that shift in his focus.

35 Notes toward a Supreme Fiction. Cummington, MA: Cummington Press, 1942.

> 8vo.; white cloth, stamped in black and gray; unprinted glassine dust-jacket.

First edition; one of eighty signed copies numbered in roman numerals (this is copy xxxvii); 273 copies, the entire edition. Edelstein A6.a.

Stevens decided to publish *Notes toward a Supreme Fiction*, a challenging stanzaic sequence ruminating on the poetic process, as a standalone poem. In it, he "notes" that there are three tenets that one must abide in order to create the "Supreme Fiction," or ideal poem: it must be abstract, it must change, and it must give pleasure.

Stevens dedicated the book to his dear friend Henry Church, to whom he sent "a copy on specially good paper . . . for the living room and then a few other copies for the bedroom, bath, and kitchen" (September 28, 1942).[25]

Notes toward a Supreme Fiction sold well, and a second edition (330 copies) came out in 1943. It was also included in its entirety in *Transport to Summer* (Knopf, 1947).

<p style="text-align:center">* * *</p>

This was the first of three collaborations between Stevens and the Cummington Press. The Press was founded in 1939 by Harry Duncan (1917-1997) and Katherine Frazier (1882-1944) as an initiative of the Cummington School of the Arts, a summer residency program led by Frazier whose alumni include Willem de Kooning and Diane Arbus. Students were taught hand-printing by Duncan and many assisted him at the Press.

In correspondence with Frazier, who solicited the manuscript, Stevens explained his decision to omit an introduction: "I don't like explanations; the chances are that poems are very much better off in the long run without explanations." He also indicated a preference for a light-colored binding: "I like things that are light: for instance, a light tan linen or buckram cover" (June 1, 1942).[26] The Press complied with Stevens's wishes.

After Frazier's death in 1944, Duncan continued running the Cummington Press on his own, and published two more books by Stevens: *Esthétique du Mal* (1945) and *Three Academic Pieces* (1947). While Stevens seemed pleased with how the books turned out, he declined an invitation to become a Trustee of the Cummington School of the Arts. Though he and Duncan exchanged dozens of letters, Stevens never visited the Press nor ever met Frazier or Duncan in person.

Duncan moved to Iowa City in 1956 and continued to publish limited edition hand-printed volumes of poetry under the Cummington Press imprint through the mid-1960s before changing the name to the Abattoir Press. Duncan also published two books by William Carlos Williams (*The Wedge,* 1944, see item #169 and *The Clouds, Aigeltinger, Russia and other verse*, 1948, item #181) in the 1940s. In addition to Stevens and Williams, he published Robert Lowell's first book of poetry, as well as work by Tennessee Williams, Allen Tate and Marianne Moore.

36 Notes toward a Supreme Fiction. Cummington, MA: Cummington Press, 1942.

> 8vo.; white cloth, stamped in black and gray.

> First edition; one of 190 numbered copies (this is 145); 273 copies, the entire edition. Edelstein A6.a.

37 The Language of Poetry. By Philip Wheelwright, Cleanth Brooks, I.A. Richards, Wallace Stevens. Edited by Allen Tate. Princeton / London: Princeton University Press / Humphrey Milford, 1942; "The Noble Rider and the Sound of Words," pp. 91-125.

> 8vo.; gray quarter-cloth and decorative purple-brown paper-covered boards, stamped in gold; pencil note ("DXX") on the front endpaper.

First edition of this volume of literary criticism edited by Allen Tate, with Stevens's essay, "The Noble Rider and the Sound of Words," later included in *The Necessary Angel*. Edelstein B27. A presentation copy, inscribed on the front endpaper: *To Nicholas Moore / from Wallace Stevens / Feb. 20, 1942.*

Nicholas Moore (1918-1986) was an English poet and critic who wrote a pastiche poem in response to Stevens's "The Idea of Order at Key West," titled "Ideas of Disorder at Torquay." The two met while Moore and his wife were living in America and Moore was teaching at Smith. In August 1943, both attended Les Entretiens de Pontigny, an annual symposium for intellectuals, writers, artists, and musicians held at Mount Holyoke College from 1942 to 1944. *Letters of Wallace Stevens* includes a letter to Moore dated October 13, 1949 that Stevens sent along with a draft of a new poem, "Angel Surrounded by Paysans," which was published in *Poetry London* a few months later (January 1950).

During the 1940s when he and Stevens were in contact, Moore was prolific, publishing seven books of poetry and two pamphlets. In 1945, Moore received the Patron Prize from *Contemporary Poetry* (awarded by Auden) and in 1947 he received the Harriet Monroe Memorial Prize from *Poetry*. Recently, there has been renewed interest in his work; in 2014, Shoestring Press published Moore's *Selected Poems*.

38 Epitaphiana. NP: Self-published by Wallace Stevens, 1943.

12mo.; bifolium; title and floral ornament on cover; single page of text inside.

Together with:

Salmi, Sylvia. Six photographs. 1943.

9¼ x 7⅛"; black and white; cardstock; each signed and dated 1943 by Salmi.

One of four known copies of the black tulip which makes a bibliographically complete collection of Stevens "A" items virtually impossible. The entire print run was reportedly "about ten copies," none for sale. Of those, one is at the Huntington Library in their

prodigious Stevens collection; Emory University also holds one; one is in the Carter Burden Collection of American Literature at the Morgan Museum and Library; at the time Edelstein published his bibliography and census, he himself was in possession of the pamphlet only; this copy is the the fourth complete set of the pamphlet and portfolio which at that time he had noted in the collection of Holly Stevens. Edelstein A7.

This extraordinary, and exquisite, publication was a labor of love by Stevens during a period when he had an intense interest in his personal history. He commissioned a genealogist to research his family history and he himself traveled back to the Reading, Pennsylvania region. The result was this brief history by Stevens – just three paragraphs – about his family's connection to Bucks County, Pennsylvania, which dates back to the early 18th century; together with the rare portfolio of photographs which Stevens commissioned from Salmi in October of 1943. Harry Duncan of the Cummington Press oversaw the design and publication, though ultimately it did not bear their imprint.

Stevens writes that "the church was a vital center for all of" his ancestors, and that his grandfather Benjamin Stevens was superintendent of the Sunday school at the North and Southampton Reformed Church in the town of Churchville for forty years. *Epitaphiana* includes a photograph of the cemetery where some of Stevens's Dutch relatives are buried, and several farm landscapes that "show the kind of country in which the members of the family spent their lives."

Sylvia Salmi (1909-1977) was a photographer from New York who shot many famous artists, authors, and political figures including Eleanor Roosevelt, Mary McCarthy, Robert Penn Warren and Frida Kahlo. Her iconic portrait of Stevens appeared in *Harmonium, Transport to Summer, Auroras of Autumn, The Collected Poems of Wallace Stevens, Opus Posthumous,* and *Letters of Wallace Stevens,* and was used by the U.S. Postal Service in 2012 as part of a Forever stamp series honoring 20th-century American poets (see item #118). (Williams was also chosen to receive a commemorative stamp.) Salmi was married to the journalist and editor Herbert Solow who, during the period of the creation of *Epitaphiana,* was an editor of *Fortune* magazine.

39 Stevens Family Portraits. NP: Self-published by Wallace Stevens, 1943.

> 18 portraits taken from paintings, daguerreotypes, and photographs; each with glassine; each in a designated envelope with a small numeral stamped on the front mapping to the accompanying list.

Together with:

> 4to.; two leaves; one printing a list of the subjects of the 18 photographs; a second with two paragraphs of text by Stevens.

One of four known copies of an equally scarce production as *Epitaphiana.* The entire print run was reportedly even smaller – six copies – none for sale. Of those, one is at the Huntington Library; one at Emory University; one is still owned by the Stevens family; this is the fourth. (Edelstein himself had the folder, but not the photographs.) Edelstein A8.

This sensitive and moving collection of portraits – together with

a list of subjects, and a two paragraph gloss – was assembled by Stevens contemporaneously with the preparation of *Epitaphiana.* These two items – *Epitaphiana* and *Stevens Family Portraits* – are perhaps the rarest in the Stevens canon. They are perhaps the most mysterious as well and yet also tremendously enlightening. As with *Epitaphiana*, Stevens enlisted Harry Duncan's help to produce a limited run of this portfolio of portraits of his relatives. Stevens wrote the brief accompanying text explaining the provenance of each image and his genealogy dating back to Jan Stryker, who immigrated from the Netherlands to New England in 1652.

In his mid '60s, with the passing of his siblings, the last of his generation of his family, Stevens's return to Reading, seeking his roots, connected him with nieces and nephews he had never known. With fraught relationships with his wife and daughter at this time in his life, his relations in Pennsylvania, both past and present, were clearly a source of solace during this period.

40 Description without Place. Read by the author as the Phi Beta Kappa poem at Harvard University in June, 1945. Reprinted from

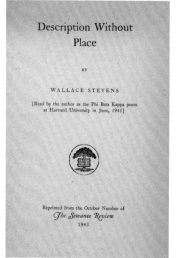

the October Number of the *Sewanee Review*, 1945. Sewanee, TN: The Sewanee Review, 1945.

8vo.; printed wrappers.

First separate printing of this poem Stevens composed for Harvard University Commencement in June 1945; it first appeared in the *Sewanee Review*, and was reprinted and distributed gratis as an off-print. The number of copies printed is unknown, but it was likely a modest run. Edelstein A9.

A copy from Stevens's library.

41 Esthétique du Mal. A poem by Wallace Stevens with pen and ink drawings by Wightman Williams. Cummington, MA: Cummington Press, 1945.

8vo.; black quarter-morocco, stamped in gold; striped paper-covered boards; printed dust-jacket.

First edition; one of forty signed copies numbered in roman numerals (this is copy viii), signed also by the artist, who colored the illustrations throughout; 340 copies, the entire edition. Edelstein A10.

Kenyon Review first published this lengthy Baudelairian poem exploring the concepts of good and evil in the Autumn 1944 issue. Stevens then decided to reprint the piece as a stand alone work, accompanied by abstract geometric illustrations by Duncan's long-time friend and collaborator at Cummington Press, Wightman Williams. When Duncan sent some of Williams's drawings for approval, Stevens found them to be "extraordinary" and agreed that they enhanced the text. Stevens and Williams both waived their royalty fees so that Duncan could print the book on high-quality

Italian paper. Stevens made this gesture many times in his career in order to support small fine presses.

In letters to his friend, artist James Guthrie, Stevens expressed exasperation at the printing timetable and anxiety about the final product. The book was four months behind schedule, coming out in November (the front cover states that it was printed in July 1945). However, when his copies finally arrived, Stevens was delighted with the book's aesthetic, calling it "marvelous," and was thrilled when the American Institute of Graphic Arts included it on their "Fifty Books of 1946" list.[27]

The poem was critically well-received and has retained its lustre. Harold Bloom has called the piece a "humanistic polemic"[28] and Randall Jarrell declared it "the best of (Stevens's) later poems:

> As one feels the elevation and sweep and disinterestedness, the thoughtful truthfulness of the best sections of a poem like "Esthétique du Mal," one is grateful for, overawed by, this poetry.[29]

Artist Paul Wightman Williams, Jr. (1920-1956) hand-colored the illustrations in each of the 40 signed copies of *Esthétique du Mal*; *Poetry* editor George Dillon described them as "marginal doodlings of his Satanic Majesty" but felt that they elevated the book into "something which belongs to the décor of opulence."[30]

42 Esthétique du Mal. A poem by Wallace Stevens with pen and ink drawings by Wightman Williams. Cummington, MA: Cummington Press, 1945.

> 8vo.; black quarter-morocco, stamped in gold; rose Natsume straw-paper-covered boards; unprinted glassine dust-jacket.

First edition; one of 300 numbered copies (this is copy #210); 340 copies, the entire edition. Edelstein A10. One of a few copies of the unsigned issue in rose Natsume straw-paper-covered boards; the majority were issued in green Natsume.

43 Typed note to Allen Tate signed, "Wallace Stevens," with autograph additions, Hartford, CT, December 4, 1944.

> One half-leaf of Hartford Accident and Indemnity Company letterhead; one page.

Stevens responds to Tate's request for poems to publish in the *Sewanee Review*, the journal Tate edited from 1944 to 1946. Stevens feels obligated to send work first to Delmore Schwartz for the *Partisan Review*, but is "very much pleased" that Tate got in touch. He also writes, "About Oscar Williams: he asked me for an article, but I did not promise to send him one. After all, I have nothing to say about the war. The big thing in the world is not the war but the rattle and bang on the left"; Stevens finishes that thought by hand, adding "and in the labor movement."

Allen Tate (1899-1979) served as Poet Laureate of the United States from 1943-1944 (from the inception of the post in 1937, until 1985, the official title was Consultant in Poetry to the Library of Congress). Tate's second book of poetry, *The Mediterranean and Other Poems*, was published by the Alcestis Press in 1936. He founded the creative writing program at Princeton, and was instrumental in transforming the *Sewanee Review*, the oldest literary quarterly in America, into one of the most prestigious journals in the country. Like Stevens, he favored formalist poetry, and wrote almost exclusively in rhymed meter. Tate greatly admired Stevens; when asked by a reporter to name the finest writers of his generation, he said,

"Of poets, Eliot is first, Ransom is second, and Wallace Stevens is third."[31]

44 **Typed letter to Allen Tate signed, "Wallace Stevens,"** with some minor autograph emendations, Hartford, CT, July 6, 1945.

> One leaf of Hartford Accident and Indemnity Company letterhead; one page.

Stevens reports on a humorous interaction he had with diplomat Sumner Welles, one of FDR's chief foreign policy advisors:

> Mr. Welles asked me to send him a copy of the poem. I told him that, if he would let me have his address, I should be glad to do so. He said that "Anything addressed to Hon. Sumner Welles, Washington, D.C. will reach me."
>
> But ish-kabibble!
>
> They elected me an honorary member which is more than they did for him. However all this may be, he is very likeable, serious beyond belief, but also, I think, honest beyond belief.

Stevens goes on to inquire whether his poem will appear in the October or January issue of the *Sewanee Review*. He concludes with an update on his summer, which he describes as "pretty disagreeable ... it is either too hot or too cold or too wet." He also expresses disappointment at not being in touch with Henry and Barbara Church – his close friends, and acquaintances of Tate's – or having time to travel to New York.

In March of 1945 Stevens was asked to deliver the Phi Beta Kappa poem at that Harvard Commencement[32]. Paul Mariani writes, "On June 27, 1945 Stevens delivered the Phi Beta Kappa poem at Harvard" - *Description without Place,* composed for the occasion. "On the podium that day was Sumner Welles, Roosevelt's former undersecretary of state, a strong proponent for the United Nations." [33] It seems likely that Stevens was made an honorary member of Phi Beta Kappa in honor of his visit – but that Welles was not.

45 Voices: A Quarterly of Poetry. "New Poems," pp. 25-29. Wallace
Stevens issue. No. 121 (Spring 1945).

> 8vo.; printed wrappers; worn; spine taped.

In addition to the four new poems ("The Pure Good of Theory," "A
Word with José Rodríguez-Feo," "Paisant Chronicle" and "Flyer's
Fall"), this special Wallace Stevens issue includes reprints of four
poems from *Harmonium*, two poems from *Ideas of Order*, excerpts
from *The Man with the Blue Guitar* and *Notes Toward a Supreme Fiction*,
and an essay about Stevens by John Malcolm Brinnin titled "Plato,
Phoebus and the Man from Hartford." Edelstein C156.

46 Typed letter to William Humphrey, signed, "Wallace
Stevens," Hartford, CT, January 14, 1947.

> One leaf Hartford Accident and Indemnity Company letter-
> head; one page.

Stevens's response to the 22-year-old Humphrey, who had contact-
ed Stevens with a rather unusual proposal: In exchange for Stevens
underwriting the purchase and upkeep of a farm, Humphrey would
write stories, tend the land, and provide Stevens with unlimited
food.[34] Stevens's brief but colorful reply reads in full:

> Dear Mr. Humphrey,
>
> I have your letter of January 8th. You cannot seriously expect
> me to do as you ask. The problem that you face is the problem
> that every man faces when he is young. I should think that
> your immediate need would be not to achieve your ambition
> but merely to improve your situation. Of course, I don't know
> how that can be done, but certainly there doesn't seem to be
> much chance for you as a writer if you are going to engage in
> farm work. I am sorry that I don't have the answer.
>
> Yours very truly, Wallace Stevens

William Humphrey (1924-1997) did become a writer – by the late
1940s, his stories had appeared in some of the same journals that
published Stevens (*Accent* and the *Sewanee Review*). In 1958, Alfred
Knopf published his first novel, *Home from the Hill*, calling it "the
finest novel to come out of Texas."

47 Typed letter to W. Y. Tindall, signed, "Wallace Stevens," Hartford, CT, March 14, 1947.

> One leaf of Hartford Accident and Indemnity Company letterhead; one page.

In this letter to William York Tindall (1903-1981), a Joyce scholar and professor at Columbia University, Stevens describes a family trip to Hershey, PA taken the previous September, and the experience of visiting the local museum devoted to the chocolatier Milton Hershey. In part:

> In spite of the chocolate bars and in spite of the reproduction (enclosed in glass) in the local museum of the room at the Hershey Country Club in which Mr. Hershey lived . . . it was impossible to be in the place without the feeling that one was in a laboratory in which a myth was in process. Conventionally, distance in time and distance in place are approaches to myth. There the almost personal trolley system, the Spanish hotel, the Italian recreation palazzo, and the really splendid theatre with electric stars twinkling in the ceiling are perfect instances of what knock myth into a cocked hat; only, actually, the myth is getting the better of them.

48 **Transport to Summer.** New York: Knopf, 1947.

> 8vo.; black quarter-cloth; printed spine label; dust-jacket.

First edition; one of 1750 copies, the first printing. (The second printing, of 1500 copies, was issued in 1951.) Edelstein A11.a.1.

A moving presentation copy, inscribed to Henry Church four days after publication, and less than two weeks before Church's sudden death: *Avoir un métier en / art, c'est arriver à / réaliser entièrement / l'idea qu'on a en soi. / Ramuz: Journal. / To Henry Church / from / Wallace Stevens / March 24, 1947.* The quotation from Swiss novelist Charles-Ferdinand Ramuz translates as follows: "To practice an art is to attain a complete realization of one's idea of oneself." Stevens dedicated *Notes Toward A Supreme Fiction* (Cummington Press, 1942) to Church; *Transport To Summer* includes the first trade edition of *Notes* . . . with the original dedication.

Henry Church (1880-1947), expatriate heir to the Arm & Hammer Baking Soda fortune, art collector, philanthropist, and publisher of the French literary periodical *Mesures*, was Stevens's closest friend. Stevens revered Church, and always sent him copies of his books immediately upon publication. When Church died suddenly on April 4, 1947, Stevens was devastated. The poem "The Owl in the Sarcophagus," first published in *Horizons* in October of 1947 and later included in *The Auroras of Autumn*, is widely believed to be an elegy for Church.

Transport to Summer includes all the poems Stevens wrote after *Parts of a World*, printing them in the order in which they were written with the exception of "Notes toward a Supreme Fiction." Although "Notes . . ." was composed and published on its own by the Cummington Press five years prior, the poem was placed last in this book. "Esthétique du Mal," also published separately by the Cummington Press, is also reprinted in this collection. *Transport to Summer* was awarded the Bollingen Prize in Poetry from Yale in 1949, as noted on the dust-jacket of the second edition (Knopf, 1951).

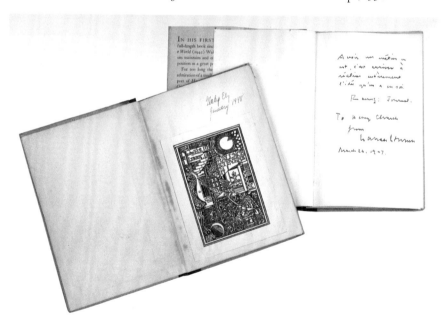

49 Transport to Summer. New York: Knopf, 1947.

> 8vo.; black quarter-cloth; printed spine label; dust-jacket frag-
> ment folded and loosely inserted (front cover and contiguous
> spine).

First edition. Edelstein A11.a.1. From Stevens's library, with his
bookplate – a 1947 black and white graphic design; and months
later owned by the poet Gladys Ely, who signed and dated the front
endpaper ("Gladys Ely / January 1948"), and underlined some text in
pencil, adding a few checkmarks and effusive exclamations such as
"Wonderful" or "Yes!" in the margins.

Ely's lengthy pencil commentary on the verso of the jacket frag-
ment merits quoting in full, as it conveys a strong sense of voice
and sensibility – not to mention high praise of Stevens:

> Rude waiters and inflationary breakfast.
>
> The bus full of noisy youngsters. Why is cheap perfume, lip-
> stick and other people's noisy gaiety so offensive in the morn-
> ing. I am perhaps not the last but the anti-climatical Puritan.
>
> A woman with a voice like Margaret Sullivan's wanted the
> windshield wiper on.
>
> It is handsome: wet sheets diffusing from red neon chalk
> marks.
>
> Wallace Stevens is perfect.
>
> Now I shall ask the woman next to me if I may smoke.
>
> Mtn. with enough snow to look like Seurat.

How Ely came into possession of this copy bearing Stevens's book-
plate just nine months after publication is not known, but our spec-
ulation is that she may have been acquainted with Holly Stevens
and been gifted this book. For more on the potential connection,
see "Ghosts in the Collection," page 123.

This bears the earlier of two bookplates Victor Hammer printed
for Stevens, but only by a few months. Stevens had solicited a book-
plate from the English printer James Guthrie, who produced this
drawing but did no further work "because it was inconvenient for

him to do anything more." [35] Immediately after Hammer produced the plates – which he noted were against his own typographical aesthetic – Stevens collaborated with Hammer on a strongly typographical design based on a family monument. (For more on that bookplate, see item #25).

50 Three Academic Pieces. Cummington, MA: Cummington Press, 1947.

 8vo.; unopened gatherings; unbound.

First edition, unsigned issue; one of seventeen copies numbered in roman numerals (this is copy I); 246 copies, entire edition. Edelstein A12.

 The final book Stevens did with the Cummington Press, published the same year as *Transport to Summer*. Stevens read this essay and two poems at Harvard (his alma mater) in February 1947. *Partisan Review* published them in May 1947 (see item #112), and the Cummington Press published them later that year (with permission from Knopf for the two poems, which had already appeared in *Transport to Summer*). The seventeen copies in this unsigned issue were bound in light blue paper-covered boards by Arno Werner. This first copy was preserved unbound and unopened.

51 Three Academic Pieces. Cummington, MA: Cummington Press, 1947.

 8vo.; striped paper-covered boards; tan cloth spine, stamped in black.

First edition; one of fifty-two signed copies numbered in roman numerals (this is copy XLIV). Edelstein A12.

 The signed copies of *Three Academic Pieces* were bound by Peter Franck, in what Harry Duncan described in a letter to Stevens as "the best binding any book of ours has had" due to Franck's "meticulous and loving craftsmanship" (December 8, 1947). [36] The rest of the edition was bound by Arno Werner.

52 **Three Academic Pieces.** Cummington, MA: Cummington Press, 1947.

> 12mo.; light blue paper-covered boards, printed in black and yellow.

First edition, unsigned issue; one of ninety-two copies hand-numbered with roman numerals (this is copy XXVII). Edelstein A12. A presentation copy, inscribed on the third blank to fellow poet and Harvard alum Albert Spaulding Cook: *the poet represents the mind in the act of defending us against itself. Wallace Stevens / For AC Spaulding / Dec. 23. 1947.*

Albert Spaulding Cook (1925-1998) was a poet, literary critic, and translator who taught Classics, English, and Comparative Literature at Brown and UC Berkeley among other institutions. He completed his undergraduate and graduate work at Harvard 1943-1948, and in 1947 founded the magazine *Halcyon*, which published poetry written by himself and his lesser known friends alongside contributions from Stevens, Allen Ginsberg, E.E. Cummings, and James Merrill. Two poems by Stevens appeared in *Halcyon*'s Spring 1948 issue: "Large Red Man Reading" and "This Solitude of Cataracts" (Edelstein C179). The quotation in the inscription is Stevens's own, one of his many aphorisms on poetry that first appeared as part of "Materia Poetica" (1940) and then later under the title "Adagia" in *Opus Posthumous* (1957).

53 **Typescript: IV. "Beauty is momentary in the mind . . . ,"** signed, "Wallace Stevens." 1947.

> Single leaf; ribbon typescript; with a typescript note.

Ribbon typescript of section IV of "Peter Quince at the Clavier," with a typescript note: "Autographed September 1, 1947 / Wallace Stevens in *Harmonium*." Signed by Stevens at the close of the poem. "Peter Quince . . . ," Stevens's first major poem, debuted in 1915 in Alfred Kreymborg's *Others* magazine, and made it into William Stanley Braithwaite's round-up *Anthology of Magazine Verse for 1915* (see item #6). Stevens included it in his first book, *Harmonium* (1923), and by

IV

Beauty is momentary in the mind –
The fitful tracing of a portal;
But in the flesh it is immortal.

The body dies; the body's beauty lives.
So evenings die, in their green going,
A wave, interminably flowing.
So gardens die, their meek breath scenting
The cowl of Winter, done repenting.
So maidens die, to the auroral
Celebration of a maiden's choral.

Susanna's music touched the bawdy strings
Of those white elders; but, escaping,
Left only Death's ironic scraping.
Now, in its immortality, it plays
On the clear viol of her memory,
And makes a constant sacrament of praise.

Lawrence Stevens [signature]

Autographed September 1, 1947
Wallace Stevens in Harmonium

1947, more than thirty years after its initial publication, the poem was recognized as a modern classic. Stevens rarely indulged requests for signed typescripts of his work.

54 Five typed letters to Vivienne Koch, signed, "Wallace Stevens," Hartford, CT, 1947-1950.

> Each on a single leaf of Hartford Accident and Indemnity Company letterhead; each one page.

A cache of letters to the poet, editor, and critic Vivienne Koch (1912-1961) concerning a possible contribution to *Focus* (a poetry book series published in London), and discussing William Carlos Williams.

Stevens comments about a photograph of William Carlos Williams's mother in the first letter of this series on January 29, 1947: "The truth is that the photograph of Williams's mother touched

me. She seems to account for a very great deal in him. But all the photographs were good without any of the nonsense that infects so many photographs of poets." He promises to send Koch some poems to consider in the next week or two.

A month later, on February 26, he apologizes to Koch for his tardy reply, explaining that he "had his hands full with something else." He encloses a poem, but laments that it is "much less of a poem than you seem to have had in mind, but it is all I have at the moment." In her response, Koch possibly expressed interest in publishing part of *Esthétique du Mal*, because on March 7, Stevens explains that "Esthetique, etc. is included in *Transport to Summer* which Mr. Knopf published this week or last and is, therefore, subject to my contract with him relating to *Transport to Summer*. In short, while I should be glad to have you use anything you like from that book, you would have to get permission from Mr. Knopf. But if it is at all possible for you to wait a week or two, I might be able to send you something."

Three days later, he writes again, enclosing "two more poems," noting,

> with the one that you have, [they] will at least make something of a group. This will make it unnecessary for you to apply to Mr. Knopf who would, I suppose, expect you to pay him something, not knowing how all this sort of thing goes on. I had a wild day doing these two yesterday.

In the final letter, dated February 13, 1950, Stevens clarifies,

> Things that I sent out before making the arrangements for the new book, if published before the new book is published, are not controlled by Knopf; otherwise if they would not be published until later. Mr. Knopf will not publish *The Auroras of Autumn* until next fall and as *Focus* is to be published this spring everything seems to be all right.

Stevens also revisits the topic of Williams and his recent election to the National Institute of Arts and Letters (parent organization to the more elite American Academy of Arts and Letters, with which it merged in 1976) noting that "while an outside honor of

that sort may mean little to him, yet it counts toward the acceptance of his work and acceptance is a big step toward understanding and liking."

Koch favorably reviewed *Esthétique du Mal* for *Briarcliff Quarterly* in April of 1946, and later *The Auroras of Autumn* for the *Sewanee Review*. She also authored the first book solely dedicated to explaining Williams for the Makers of Modern Literature series (New Directions, 1950; see item #188). Stevens, Williams and Koch all had work featured in *Focus Five: Modern American Poetry*; Koch wrote essays on Allen Tate and John Crowe Ransom, and Stevens and Williams each contributed four poems.

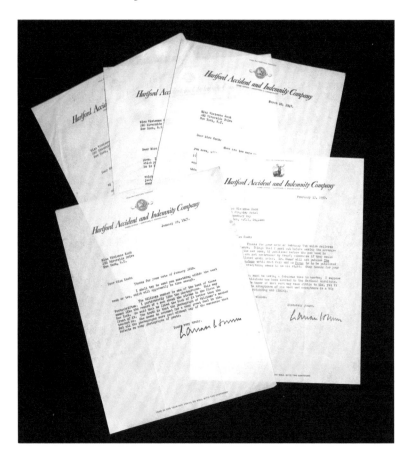

55 Nine typed letters to William Cole, signed, "Wallace Stevens," Hartford, CT, 1947-1955.

> Nine leaves of Hartford Accident and Indemnity Company letterhead; each one page.

A fascinating trove of letters to the Publicity Director at Knopf, William Cole (1919-2000). In the first, dated April 2, 1947, Stevens explains his reasons for turning down a profile offer from *Life Magazine*:

> It doesn't take much imagination to see what happens when a man in a large office permits the sort of thing that <u>Life</u> is thinking of. His associates take it for granted that he is promoting himself and the whole thing tends to alienate him from them. I cannot think of anything more imprudent and will have nothing to do with it.

Cole was instrumental in creating the National Book Awards in 1936. Suspended during World War II, the Awards resumed in 1950, partly due to Cole's efforts. Three of Stevens letters from 1951 concern Stevens's duties as a judge for the 1952 National Book Award for Poetry, a position he was initially reluctant to accept despite having won the award himself the previous year (for *The Auroras of Autumn*). "The truth is that I read very little poetry," he explains on August 31, " . . . and, that being so, I might not be the right man for the job." If Cole still wants him on the committee, Stevens asks to see a list of books for consideration so he can then select which he is interested in reviewing.

On October 30, after seeing the longlisted books, Stevens requests copies of four titles: his friend Richard Eberhart's *Selected Poems*, Randall Jarrell's *The Seven-League Crutches*, Robert Lowell's *The Mills of the Kavanaughs* and Marianne Moore's *Collected Poems* (which ultimately won); Williams had two books that were also finalists – *Collected Earlier Poems* and *Paterson (Book Four)*. In the next letter, dated December 11, Stevens expresses his preference for a morning or early afternoon meeting on Friday, December 28 for the Poetry Jury so that he can catch the 5:10 train back to Hartford that evening. By this point, Cole and Stevens were close enough for Stevens to be a little

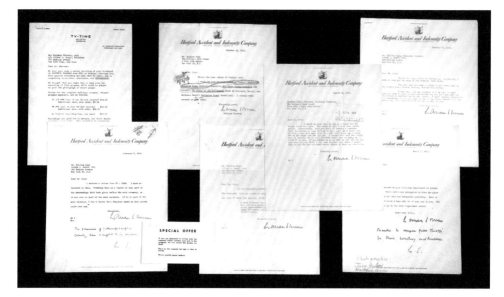

humorous before his sign-off: "This gives you all the filthy facts."

That dry humor reappears in a letter from February 8, 1954, after Stevens read Jarrell's novel, *Pictures from an Institution*, published by Knopf. Stevens offers faint praise, which he tells Cole he can use if he likes to promote the book:

> A most literate account of a group of most literate people by a writer of power (both natural and acquired). No plot, no action, yet a delight of true understanding.

Though sometimes a fan of Stevens's work, Jarrell strongly disliked *The Auroras of Autumn*, calling the poems "abstract," "monotonous" and "lack[ing] immediate contact with lives" (in his essay "Reflections on Wallace Stevens" from his book *Poetry and the Age*, Knopf, 1953). This letter suggests Stevens had neither forgotten nor forgiven Jarrell for his harsh criticism.

On August 30, 1954, Stevens declines an invitation to speak at New York University: "I never did like to read in public, not only because of personal inhibitions, but because I never thought it was quite the right thing for me to do." He says the only reading he plans to do in the fall is for the YMHA (Young Men's Hebrew Association)

94

on November 6. He also explains his decision to turn down an invitation from George N. Schuster to join "a board or council having to do with the promotion of an interest in books" because it would entail more trips to New York and because, Stevens says, "I don't have an idea in my head about promoting an interest in books."

The final two letters are dated January 17, 1955 and February 7, 1955. Stevens had just won his second National Book Award – for *Collected Poems*: "As you say, I seem to have got the hang of the National Book Award." With regards to tickets to an upcoming event in New York that Cole invited him to in his letter from January 14 (perhaps something honoring the National Book Award winners), Stevens says that unfortunately only Holly will be able to attend and asks that Cole mail one ticket to Hartford.

He refers to an enclosed letter (not present) he sent to the Poetry Room at Harvard's Widener Library as well as a letter from *TV-Time*, which is included. The *TV-Time* letter regards a recording of a WNYC "Reader's Almanac" broadcast from February 1; Stevens seems uncertain of what the network is trying to sell him – possibly footage from the National Book Awards ceremony – but regardless, has no interest in purchasing a copy and jokes that "I don't wonder that Faulkner spoke so that nobody could hear him." With a pencil postscript in Stevens's hand, also in reference to Faulkner: "The pursuit of Yoknapatawpha County has taught him wisdom."

56 The Hudson Review. "In a Bad Time," p. 29. I.1 (Spring 1948).

 8vo.; printed wrappers.

First appearance of this poem in the inaugural issue of *The Hudson Review*, a literary journal still in print today. Edelstein C180.

57 Autograph letter to Delmore Schwartz, signed, "Wallace Stevens," February 10, 1948.

 One leaf, creased where folded; one page.

Stevens tells Schwartz that he will be giving the Bergen lecture at Yale next month and has yet to prepare any remarks, and therefore cannot accept Schwartz's invitation for a New York event on February 23.

Delmore Schwartz (1913-1966) was a writer whose most famous short story, "In Dreams Begin Responsibilities," appeared in the first issue of *Partisan Review* in 1937. A year later, this was the title story in a collection of short fiction and poetry, which was an instant success. Allen Tate wrote that Schwartz's style represented "the first real innovation we've had since Eliot and Pound."

Schwartz edited *Partisan Review* from 1943 to 1955, during which time he published multiple poems by Williams and Stevens. He was awarded the Bollingen Prize in 1960, and taught at Princeton, Kenyon College, and several other universities. Schwartz's personal life was more tumultuous than his career – he was twice divorced and struggled with alcohol and depression in later years. The brilliant but troubled title character of Saul Bellow's 1975 novel *Humboldt's Gift* was modeled after him, and Robert Lowell and John Berryman paid tribute to him in poems written after his death.

58 A Primitive Like an Orb. With drawings by Kurt Seligmann. Printed for the Gotham Book Mart. New York: Banyan Press, 1948.

8vo.; printed wrappers; string-tied.

First edition; 500 copies, the entire edition. Edelstein A13.

Claude Fredericks partnered with the legendary Gotham Book Mart to publish this single poem by Stevens, in a slim pamphlet of 16 pages. It was one of the first projects he undertook after founding the Banyan Press in 1946, working out of the basement of a butcher shop in Manhattan's East Village before moving the operation to Vermont in 1948. The Banyan Press became known for its exquisite hand-set limited editions, publishing work by Stevens, Gertrude Stein, John Berryman and James Merrill.

Stevens asked for, and was granted, Fredericks's permission to read from the book before it was published, as part of the Bergen Lecture he was delivering at Yale on March 18, 1948. He expressed confidence in the project, writing, "If everything else about this particular pamphlet is as good as your printing, it will be worth while [*sic*]" (March 2, 1948).[37]

Swiss-born Surrealist painter and engraver Kurt Seligmann (1900-

96

1962) trained in Paris and immigrated to New York in 1939, rising to prominence in the art world after World War II.

59 Gromaire. Exhibition of Paintings. "Marcel Gromaire," pp. 2-3. December 5-31, 1949. Louis Carre Gallery, 712 Fifth Avenue, New York. NY: Louis Carre Gallery, 1949.

> Slim 8vo.; four leaves; illustrated; coated illustrated wrappers.

Stevens's biographical and critical essay on Gromaire; illustrated with three black and white plates. Edelstein B43. Number of copies unknown, but as they were prepared for distribution gratis, likely the run was small. From Stevens's own collection.

Stevens describes Gromaire as "in no way derivative," and these later works – Gromaire was at this time 57 – as "oddly hallucinatory tableaux . . . , the pictures of a determined man, somewhat possessed, predestined and, because of these characteristics, also rebellious. Being rebellious is being oneself and being oneself is not being one of the automata of one's time." He concludes by describing Gromaire's "pictures as they are:

> Heterodox, slightly grim (an orthodox element in anything intended to be social comment), dense in color, as becomes a Goth, rugged with realism . . . uncompromising . . . endowed with the strength that comes from participation in life's struggle, full of the mesmeric presence of meanings below the surface, things not of the school of Paris, but of some harsher, more fundamental zone – and one need only have in mind, say, much of Europe, much of everywhere, always.

60 The Auroras of Autumn. New York: Knopf, 1950.

> 8vo.; dark blue cloth, stamped in blind and gold; blue topstain; printed dust-jacket.

First edition; 3,000 copies, the entire edition. Edelstein 14.a.1. A presentation copy, inscribed to Barbara Church – widow of Henry Church – on the half-title, a month after its September 11 publication date: *To Mrs. Church / Wallace Stevens / Oct. 16, 1950.*

Winner of the National Book Award in Poetry (1951). In a letter thanking his editor at Knopf, Herbert Weinstock, Stevens wrote, "Someone at home said that it is 'as smart as a new hat.' But looked at as a publication of the kind of poetry that I try to write it seems to be perfect. It compels the reader to move through it slowly and deliberately . . . he is not pulled away from one thing to the next" (August 11, 1950).[38]

Stevens remained close to Henry Church's widow Barbara (1879-1960) after Henry's death in 1947. In the years following, Barbara spent much of her time in their second home in Ville d'Avray outside of Paris, and traveling throughout Europe. But she always spent the winter months in New York where Stevens would occasionally join her and her friends for dinner.

In "An Ordinary Evening in New Haven," included in this volume, Stevens drew from Church's descriptions of the places she was visiting abroad. In postcards and letters sent in the summer of 1949, she mentions a day trip to Stockholm, touring Bergamo, and eating lunch with friends at a café near Notre Dame, which seems to have inspired these lines:

> Bergamo on a postcard, Rome after dark,
> Sweden described, Salzburg with shaded eyes
> Or Paris in conversation at a café.

Stevens told Church that he believed *The Auroras of Autumn* would be his last book of poetry and that anything he wrote after would go in "some general collection," (July 17, 1950) a prediction that turned out to be true.[39]

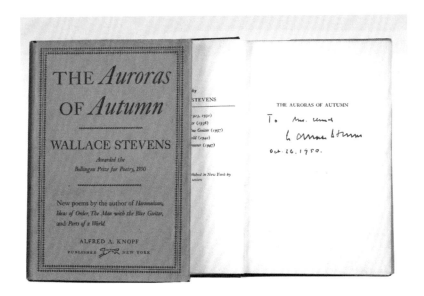

61 The Auroras of Autumn. New York: Knopf, 1950.

> 8vo.; dark blue cloth, stamped in blind and gold; blue topstain;
> printed dust-jacket.

First edition. Edelstein A14.a.1. A presentation copy, inscribed on
the half-title: *To Tom McGreevy / Wallace Stevens.*

The poem "Our Stars Come from Ireland," included in *The Auroras
of Autumn*, was inspired by Stevens's epistolary friendship with Irish
poet and art critic Thomas McGreevy (1893-1967). McGreevy first
wrote to Stevens in 1948, after their mutual friend Barbara Church
told him that Stevens had praised his work. McGreevy, a friend of
Joyce, Eliot, Beckett, and others, published one volume of poetry,
Poems (William Heinemann, 1934), but by the time he contacted
Stevens he had moved on to writing mostly art criticism. He served
as the director of the National Gallery of Ireland from 1950 to 1963.
Stevens, in his reply, confessed, "I do not actually remember the
poems, to be honest about it – but I do remember seeing them and
being very much affected by them at the time" (April 20, 1948).[40] Mc-
Greevy sent Stevens a copy of *Poems*, along with his book about the

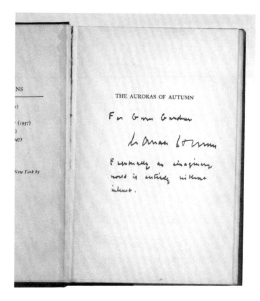

Irish painter Jack B. Yeats.

Thus began a correspondence that continued until Stevens's death in 1955. The two men only met in person once – at a literary salon hosted by Barbara Church in 1954 – but exchanged numerous lively letters about art, writing, politics and nostalgia for their hometowns (McGreevy grew up in Ireland in the rural village of Tarbert; Stevens, in Reading, Pennsylvania). "Our Stars Come from Ireland" references both Tarbert and Mc-Greevy; in the section titled "Tom McGreevy, in America, Thinks of Himself as a Boy," Stevens, writing in first person, imagines himself as a young McGreevy. McGreevy was delighted with the poem and wrote to Stevens on August 4, 1948: "The whole poem was like myself talking to myself – about Wallace Stevens maybe. Another mystery that doesn't seem at all mysterious but quite natural."[41] Holly Stevens described McGreevy as one of the few "with whom . . . [Stevens] was most himself."[42]

62 The Auroras of Autumn. New York: Knopf, 1950.

8vo.; blue cloth, stamped in blind and gold; pencil notes on rear endpaper ("291/1 DOCX.CX"); printed dust-jacket.

First edition; 3000 copies, the entire edition. Edelstein A14.a.1. A presentation copy, inscribed on the half-title: *For Gray Gardner / Wallace Stevens / Eventually an imaginary / world is entirely without / interest.*

Gardner was a fellow executive at Hartford Accident and Indem-

nity; presentations to Stevens's work colleagues are rare as he liked to keep his two careers separate. The quotation is from his collection of aphorisms, "Materia Poetica" (later grouped together with the title "Adagia" in *Opus Posthumous*).

63 Typed letter to D.D. Paige, signed, "Wallace Stevens," Hartford, CT, January 27, 1950.

> One leaf of Hartford Accident and Indemnity Company letterhead; one page.

Together with:

Typescript: "A List of Poems That I Like."

> One leaf of onionskin; one page.

Stevens responds to Paige, who sent him an advance copy of the book of Pound's letters he was editing (*The Selected Letters of Ezra Pound: 1907-1941*). He includes a typescript of favorite pieces from his books ("a list of poems that I like") but cautions that it "is not

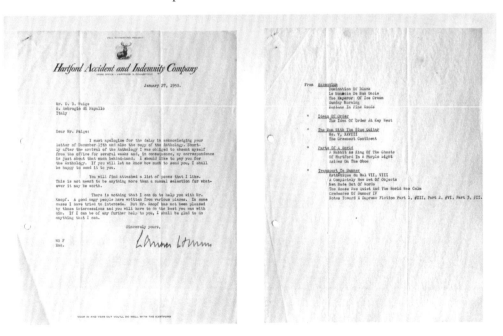

meant to be anything more than a casual selection for whatever it may be worth." Stevens also apologizes for not being able to advocate on Paige's behalf to Mr. Knopf (presumably regarding his next book project): "There is nothing I can do to help you with Mr. Knopf . . . you will have to do the best you can with him."

The enclosed list includes five poems from *Harmonium* ("Domination of Black," "Le Monacle de Mon Oncle," "The Emperor of Ice Cream," "Sunday Morning," "Bantams in Pine Woods"); one from *Ideas of Order* ("The Idea of Order at Key West"); two from *The Man with the Blue Guitar* ("No. v, xxviii," "The Greenest Continent"); three from *Parts of a World* ("A Rabbit as King of the Ghosts," "of Hartford in a Purple Light," "Asides on the Oboe"); and six from *Transport to Summer* ("Esthetique de Mal vii, viii," "A Completely New Set of Objects," "Men Made Out of Words," "The House Was Quiet and the World Was Calm," "Credences of Summer iv," "Notes Toward a Supreme Fiction Part 1, #iii, Part 2, #vi, Part 3, #ii").

He included nothing from his latest book, *The Auroras of Autumn*.

64 **The Relations Between Poetry and Painting.** A lecture delivered at the Museum of Modern Art on January 15, 1951. New York: Museum of Modern Art, 1951.

4to.; printed wrappers.

Together with:

The Relations Between Poetry and Painting. A lecture delivered at the Museum of Modern Art on January 15, 1951. New York: Museum of Modern Art, 1951.

4to.; printed wrappers.

First edition; a copy of the suppressed first issue, with Stevens's name spelled incorrectly ("Stephens") in the copyright notice; together with the corrected issue. Edelstein A15, making no mention of the typo as it was unseen by him at the time of publication. Though copies of this title are not uncommon in institutions, how many of the suppressed first issue survive is unknown; the title in either issue is virtually unprocurable.

In this talk Stevens gave on the intersections of writing poetry and painting, he notes that poets and painters undertake a similar process: Each attempts to reconcile imagination/abstraction with realistic representation; each has had its form and content transformed by Modernism. He concludes: "The paramount relationship between poetry and painting today is simply this: that in an age in which disbelief is so profoundly prevalent, poetry and painting, and the arts in general, are a compensation for what has been lost." Due to the success of *The Relations* . . . Knopf commissioned a book of essays and criticism from Stevens (*The Necessary Angel*, 1951), which includes a reprinting of this text.

Echoes of this essay can be found in William Carlos Williams's annotations to an article he pasted into the rear of a copy of his *Selected Poems* (1949, see item #184): "Only when the arts thrive can man stand up & say 'I am'." He addresses Arnold Toynbee's statement

of civilization's inequality below: "This inequality is perpetuated in the various mechanical inheritances which constitute our art & its form." Posthumously, the Whitney Museum in New York City mounted an exhibition entitled, "William Carlos Williams and the American Scene, 1920-1940" (see item #211).

65 **Two or Three Ideas.** Chap book published by the College English Association, University of Massachusetts, as a Supplement to The CEA Critic. Macwell H. Goldberg, Editor. Vol. XIII, No. 7. October 1951.

Slim 8vo.; wrappers.

Supplement to *The CEA Critic* for October 1951; number of copies unknown. Edelstein A16.

Midway through this eight-page lecture which Stevens delivered April 28, 1951, at the spring meeting of the New England College English Association held at Mt. Holyoke College, he restates his "two or three ideas":

> The first is that the style of a poem and the poem itself are one; the second is that the style of the gods and the gods themselves are one; the third is that in an age of disbelief, when the gods have come to an end, when we think of them as the aesthetic projections of a time that has passed, men turn to a fundamental glory of their own and from that create a style of bearing them-selves in reality. They create a new style of a new bearing in a new reality. This third idea, then. . . . the style of men and men themselves are one. (pp. 4-5)

A footnote in the pamphlet records that "[t]he same day, at Roosevelt College, the Chicago College English Association Conducted a series of analyses, from different critical approaches, of" Stevens's *Thirteen Ways of Looking at a Blackbird.*

66 **The Necessary Angel: Essays on Reality and the Imagination.** New York: Knopf, 1951.

8vo.; green cloth, stamped in blind and gold; printed dust-jacket.

104

First edition. Edelstein 17.a.1. A presentation copy, inscribed on the half-title: *To Mrs. Church / Wallace Stevens.*

Barbara Church's copy of this compilation of essays and criticism or, according to Stevens, "odds and ends of papers" (August 13, 1951).[43] Though he explicitly told Monroe Wheeler, who handled the publication of *The Relations Between Poetry and Painting*, that he had "no present intention of ever publishing a volume of prose," (January 23, 1951) Weinstock at Knopf convinced him to do otherwise.[44]

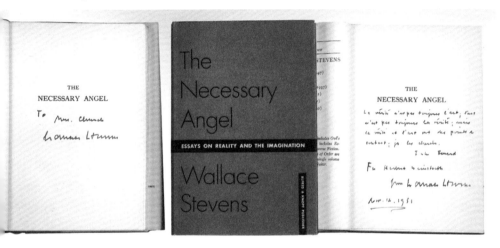

67 The Necessary Angel: Essays on Reality and the Imagination. New York: Knopf, 1951.

8vo.; green cloth, stamped in blind and gold; printed dust-jacket.

First edition. Edelstein A17.a.1. A presentation copy, inscribed on the official publication date to Herbert Weinstock on the half-title: *La vérité n'est pas toujours l'art; l'art / n'est pas toujours la vérité; mais / la vérité et l'art ont des points de / contact; je les cherche. / Jules Renard. / For Herbert Weinstock / from Wallace Stevens. / Nov. 12, 1951.*

The quote, from French author Jules Renard, translates as follows: "Truth is not always art; art is not always truth; but truth and art have points of contact; I am seeking them." Herbert Weinstock (1905-1971) was Stevens's editor at Knopf. Before working in publishing, he wrote a number of biographies of composers including

Tchaikovsky, Handel, and Chopin, and reviewed operas for the *New York Times*. He joined Knopf in 1943 and, excepting brief stints with Doubleday and Macmillan, remained there until his death.

68 Autograph note to Richard Eberhart on the interior of a Christmas card, signed, "Wallace Stevens," Hartford, CT, December 21, 1951.

> 6½ x 4½"; bifolium card with faded color photo of Stevens in his garden, with his house in the background; original envelope addressed to Eberhart.

The touching note reads in full: "It warmed my heart to have your note this morning. I hope to see you the next time I am in Cambridge. All of you look happy and healthy. Merry Xmas and a Happy New Year. This is a photo by my wife of myself in the garden: a few roses (late autumn) but mostly chrysanthemums."

Stevens counted Richard Eberhart (1904-2005) among his closest poet friends; the two men appreciated each other's work, shared a Harvard connection (Eberhart was a graduate student there in the 1930s), and both held full time jobs in the business sector while also

writing poetry, although Eberhart went on to teach. They first met when Eberhart, while working for his wife's floor wax company, visited Stevens in his office. In a 1979 *New York Times* article commemorating what would have been Stevens's 100th birthday, Eberhart was quoted on the impossibility of reading Stevens's poems on one's own level; rather, he said, one reads Stevens to "exceed [one]self."[45] He taught at his alma mater Dartmouth for thirty years, and served as U.S. Poet Laureate from 1959 to 1961. Eberhart went on to win many of the same major literary awards as Stevens, including the Bollingen Prize (1962), the Pulitzer Prize for Poetry (1966), and the National Book Award (1977).

69 Three Photographs. Stevens in his garden at 118 Westerly Terrace, Hartford, CT, 1951; with two additional exterior photos of his home.

 3 Kodacolor prints; 3½ x 5 ¼"; stamped 1951.

Stevens took great pride in his garden, which he had started but which his wife took over tending. He bought the house on Westerly Terrace for all cash in 1929 and lived there until his death in 1955. His wife continued living there until her passing in 1963.

70 Columbia University One Hundred and Ninety-Eighth Commencement program. New York: Columbia University, June 5, 1952.

 8vo.; printed wrappers.

The program from the commencement exercises at Columbia University from the year they conferred an honorary Doctorate of Letters to Stevens, signed by Stevens on the title page.

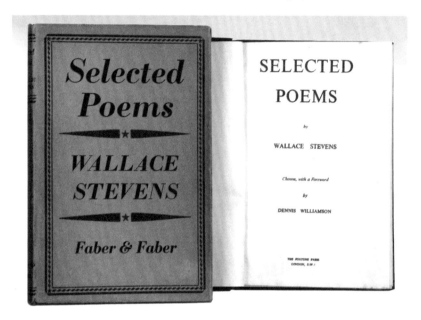

71 Selected Poems. Chosen, with a foreword by Dennis Williamson. London: Fortune Press, 1952.

 8vo.; alligator-patterned black cloth; smooth black cloth spine, stamped in gold.

First edition, advance copy, withdrawn before publication; number of copies unknown but likely one of very few copies distributed for review prior to publication. Edelstein A18.

In the fall of 1946 the Fortune Press requested permission to print a selection of Stevens's poems. Though Knopf negotiated a contract

with them, Knopf then canceled it to seek out a better arrangement with a more established press. Five years later, Faber & Faber secured the rights to publish Stevens's *Selected Poems*, ensuring "a decent and adequate presentation in England," according to a letter from Knopf to Stevens dated December 4, 1951.[46]

A year later, however, before Faber & Faber's volume had come out, some reviewers received advance copies of *Selected Poems* from Fortune Press. A friend of Stevens mentioned reading a review of the book by Austin Clarke in the *Irish Times*. Upon learning of this bootleg publication, Knopf immediately took legal action, demanding that all copies of the book be destroyed.

Charles Doyle, who edited the Critical Heritage collection of reviews of Stevens's work, called this book "an instant collector's item."

72 Selected Poems. London: Faber and Faber, 1953.

 8vo.; purple cloth, stamped in silver; printed dust-jacket.

First edition. Edelstein A19.a.1.

Stevens fretted over choosing pieces for inclusion in Faber's *Selected Poems*, at one point enlisting Marianne Moore's assistance. Eventually, he chose the poems himself, and work from each of his previous books is represented herein. It was Moore, however, who suggested the inclusion of "Final Soliloquy of the Interior Paramour," which had been published previously in *The Hudson Review* but not in any of his books; at her urging, Stevens decided to add it at the last minute. After receiving the proofs from Faber, he wrote to Barbara Church: "The book seemed rather slight and small to me – and unbelievably irrelevant to our actual world. It may be that all poetry has seemed like that at all times and always will" (September 10, 1952).[47]

73 Autograph letter to Richard Eberhart, signed, "Wallace Stevens," Hartford, CT, April 17, 1953.

 One leaf; two pages; original envelope addressed to Eberhart.

A jovial letter in which Stevens comments on his letter-writing preferences, the weather, and his philosophy regarding reviews of his work. Eberhart was at the time teaching across the country at the Uni-

versity of Washington. The letter, which is not among the seven addressed to Eberhart published in *Letters of Wallace Stevens*, reads in part:

> You are so far away that Korea must be on the other side of your back fence. And yet you are everywhere. I came across you this week in the Yale Library Gazette (acknowledgement of a gift) and in the Hudson Review (announcement of a poem). It has been too wet – rainy – to write letters. Besides my correspondence has to yield to practically everything here at the office and I never write letters at home. The long week-ends would be ideal, except that I don't like to write letters anyhow: I like to receive them only . . .
>
> My book in England is doing well although the first two reviews that I saw were silly things . . . Rilke felt that such things muddled his unconsciousness. I can only say that some of them are well done, more are not and that the poet should read both kinds as if they related to some one else. They are like the opinions of judges in law-suits – the bad ones are unbelievably rotten, and the good ones are premier cru.

Stevens signs off wishing that Eberhart will return to New England soon, although he suspects his wife, "like all Bostonians," probably prefers the West Coast.

74 Signed typed letter of agreement from The New American Library of World Literature for the reprint of "Farewell Without a Guitar." Hartford, CT: November 11, 1953.

> One leaf of onion skin NAL letterhead; one page; annotated in ink and pencil.

In this one-page contract, signed and dated by Stevens (November 11, 1953), Stevens grants World First Serial Rights in English to the New American Library of World Literature for the poem "Farewell Without a Guitar." The publisher agrees to pay Stevens $10 for the first 100,000 copies of the anthology that will include the poem (*New World Writing*).

75 Typed letter to Philip Wittenberg, signed, "Wallace Stevens," Hartford, CT, December 31, 1953.

Two leaves of Hartford Accident and Indemnity Company letterhead; two pages.

Together with:

The Dylan Thomas Fund. Form letter signed in type by the Dylan Thomas Fund Committee: Stevens, Auden, Cummings, Moore, Williams, Arthur Miller and Thornton Wilder. Philip Wittenberg, Treasurer / 70 West 40th Street, New York, NY. November 10, 1953.

One leaf; one page.

THE DYLAN THOMAS FUND

c/o Philip Wittenberg, Treasurer
70 West 40th Street, New York, N. Y.

November 10, 1953

Dear Friend,

 I am sure you have read in the press of the sudden and tragic death of the great poet Dylan Thomas. Thomas died of encephalopathy at St. Vincent's Hospital in New York on November 9th, after an illness of four days. He was only 39 years old. He was attended by one of the finest brain surgeons in New York and everything possible was done to save him.

 Thomas' death is an incalculable loss to literature. His work was growing in stature with every year. But there is also a personal tragedy - he leaves a widow without means of support and three children - which gravely concerns his friends and admirers.

 As spokesmen for a committee of his friends we are making this urgent appeal to you for a contribution to The Dylan Thomas Fund, which we have hastily organized, which will be used to meet his medical bills and funeral expenses and, if the response is as generous as we hope, to tide his family over the next difficult months.

 Please send your check to The Dylan Thomas Fund, care of Philip Wittenberg, Treasurer, 70 West 40th Street, New York City. An accounting of disbursements from the Fund will be sent to the contributors at a later date.

For the DYLAN THOMAS FUND COMMITTEE

W. H. Auden	Marianne Moore
E. E. Cummings	Wallace Stevens
Arthur Miller	Tennessee Williams
Thornton Wilder	

Philip Wittenberg sent out a public letter regarding the sudden death of Dylan Thomas, who died of encephalopathy in the hospital on November 9. The letter, co-signed by Stevens, Marianne Moore,

Arthur Miller, Cummings, Tennessee Williams, Auden and Wilder outlines plans for a committee of Thomas's friends to raise money for the Dylan Thomas Fund to cover medical expenses and funeral costs.

Stevens was on the committee and in this letter expresses his misgivings about a resolution to be discussed at a meeting in January which he is unable to attend. He strongly believes that it is essential that the Fund be established with the help of a lawyer, and that a corporate, rather than personal, trustee be named to oversee it. Stevens sent this letter with a memorandum prepared by one of his associates (not present) outlining the legal situation: "Legal advice is part of the problem of public relations which is involved. I think we should invite some lawyer to associate with us and advise us, prepare the trust instrument, arrange with the trust company and procure the court order, without charge or expense." Until everything has been arranged, Stevens says he thinks "Mrs. Thomas and the children are entitled to reasonable informal payments as needed."

The Fund letter reads in part:

Dear Friend,

I am sure you have read in the press of the sudden and tragic death of the great poet Dylan Thomas. Thomas died of encephalopathy at St. Vincent's Hospital in New York on November 9th, after an illness of four days. He was only 39 years old. He was attended by one of the finest brain surgeons in New York and everything possible was done to save him.

Thomas' death is an incalculable loss to literature. His work was growing in stature with every year. But there is also a personal tragedy – he leaves a widow without means of support and three children – which gravely concerns his friends and admirers.

As spokesmen for a committee of his friends we are making this urgent appeal to you for a contribution to The Dylan Thomas Fund, which we have hastily organized, which will be used to meet his medical bills and funeral expenses and, if the response is as generous as we hope, to tide his family over the next difficult months.

... An accounting of disbursements from the Fund will be sent to the contributors at a later date.

76 Raoul Dufy: A Note. New York: Pierre Berès, Inc., 1953.

>Oblong 4to.; blue printed wrappers; string-tied.

First edition; 200 numbered copies, on handmade Arnold paper
(this one is unnumbered), the entire edition. This copy contains
no copyright stamp on the inside front wrapper and the colophon
page is not numbered in holograph. Edelstein A20.

>A four-page essay on Dufy's enormous 250-panel fresco "La Fée
Electricité" (The Fairy of Electricity), commissioned for the 1937
Exposition Internationale des Arts et Techniques dans la Vie Mod-
erne (International Exposition dedicated to Art and Technology in
Modern Life). Stevens had a love and appreciation of contemporary
art, particularly of French artists.

77 Seven typed letters and one autograph letter to John
Gruen, signed, "Wallace Stevens," Hartford, CT, 1953-1955.

>Primarily on Hartford Accident and Indemnity Company letter-
head; each one page; minor autograph emendations in Stevens's
hand.

Together with:

Thirteen Ways of Looking at a Blackbird. Words by Wallace
Stevens. Music by John Gruen. Op. 20. New York: John Gruen, 1953.

>4to.; 11 leaves, 21 pages; printed manuscript score; stapled into a
black paper folder.

A copy of Gruen's manuscript score, printed by the Circle Blue Print
Co., Inc. Edelstein F4 (Edelstein G5 for the 1958 recording). Signed
by Gruen on the title page. With an autograph note in Stevens's
hand beneath the signature: "Merry Xmas & a Happy New Year."

Together with:

Mattino domenicale e altre poesie. A cura di Renato Poggioli.
Giulio Einaudi Editore, 1954.

>8vo.; discreet Italian price ticket in the rear, contemporary with
publication; printed wrappers.

First edition of this selection of thirteen poems in English and Italian, one of which was not previously published ("The River of Rivers in Connecticut"). The book also contains commentary by Stevens, taken from letters he wrote to Poggioli about the project. Edelstein A21. A presentation copy, inscribed on the half-title: *To John Gruen / from his friend / Wallace Stevens / April 29, 1954.*

<p style="text-align:center">* * *</p>

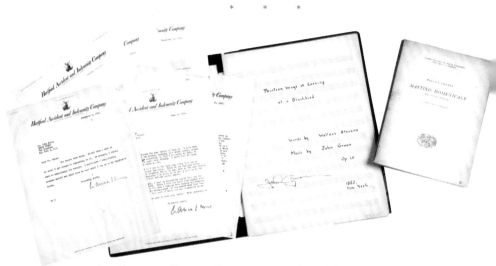

A collection of letters documenting a friendship Stevens cultivated in the last few years of his life, with the New York-based composer John Gruen (1926-2016).

The first letter, dated June 30, 1953, refers to a recording Gruen sent Stevens of musical settings of several E.E. Cummings poems. Gruen was interested in collaborating on a similar project with Stevens and they had recently met in person to discuss it. Stevens praises Gruen's style as "dynamic" and "original," trying to articulate its power:

> No doubt as I hear more of your music, I shall get at its essential quality which I don't feel that I have yet got hold of. While your dynamics are the dynamics of dramatic song, still that is not nearly all there is to say on what seems to be your essential vitality. Perhaps if I said simply that it is the strong music of a young musician, I should be saying as much as if I tried to elaborate, which it would be difficult for me to do since I am not a musician.

He concludes by thanking Gruen for his recent hospitality: "I got an enormous amount of pleasure out of my visit at your house the other day (except for the cats)."

In the next letter – the only autograph letter in the grouping, dated July 17, 1953 and tipped-into a first edition of *Mattino domenicale* – Stevens expresses delight at having received the score and apologizes for his delayed acknowledgement, and mentions the very translation into which he tipped it. He offers "sincerest thanks" to Gruen for sending the score for "Thirteen Ways," noting that the poem has just been translated by Renato Poggioli from Harvard. He says he is not likely to be in New York when the piece is performed, but looks forward to seeing Gruen in the near future.

The two next letters (December 3 and 10, 1953) concern a recording of Gruen's song cycle featuring the text of Stevens's "Thirteen Ways of Looking at a Blackbird" performed by soprano Patricia Neway – on the 3rd, Stevens says he received the record, but will have to wait until he is at his daughter's house to listen to it because he does not have a "long-playing machine" (a specific type of record player). By the 10th, he has had a chance to listen and praises Ms. Neway's performance: "The record of Thirteen Ways etc. is in Class A. Miss Neway has a voice perfectly adapted to your score. Please hand her a bouquet for me." (Not everyone, however, was as impressed with Neway – critic Philip Miller felt her approach to the song cycle was "aggressive," and that her voice showed "power rather than intimacy.")[48]

Stevens then expresses enthusiasm for the "excellent" forthcoming Poggioli translation (for *Mattino domenicale*) and promises to send Gruen copies when it is completed: "You can then let me know, if you care to, what your own judgment of them is since Italian is your native tongue." An inscribed copy is present herewith. Stevens laments that on his last two trips to New York he did not venture "south of Grand Central" (Gruen lived in Greenwich Village) but says he hopes to visit him and his wife soon.

In a brief letter dated October 29, 1954, Stevens politely declines an invitation to attend a concert of Gruen's work and promises to "do what [he] can" in terms of helping Gruen secure a Guggenheim grant. He also jokes, "I am horrified to find you have left Bleecker Street" in

reference to Gruen's recent move to the Upper East Side of Manhattan.

The two letters from December 1954 concern an encore performance of Vincent Persichetti's *Harmonium* song cycle, first written and performed in 1952; Stevens was unable to attend and asked Gruen to go and report back. Stevens enclosed tickets to the performance in his December 6th letter, then wrote again on the 13th to follow up. In that letter, he recalls a review of Persichetti's piece when it premiered:

> When Berger reviewed the original production in one of the New York papers, he said that the trouble was that there was too much of it and that the poems were not of an emotional character. It is true that they are not of the emotional character that Schubert would have selected as texts. But, then, it is no good to argue about that or anything else. I hope it was all right to ask you to go.

Stevens signs off wishing Gruen good luck on his Guggenheim application, writing "I hope you win a Guggenheim although I am bound to say that those awards are rarely made except to people who have a considerable amount of work that has already been published."

Poignantly, in the final letter from this set, dated June 22, 1955, Stevens says he has been ill and has spent most of the past two months in the hospital; he doubts that he will make it to New York much over the summer. He also expresses regret that Gruen did not get a Guggenheim Fellowship, noting "since I have not heard from anyone else, I assume that others for whom I vouched were equally unfortunate." Stevens did not, in fact, make it to New York at all that summer; his health continued to decline and he died just six weeks after this letter was written.

Stevens and Gruen did not become acquainted until the final years of Stevens's life. Gruen first contacted Stevens in 1953 and sent him a recording of his song cycle set to poems by E.E. Cummings. After their collaboration on "Thirteen Ways of Looking at a Blackbird," the two men remained close. In Peter Brazeau's oral biography *Parts of a World: Wallace Stevens Remembered* (Random House, 1983), Gruen describes how Stevens felt about his own work: "He told me that he didn't know what his poetry meant at times, that he really had to think hard as to what he meant by that image or that phrase or that word, even."[49]

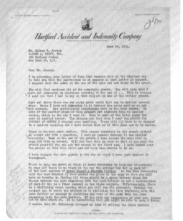

78 Typed letter to Sidney R. Jacobs, signed, "Wallace Stevens," Hartford, CT, June 29, 1954.

> One leaf of Hartford Accident and Indemnity Company letterhead; two pages; red pencil checkmarks and short autograph note by Jacobs in the left margin on recto.

This letter to Jacobs, an editor at Knopf, accompanied Stevens's corrected proofs of *Collected Poems*. Stevens notes some spelling and punctuation inconsistencies (he prefers "centre" to "center," "metier" to "métier," and "gayety" to "gaiety"), then comments at length on a spacing issue with "Notes Toward a Supreme Fiction." In the Cummington Press printing of *Notes*, the final section appeared on its own page "because the part beginning with the word Soldier is not a continuation of part 10 but is a final comment on the whole subject." Stevens requests something to clarify this, perhaps even italicizing the whole section to set it apart visually, if not spatially. Jacobs has checked off Stevens's sections as follows:

> · Enclosing proofs: "you will note that I have not commented on questions related to the use of . . . · This is because I said all that I had to say on that subject on one of the earlier proofs."
> · Consistency of spelling, especially of the word "centre," which he would like spelled that way.

117

· Consistency of spelling of "metier," which he prefers with an accent.

In his penultimate, lengthiest note, Stevens discusses spacing concerns with "part 10 of the last section of *Notes Toward a Supreme Fiction*." Jacobs adds his potential solution to the margin.

Stevens's final note is his briefest: "I notice that Mr. Weinstock scrapped my idea of calling the final section The Rock." Jacobs has neither check-marked nor commented, but that section title was ultimately restored.

79 **The Collected Poems of Wallace Stevens.** New York: Knopf, 1954.

> 8vo.; discreet bookplate on front pastedown ("John Davidson"); printed dust-jacket.

First edition; 2500 numbered copies (this is copy #390). Edelstein A23.a.1. A presentation copy, inscribed on the front endpaper three days after the official publication date: *To Jerry Barter / from Wallace Stevens / Oct. 4, 1954.*

Winner of Stevens's second National Book Award and the Pulitzer Prize for Poetry in 1955, this volume includes selections from all of Stevens's previous books, along with 25 poems, all but six previously unpublished, in a section titled "The Rock." *Collected Poems* was published on October 1 to coincide with Stevens's 75th birthday the next day, and this copy was inscribed shortly afterward.

In his National Book Award acceptance speech, Stevens spoke on the role of the poet in society, reflecting eloquently and humbly on his life's work:

> I think then that the first thing that a poet should do as he comes out of his cavern is to put on the strength of his particular calling as a poet, to address himself to what Rilke called the mighty burden of poetry and to have the courage to say that, in his sense of things, the significance of poetry is second to none. We can never have great poetry unless we believe that poetry serves great ends
>
> Now, at seventy-five, as I look back on the little that I have

done and as I turn the pages of my own poems gathered together in a single volume, I have no choice except to paraphrase the old verse that says that it is not what I am, but what I aspired to be that comforts me. It is not what I have written but what I should like to have written that constitutes my true poems, the uncollected poems which I have not had the strength to realize.

80 **The Collected Poems of Wallace Stevens.** New York: Knopf, 1954.

8vo.; maroon cloth, stamped in silver and gold; yellow topstain; printed dust-jacket.

First edition; 2500 numbered copies (this is copy #335). Edelstein A23.a.1. A presentation copy, inscribed on the front endpaper to Barbara Church, on the occasion of a cocktail party held by her in honor of a reading by Stevens: *Tom-Tom, c'est moi, / To Barbara Church / from Wallace Stevens / New York / Nov. 6, 1954.*

This copy was gifted to Church on the night Stevens gave a reading at the 92nd Street Y to celebrate the book's publication. He quotes himself in the inscription, from canto XII of "The Man with the Blue Guitar": "Tom-tom, c'est moi / The blue guitar and I are one." There is a light stain on the inscription page, perhaps from a martini jostled during the signing. Here, in an inscription to the widow of the man he may have admired most, Stevens sums up his view of himself as he closes in on the last eight months of his life.

In the months following the book's release, Stevens's health deteriorated as his cancer spread and he was hospitalized multiple times. He was admitted to St. Francis Hospital in Hartford on July 21, 1955 and died on the morning of August 2.

81 **Typed letter to Richard Eberhart, signed, "Wallace Stevens,"** Hartford, CT, January 26, 1955.

One leaf of Hartford Accident and Indemnity Company letterhead; one page; with original envelope addressed to Eberhart.

Stevens responds to Eberhart's note of January 22nd, which offered congratulations on his recent National Book Award. Stevens de-

scribes the ceremony, hosted by Clifton Fadiman, who "did a wonderful job." He jokes that one of the judges, Christopher LaFarge, "did so well by Cummings that if my name had not already been on the plaque I should have been moved to give it to him."

82 **Photographs of Stevens at Avery Convalescent Hospital.**
Hartford, CT: July 1955.

> Four Kodachrome prints; 3 ¼ x 2 ¼"; stamped July 1955.

 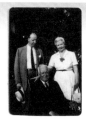

Photographs of Stevens at Avery Convalescent Hospital (at St. Francis Hospital), in Hartford, taken during his final illness, just days before he passed away, during the visit of a close work colleague, Anthony Sigmans and his wife Mary. Stevens looks serene, perhaps not yet realizing the gravity of his condition.

83 **Letters of Wallace Stevens.** New York: Knopf, 1966.

> 6 x 27"; galley pages; unbound.

Advance uncorrected long galley proofs of the nearly 1,000 letters written by Stevens from 1895 to 1955, selected and edited by Holly Stevens. Edelstein A29.a.1.

Holly Stevens intended to write a biography of her father, but never did. These letters and diary entries fill that gap, offering insight into Stevens's relationships with his family and closest friends, fellow writers, and the editors who published his work.

84 **Letters of Wallace Stevens.** Selected and edited by Holly Stevens. New York: Knopf, 1966.

> 8vo.; gray cloth, stamped in black and gold.

First edition. Edelstein A29.a.1. A presentation copy, inscribed by Holly Stevens to Harold Bloom on the first blank: *For Harold / to whom I owe so much, and / enjoy doing so immensely - / "Book of a concept only possible / In description." / Affectionately, / Holly.*

With Bloom's pencil ticks to the index to authors such as Arthur Schopenhauer, Blaise Pascal, Friedrich W. Nietzsche, Charles Forbes Comte de Montalembert, and to the Stevens poems "The Emperor of Ice-Cream" and "Description without Place"; and circles around T.S. Eliot, Stevens's "Esthétique du Mal" and "Credences of Summer"; and with his more substantive notes on the rear endpaper for two Stevens-related book projects. The first, titled "Poetic Crossing: The Breaking of Form," is "for Kenneth Burke," and outlined as follows:

> Introduction: The Breaking of Form
> 1. Poetic Crossing: Rhetoric and Psychology
> 2. American Poetic Stances: Emerson to Stevens
> 3. Stevens: <u>Someone Puts a Pineapple Together</u>

Though this project never came to fruition, Bloom published his essay "Poetic Crossing: Rhetoric and Psychology" in *The Georgia Review* (Vol. III.3, Fall 1976) and "American Poetic Stances: Emerson to Stevens" became the first chapter in *Wallace Stevens: The Poems of Our Climate* (Cornell University Press, 1977). He lays out the outline for that book here as well, including a preface, introduction ("Poetic Crossing and Mapping Stevens") and twelve chapters. The published book follows this structure with the addition of a second essay on *The Auroras of Autumn* and the replacement of an introduction with a final essay, "Coda: Poetic Crossing."

Harold Bloom (b. 1930) was one of the greatest critical champions of Stevens's poetry. In his essay "The Central Man" (*The Massachusetts Review*, 1966), he names Stevens as the "heir" of Emerson and Whitman, "the ironically yet passionately balanced fulfillment of the American Romantic tradition in poetry."[50]

The quotation in Holly's inscription comes from Stevens's poem "Description Without Place," which was first published by the *Sewanee Review* and then distributed as an offprint after Stevens read it at the Phi Beta Kappa commencement exercises at Harvard in June of 1945.

85 Hockney, David and Wallace Stevens. The Blue Guitar. Etchings by David Hockney. London and New York: Petersburg Press, 1977.

8vo.; blue wrappers; printed cover label; printed dust-jacket.

First edition of this volume of twenty etchings by Hockney, each accompanied by an excerpt from Stevens's ekphrastic poem "The Man with the Blue Guitar" which was inspired by Picasso's 1903 painting "The Old Guitarist."

86 Levine, David. Illustrated Portrait Print of Wallace Stevens. From the *New York Review of Books*, Vol. VII.9 (December 1, 1966), p. 6.

Print; black and white; matted to 7 ½ x 11"; framed.

This illustration accompanied Denis Donoghue's review of *Letters of Wallace Stevens*. David Levine (1926-2009) completed nearly 4,000 iconic pen-and-ink caricatures of writers, artists and politicians for the *New York Review of Books* beginning in 1963. He was known for capturing the essence of his subjects in a humorous but not cruel way. His work also appeared in *Rolling Stone, The New Yorker, Playboy, Time, Newsweek,* the *New York Times* and the *Washington Post.* Levine trained as a painter at the Pratt Institute in Brooklyn, but after he began creating political cartoons for *Esquire* in the early '60s, he switched his focus to drawing. His illustration of William Carlos Williams accompanied the tribute penned by Kenneth Burke in the NYRB three months after Williams's death in 1963 (see item #207).

Ghosts in the Collection

One of the stimulating aspects of collecting books is finding inscriptions by an author in a copy of his or her work, or finding an association between the first owner of a book and its author.

In the case of Wallace Stevens, this catalogue includes books inscribed to his daughter, to his editor at Knopf, to co-workers such as his secretary and lawyers who worked with him at the Hartford Accident and Indemnity Company, to fellow poets and to key individuals who each played an important role in Stevens's life. Inscriptions by William Carlos Williams in this catalogue include those to his wife, his mother-in-law, his son and well-known members of the art world throughout Williams's career: Malcolm Cowley, Man Ray, Martha Graham and others. In each of these instances, the recipient of the book is someone whose identity can be reasonably easily ascertained and whose role in the biography of either Stevens or Williams is fairly well-known or can be readily appreciated.

But then there are circumstances which any collector knows are tantalizing and frustrating. A copy of a book has made its way decades later into the collector's hands and there is no clear answer to the question, How or why was this book inscribed for its recipient? Or even, Who was the recipient and under what circumstances did he or she encounter the author? One example in this catalogue is the first edition of Williams's *Selected Poems*, published by New Directions in 1949 (see item #183), inscribed on its title page: "Isabel Wyckoff / best luck / William Carlos Williams. / July 25/51."

Isabel Wyckoff

(best luck

WILLIAM CARLOS WILLIAMS

SELECTED POEMS

with an introduction by Randall Jarrell

The New Classics Series

William Carlos Williams

July 25/51

Who was Isabel Wyckoff and why did Williams inscribe a book to her in late July of 1951? A look at the indices of biographies of Williams, his *Selected Letters* and various other collections of his letters shows no references to Isabel Wykoff or Wyckoff (Williams was a notoriously poor speller of names, even more so after his heart attacks and strokes). An on-line search shows a number of different Isabel Wyckoffs who would have been alive in 1951, at least one in New Jersey and one in Connecticut. There is even a town in New Jersey named Wyckoff. Paul Mariani's comprehensive biography of Williams places Williams in Connecticut, by the shore, on July 25, 1951, recovering from yet another stroke, however, making a Connecticut-based recipient most likely.

Who was Isabel Wyckoff of Connecticut in 1951? United States census records become publicly available 72 years after each census. The most recent census records publicly available are from 1940. They show an Isabel Wyckoff living in Hartford, Connecticut, age 54, working as a public school teacher earning $2600 a year. She was born in Connecticut and she shared an apartment in a house at 16 Atwood Street with two other women, one of whom was 45 and worked at a department store and the other was a 42-year-old practical nurse. The 1940 census record also shows that in 1935 Wyckoff was living in Bloomfield, Connecticut, a town near Hartford. The 1930 US census shows Isabel Wyckoff, then age 44, living with her mother on Park Avenue in Bloomfield and working as a public school teacher. A small note in the *Hartford Courant* on July 5, 1922 makes mention that Isabel Wyckoff of Park Avenue in Bloomfield, "... has gone to Wilton, Maine, where she will have charge of a camp for girls. This is her second year at this place." The 1910 census has her living with her mother and brother in Bloomfield and her occupation as "Teacher, Grammar School." And Connecticut records show Wyckoff graduating from the New Britain State Normal School, a teacher training school in another neighboring town to Hartford, on June 23, 1908. According to Social Security records she died in Connecticut in December of 1967. Could this be the Isabel Wyckoff – by 1951, 65 years old – possibly still active as a school teacher, for whom William Carlos Williams inscribed a copy of his *Selected Poems* by the Connecticut shore in late July? How precisely she and Williams

encountered each other, whether she already had a copy of the book and used the opportunity to have Williams sign it, for instance, seems impossible to ascertain. Did they have a mutual acquaintance or, perhaps, was she, too, spending some time by the water that summer?

One small coincidence regarding Isabel Wyckoff of 16 Atwood Street, Hartford, Connecticut in 1940: At least in 1940, Wallace Stevens walked past the street where Isabel Wyckoff lived each work day. 16 Atwood Street is almost exactly halfway between the headquarters of the Hartford Accident and Indemnity Company and Westerly Terrace in Hartford, where Wallace Stevens lived for the last 26 years of his life. And it is just a half-block off of Asylum Avenue, which is the street along which Wallace Stevens famously walked the two miles from his home to his office every day, composing his poetry as he went. Ten years later, it seems that she had a book inscribed to her by William Carlos Williams.

Another ghost in this collection relates to two books bearing Wallace Stevens's personal bookplate: a copy of the Knopf edition of *Ideas of Order* (1936) (item #25) and *Transport to Summer* (1947) (item #49). As discussed above, Stevens had these two distinct bookplates designed and printed for him by the expatriate artist and typographer Victor Hammer. How did these two books make their way from Stevens's library into the possession of Gladys Ely? Ely signed each book, and in the copy of *Transport to Summer* dated her signature "January, 1948" – meaning that Ely obtained this copy nine months after publication and only a few months

after Stevens received the bookplates. Who was Gladys Ely and why was she the recipient of these books from Wallace Stevens's library?

We know from the dealer who later sold the books that Gladys Ely was a published poet and a long-time teacher at the Brearley School in Manhattan. With this information, it can be ascertained that she passed away in 2009 at the age of 86, which means that she was only 24 or 25 years old when she received these books. Some investigation shows that she was a 1945 graduate of Smith College and that in 1941, Ely graduated from the public high school in New Britain, CT, a city nine miles from Stevens's home in Hartford, by coincidence the same setting for the teacher training school that Isabel Wyckoff had graduated from in 1908. A review of US census records and the New Britain annual city directory shows that Gladys was born on January 30, 1923, and grew up in New Britain, where her father was head of personnel at a ball bearing manufacturer. Her high school yearbook, of which she was literary editor, describes "Gladdy," apparently her nickname, as having ". . . an unusual flair for Latin and writing poetry." She was a member of the National Honor Society and the Poetry Club and was Class Secretary. After graduating college from Smith, she obtained an M.A. from Columbia University and taught in San Francisco, Seattle and New Jersey before settling at the Brearley School in 1951 where she fulfilled the promise suggested by her yearbook notes by teaching English and Latin for the next 36 years. Her poetry was published in various periodicals over the following decades. A Brearley faculty contemporary recalls Ely as "extremely nice, an interesting, cerebral individual," noting, "She was about the only person I talked to in the faculty lounge in breaks between classes."

But what was the connection between Ely and Stevens in January of 1948? Ely was clearly someone who would have known of Stevens and his work at that time. Could her father have somehow become acquainted with Stevens and told him of his daughter's interest in poetry? Perhaps, although they worked in very different professional spheres and it would seem therefeore unlikely that the senior executive at an insurance company would have encountered the head of personnel at a manufacturing company, despite their relative physical prox-

imity. Or that Stevens, not the most gregarious of individuals, would have passed on these books. However, it is possible to speculate that Ely may have been acquainted with Holly Stevens, Stevens's daughter. Holly, who was a year younger than Ely, graduated from high school in Hartford in 1941 as well and started at Vassar in the fall of that year. Could the poet's daughter and the member of the Poetry Club at New Britain High School have had over-lapping social circles? By January of 1948, Holly Stevens had dropped out of Vassar, married, given birth to a son in the spring of 1947 and separated from her husband. It is conceivable that when Ely was home for the holidays while getting her master's degree at Columbia, or on a winter break from one of the teaching jobs she held during this period, she received these books as a gift from Holly, knowing of Ely's intense interest in poetry. And as Ely had a birthday in January of 1948, perhaps they were a birthday present. As with Isabel Wyckoff and her inscription from William Carlos Williams, we will never know for certain how these books came to belong to Gladys Ely. They stayed in her possession for the next sixty years.

In the way the world can work sometimes, one small coincidence should be noted regarding Gladys Ely and her published poetry. In September of 1958 her work made its only appearance in *Poetry* magazine, with four poems published in Vol. 92, Number 6 of *Poetry*. The featured selection of that issue was an "Excerpt from 'Paterson V'," by William Carlos Williams, in advance of the publication of *Paterson V* that autumn.

STEVENS & WILLIAMS
TOGETHER

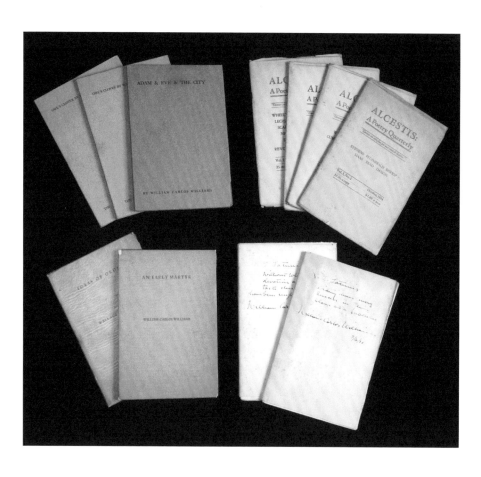

The Alcestis Press Collection

Ronald Lane Latimer was the founder and publisher of the Alcestis Press, which operated from 1933 to 1938. Four issues of the *Alcestis Quarterly* were printed in 1934 and 1935 and fewer than ten limited edition books, of exquisite quality, were published from 1935 through 1937. Despite the short period of time in which it operated, Alcestis had an outsized influence on the development and history of Modernist poetry. The Alcestis Press published two books by Stevens – *Ideas of Order* and *Owl's Clover* – two books by Williams – *An Early Martyr and Other Stories* and *Adam and Eve and the City* – and books by Allen Tate, Robert Penn Warren, John Peale Bishop and Willard Maas.

Stevens carried on an extensive correspondence with Latimer, using Latimer as a sympathetic reader as Stevens worked out the development of his ideas on the nature and place of poetry during the mid-1930s. Stevens credited Latimer with stimulating much of his poetry during this period. Williams was more circumspect in his interactions with Latimer. He had first encountered Latimer when Latimer was going by his birth name – James Leippert – and publishing literary journals while an undergraduate at Columbia University. Then Leippert began using the name Martin Jay, Mark Jason and finally Ronald Lane Latimer, among other pseudonyms. This chameleon-like quality of Latimer made Williams wary of him, as it did others who dealt with Latimer (see item #14, a letter from Stevens to Witter Bynner).

Ultimately, after the Alcestis Press ceased operating, Latimer traveled to Japan, studied Buddhism, returned to the United States shortly before the Japanese attack on Pearl Harbor, became a Buddhist monk in Los Angeles, subsequently studied at a divinity school in Berkeley, became an Episcopal priest, worked in New Jersey, Santa Fe and Florida and died in Florida in 1964 at the age of 55. His correspondence is held in the Special Collections Research Center of the University of Chicago. The bulk of this trove came into this collection recently, directly from Latimer's descendants.

87 **Harmonium**. New York: Alfred A. Knopf, 1931.

> 8vo.; gray paper-covered boards; black cloth spine with printed label; insect damage to spine; glue-stains to preliminaries.

Second edition (in the first binding), but so emended as to be a new book; three poems removed from the 1923 edition, and fourteen new ones added; 500 copies this binding, 1500 copies the entire edition. Edelstein A1b. A presentation copy, inscribed on the title page: *For Ronald Lane Latimer / From Wallace Stevens / January 14, 193[5?]*. With a pair of dampstain-ringed spots carrying through the preliminaries, in an attempt to remove an ink notation of a date (seemingly "June [], 1934") from the blank opposite the half-title, and perhaps another word from the front endpaper (beneath the inscription, in Latimer's hand: "The Alcestis Library.")

88 **Alcestis: A Poetry Quarterly**. I.1 (October 1934); I.2 (January 1935); I.3 (April 1935); I.4 (July 1935.)

> 4 vols., 8vo.; cream printed wrappers; unopened.

All four issues of Latimer's poetry journal. Work by Stevens appears in numbers 1 and 3; work by Williams, in numbers 2 and 4.

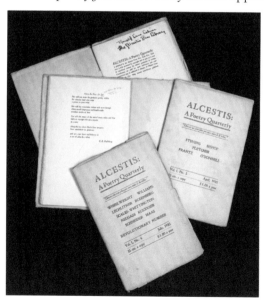

Each volume – all with uncut leaves – is docketed in Latimer's heavy black ink script on the first page: *Ronald Lane Latimer / The Alcestis Press Library.*

89 Stevens. Manuscript: "The Weeping Burgher," signed "Wallace Stevens," annotated on the verso by Latimer.

Ca. March 12, 1935.

8¼ x 10½"; paper-taped at top corners and top mid-edge to matte; paper tape residue covering a quarter-sized portion of the Latimer explanation and the paper tape at mid-top-edge covering the top half of three words.

Stevens wrote to Latimer on March 12, 1935, enclosing this poem. "This is in my normal handwriting, which is, I hope, what you want." He also encloses "Sailing After Lunch," which he hopes Latimer will use to open his next collection – for which Stevens proposes the title, *Ideas of Order.* "Perhaps it means more to me than it should you might like to use it in connection with the group that I sent you a few days ago, putting this at the beginning of the group."[51]

Latimer annotated this manuscript on the verso: "This holograph manuscript was written for me by Wallace Stevens / on paper which I provided. March 12, 1935. / Ronald Lane Latimer, editor, Alcestis: A Poetry / Quarterly."

90 Typed letter to Ronald Lane Latimer, signed, "W.C. Williams," Rutherford, NJ, May 9, 1935.

One leaf; one page.

May 9, 1935

Dear Latimer:

The measure of your exasperation over your literary labors should in equal measure convince you of your heroism and the gratitude of at least one man, myself. I am looking forward to the appearance of my book of poems with as much enthusiasm as I ever experienced over any publication of my work in the past. I feel deeply indebted to you for what you are doing.

The word is not "Possensck" but PASSENACK - a combination of the two place names Passaic and Hackensack . I used it once before in a story ; Thank you.

Best wishes and - Take it easy. For Madox Ford was speaking of you the other evening.

Best wishes

W.C. William

9 Ridge Rd.
Rutherford, N.J.

This fascinating note, as Williams awaits the publication of *An Early Martyr*, comes a year after the publication of the Objectivist Press edition of Williams's *Collected Poems*. Williams had published no new books of poetry since *Spring and All* in 1923 until the *Collected Poems*. Latimer had an enthusiasm for Williams's work, as evidenced by his inclusion of Williams in the student publication he edited, *The Lion and Crown*, prior to starting the Alcestis Press. Williams struggled during his early career to find a publisher with whom he could have any kind of consistent working relationship, as Stevens had developed with Knopf. Williams would only successfully find that kind of relationship due to the enthusiasm of another young, untested publisher then just out of college: James Laughlin of New Directions, who published Williams's novel *White Mule* in 1937, two years after this letter. By that time, the Alcestis Press was nearing its end. New Directions continues to keep Williams's work in print to this day, as Knopf does that of Stevens.

Dear Latimer:

The measure of your exasperation over your literary labors should in equal measure convince you of your heroism and the gratitude of at least one man, myself. I am looking forward to the appearance of my book of poems with as much enthusiasm as I ever experienced over any publication of my work in the past.

I feel deeply indebted to you for what you are doing.

The word is not "Possenack" but PASSENACK - a combination of the two place names Passaic and Hackensack. I used it once before in a story: Thank you.

Best wishes and - Take it easy. For[d] Madox Ford was speaking of you the other evening.

Best wishes
W.C. Williams

91 Stevens. **Ideas of Order**. New York: The Alcestis Press, 1935.

8vo.; cream printed wrappers with flaps; unprinted glassine dust-jacket.

First edition; one of twenty signed copies numbered in roman numerals (this is copy I), printed on handmade paper; 165 copies, the entire edition. Edelstein A2.a.

A presentation copy, inscribed on the title page: *For Ronald Lane Latimer / Wallace Stevens.* Opposite the title page, Stevens has written out and signed the poem, "The Pleasure of Merely Circulating."

92 Stevens. Typescript: "The Guide of Alcestis," annotated and initialed by Stevens. August 16, 1935.

6³/₈ x 9"; horizontal crease.

Stevens wrote to Latimer on August 16, 1935 – four days after the official publication date of *Ideas of Order* – enclosing this typescript, but noting,

> *The naked Proserpine* will have to become *The living Proserpine*, because, although one sees everyday people wearing smocks who are as good as naked, nevertheless, the *living* Proserpine is much better all round. I have therefore changed this line and send you a new copy to be inserted in the book, with the request that you destroy the copy which I sent you the other day.

Stevens initialed his note in ink at the top: "The only copy." The prior copy which Stevens sent to Latimer, without the revision noted by Stevens, is included in Latimer's papers held at the University of Chicago – clearly Latimer did not destroy it as Stevens had requested.

THE GUIDE OF ALCESTIS

(A boor of night in middle earth cries out.)
Hola! Hola! What steps are those that break
This crust of air?...(He pauses.) Can breath shake
The solid wax from which the warmth dies out?

I saw a waxen woman in a smock
Fly from the black toward the purple air.
(He shouts.) Hola! Of that strange light, beware!
(A woman's voice is heard replying.) Mock

The bondage of the Stygian concubine,
Hallooing haggler; for the wax is blown,
And downward, from this purple region, thrown;
And I fly forth, the naked Proserpine.

(Her pale smock sparkles in a light begun
To be diffused, and, as she disappears,
The silent watcher, far below her, hears:)
The soaring mountains glitter in the sun.

93 Stevens. **Ideas of Order.** New York: Knopf, 1936.

> 8vo.; multi-color striped cloth; printed spine label; dust-jacket.

First trade edition, 1000 copies; one of 500 copies in the first of three bindings. Edelstein A2b. Includes three new poems added after the Alcestis Press edition: "Farewell to Florida," "Ghosts as Cocoons," and "A Postcard from the Volcano."

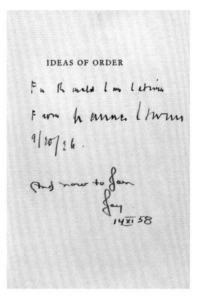

A presentation copy, inscribed and signed by Stevens nearly three weeks before the official October 19th publication date: *For Ronald Lane Latimer From Wallace Stevens 9/30/36.* Beneath this inscription, a later inscription from Latimer, who passed the book on, signing it "Jay," one of his many pseudonyms: *And now to Jan / Jay - 14 XI 58.*

94 Williams. **An Early Martyr and Other Poems.** New York: Alcestis Press, 1935.

> 8vo.; cream printed wrappers with flaps; unprinted glassine dust-jacket.

First edition; 165 numbered copies, the entire edition (this is copy #I of XX copies printed on Duca Di Modena, an Italian handmade paper, for presentation purposes).

A presentation copy, inscribed on the half-title: *To Robert Lane Latimer / out of whose interest / the book has grown. / William Carlos Williams.* Additionally signed by Williams at the colophon. On the verso of the fly leaf, Williams has written his poem "The Farmer" – adding a new line with a final word, not in the published text: "– Antagonist."

Docketed by Latimer at the colophon, *copy I, which is the publisher's own copy / J.R.L.L.*

95 Williams. **Adam and Eve and the City**. Peru, VT: Alcestis Press, 1936.

> Unbound signatures; unopened; first signature (preliminaries) folded backwards, creating the appearance of a blank wrapped front cover, with the preliminaries appearing inside the rear of the volume.

First edition unbound, unopened signatures, with some oddities: reverse folding of the preliminary signature creates the appearance of blank wrappers, with the printed preliminaries appearing in the rear. Wallace A17.

A presentation set, inscribed on the cover: *R. L. Latimer / without whose patient / devotion and good / taste these books would / have been impossible / William Carlos Williams.* With the manuscript poem, "The Rose," written out by Williams and signed by him on the verso of the first blank, and signed as called for at the colophon. Latimer has docketed the colophon – unnumbered but signed by Williams –

Publisher's Special Copy / J. Ronald Lane Latimer. And further, at the head of the title page, which appears in the rear: *J.R.L.Latimer / April 16/36.*

96 Williams. **Adam and Eve and the City**. Peru, VT: Alcestis Press, 1936.

> Unbound signatures; unopened; first signature (preliminaries) folded backwards, creating the appearance of a blank wrapped front cover, with the preliminaries appearing inside the rear of the volume; lacking the first text signature through page 16.

First edition unbound, unopened signatures, with some oddities: reverse folding of the preliminary signature creates the appearance of blank wrappers, with the printed preliminaries appearing in the rear; first text signature through page 16 absent. Wallace A17.

A presentation set, inscribed on the cover: *R. L. Latimer / Wishing him every / success in his / plans as a publisher / William Carlos Williams / 7/16/36.* With the manuscript poem, "To a Wood Thrush," written out by Williams and signed by him on the verso of the first blank. Latimer has docketed the colophon – unnumbered but signed by Williams – *Publisher's Special Copy / J. Ronald Lane Latimer.* And further, at the head of the title page, which appears in the rear: *J.R.L.Latimer / April 16/36.*

97 Williams. **Adam and Eve and the City**. Peru, VT: Alcestis Press, 1936.

> 8vo.; olive printed wrappers with flaps.

First edition; one of twenty signed copies numbered in roman numerals (this is copy #I); 167 copies the entire edition. Wallace A17.

A presentation copy, inscribed on the half-title: *Ronald Lane Latimer / with many thanks / William Carlos Wil-*

Latimer has docketed the colophon, *which is the publisher's copy 10/22/36*. With Williams's poem, "Young Woman at a Window" (from this volume) in Williams's hand on the first blank, with his note beneath: *Fools! I can write! (almost) / William Carlos Williams.*

98 Stevens. Owl's Clover. New York: Alcestis Press, (1936).

8vo.; orange printed wrappers with flaps.

First edition; one of twenty signed copies numbered in roman numerals (this copy is signed but unnumbered); 105 copies, the entire edition. Edelstein A3.

A presentation copy, inscribed on the colophon: *For Ronald Lane Latimer / Wallace Stevens / October 26, 1936.* Docketed by Latimer at the colophon: *Publisher's copy, first issue with errors.*

99 Stevens. Owl's Clover. New York: Alcestis Press, (1936).

8vo.; orange printed wrappers with flaps.

First edition; one of twenty signed copies numbered in roman numerals (this is copy I). Edelstein A3.

A second presentation copy, identically inscribed on the half-title: *For Ronald Lane Latimer / Wallace Stevens / October 26, 1936.*

100 Stevens. **Notes Toward a Supreme Fiction.** Cummington, MA: Cummington Press, 1942.

8vo.; white cloth, stamped in black and gray.

First edition; one of 80 numbered copies, signed by Stevens (this is copy LVI); 273 copies, the entire edition. Edelstein A6a. Docketed

*from the Alcestis Library of
Bhikshu Padmasambhava
(Ronald Lane Latimer)
1942*

Notes toward a Supreme Fiction
has been hand-set in Centaur types & printed for the first time
by hand on dampened all-rag papers : 190 copies numbered
1 to 190 on Dutch Charcoal, 80 copies numbered I to LXXX
signed by the author on Worthy Hand & Arrows, & 3 copies
lettered A to C on Highclere, an English hand-made paper.
The title-pages are from designs by Alessandro Giampietro.
Completed at Cummington, Massachusetts, September, 1942.

This is copy number **LVI**

in an ornate hand at the head of the colophon page: *from the Alcestis Library of Bhikshu Padmasambhava (Ronald Lane Latimer) 1942.*

The inscription, and the very existence, of this edition of *Notes Toward a Supreme Fiction* is interesting and intriguing. Latimer went to Japan and became a Buddhist monk, but made his way back to the United States just a month before the Pearl Harbor attack. He has signed this copy using – seemingly – his Buddhist name as well as his "real" name – which was also a name he took long after his birth. Information about Latimer is still emerging, but there is no evidence we've uncovered that Latimer was involved in the poetry world at all at this time, let alone in touch with Stevens. By 1942, Latimer was a Buddhist priest at a temple in Los Angeles. None of Latimer's correspondence held at the University of Chicago with Stevens, Williams or any other members of the poetry world goes past 1938. How did he end up with one of the special limited copies of a title with an already small print run? This item calls into question the timeline of his relationship with Stevens, opening up the possibility that they had later contact – perhaps even a continuous relationship – than people have generally understood to be the case.

101 Stevens. Esthétique du Mal. A poem by Wallace Stevens with pen and ink drawings by Wightman Williams. Cummington, MA: Cummington Press, 1945.

> 8vo.; black quarter-morocco, stamped in gold; green Natsume straw-paper-covered boards.

First edition; one of 300 numbered copies (this is copy #21); 340 copies, the entire edition. Edelstein A10. Docketed in an ornate hand beneath the colophon: *from the Alcestis Library / of / Ronald Lane Latimer.*

On the heels of the copy of *Notes Toward a Supreme Fiction* above, this copy of *Esthétique du Mal* from Latimer's library runs counter to previous conceptions of the brevity of Latimer's connection to Stevens. By 1945 Latimer was in northern California studying to become an Episcopal minister. At a minimum, Latimer was apparently keeping up his interest in Stevens. Did Stevens send this to Latimer? It seems unlikely. Latimer had disappeared. Did Latimer subscribe to

this and *Notes . . .* from the Cummington Press? Was Stevens aware? Neither *The Man with the Blue Guitar* nor *Parts of a World* is present in the archive maintained by Latimer's descendant. If Latimer had copies of those, perhaps they were given away as was his Knopf edition of *Ideas of Order.* Or perhaps those came out when Latimer was in Japan. Copies of limited editions of Stevens work from 1942 and 1945 in Latimer's hands are unexpected, and truly fascinating.

102 Stevens. **Autograph note for Latimer, signed, "W. Stevens."** N.d.

> 4¼ x 5 ½"; lined note paper; torn from a larger piece.

The seven-line note from Stevens to Latimer reads, "I am sorry to / have reversed the / poems copied for / you, which came / about by my failing / to distinguish between / I and 1 / W Stevens."

103 Williams.

Manuscript: "This is Just to Say," signed, "Willliam Carlos Williams." N.d.

> 8 x 10".

Manuscript copy of Williams's canonical poem, prepared for and presented to Latimer: *To R. L. Latimer - / best wishes / William Carlos Williams.*

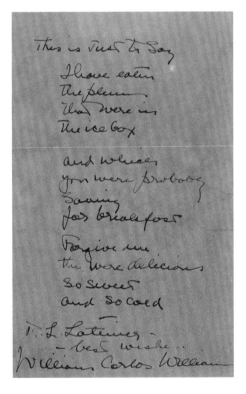

Publications and Ephemera

These journals and anthologies from various small presses in
this section ranging over a forty year period are a sampling of the
publications in which the work of Stevens and Williams appeared
together. Not infrequently, as a result, a reader of contemporary
poetry in publications in the period from World War I through
the mid-1950s was reading Stevens and Williams together, along
with other exemplars of American mid-century Modernism such
as Cummings, Eliot and Moore together with Frost and Sandburg.
A reader of the output of the Alcestis Press in the 1930s and of the
Cummington Press in the 1940s was also certainly reading both
Stevens and Williams.

Stevens had gained a kind of stature by the end of the 1930s still
sought then by Williams for his verse, a stature Williams did not
achieve until the acclaim he received for his volumes of *Paterson*,
starting with *Paterson (Book One)* in 1946. The relative progress of their
reputations can be seen in the fact that Stevens had an issue of the
Harvard *Advocate* (which Stevens had edited as a Harvard under-
graduate forty years earlier) devoted to him in 1940, with Williams's
participation, while Williams had to wait until 1946 for the *Briarcliff
Quarterly* to have a William Carlos Williams issue, with Stevens's
participation.

The recordings of acclaimed poets reading at Harvard put out
in 1978 would not have been complete without contributions from
both Stevens and Williams, nor would the U.S. postal stamp issue
of ten American poets in 2012 have been complete without iconic
images of both of them.

104 Others: A Magazine of New Verse. I.2 (August 1915).

8vo.; orange printed wrappers.

The first appearance of Stevens's canonical "Peter Quince at the Clavier" and "The Silver Plough-Boy." Edelstein C45. With four poems by Williams: "Pastoral (The little sparrows)," "Pastoral (If I say I have heard voices)," "The Ogre" and "Appeal." Wallace C9.

A copy from Stevens's collection.

105 Others. An anthology of the new verse. Edited by Alfred Kreymborg. New York: Alfred A. Knopf, 1916.

8vo.; brown paper-covered boards, stamped in gold; dust-jacket.

First edition. Includes nine poems by Stevens: "Peter Quince at the Clavier," "The Silver Plough-Boy," "Six Significant Landscapes," "The Florist Wears Knee-Breeches," "Tattoo," "Song" ("There are great things doing"), "Inscription for a Monument," "Bowl" and "Domination of Black." Edelstein B6. With eight poems by Williams: "Pastoral (The little sparrows)," "The Ogre," "Pastoral (If I saw I have heard voices)," "Appeal," "Tract," "Touché," "To a Solitary Disciple" and "Stillness." Wallace B3, noting that all appear in *Collected Earlier Poems* except "Stillness," and that "Touché" is retitled "Sympathetic Portrait of a Child."

A copy from Stevens's collection.

106 Contact. 3 (Spring 1921).

8vo.; printed wrappers.

Third issue of Williams's influential journal, co-founded with Robert McAlmon, with both their names on the masthead. Including contributions by Williams: "Portrait of the Author," "Yours, O Youth," and "The Accident." Wallace C60, C61, C62. Along with "Lulu Gay" and "Lulu Morose" solicited from Stevens. Edelstein C68. Apart from Willliams, Stevens and McAlmon, the only other contributors are H.D., Kenneth Burke, Marsden Hartley and W. Bryher. McAlmon (1895-1956) and Williams co-founded the literary magazine *Contact*, which published five issues from December 1920 to

146

June 1923. The journal featured work by Williams and Stevens, but despite being inexpensively made (the first two issues were printed with a mimeograph machine on paper donated by Williams's father-in-law), it was not profitable, with a subscriber base of only 200 people and no advertising revenue. McAlmon abandoned the magazine and with his father-in-law's financial backing started his own publishing endeavor, Contact Publishing Company, also known as Contact Editions, which published Williams's *Spring and All* in 1923. In the same year he published Ernest Hemingway's first book *Three Stories and Ten Poems.* He also published books by Gertrude Stein, Ford Maddox Ford, Mina Loy and H.D. In 1932, Williams revived *Contact* with the help of the novelist Nathanael West, publishing three issues of poetry and fiction, with ads promoting upcoming releases from Contact Editions and books authored by other contributors. (See item #137, for an "Advertising Number" of *Contact* printing almost exclusively work by Williams.)

107 The Westminster Magazine. XXIII.3 (Autumn 1934).

 8vo.; orange printed wrappers; front cover detached.

Includes three poems by Stevens: "Gallant Chateau," "Gray Stones and Gray Pigeons," and "Polo Ponies Practicing." Edelstein C92. And three poems by Williams: "A Crystal Maze," "Young Woman at a Window (While she sits)," and "Young Woman at a Window (She sits with)." Wallace C206.

 George Oppen's copy, with his contribution – "Three Poems" – corrected in his hand. Oppen adjusted the text to fall into four poems instead of three, changing the title accordingly, inked out and rewrote a new version of the final line of the "I.b," and changed a word in "II."

108 Twentieth Century Verse. Nos. 12-13 (September-October 1938).

 8vo.; printed wrappers.

Includes Stevens's poem "Connoisseur of Chaos," and his answers to a three-question survey about American poetry the journal published after soliciting responses from a number of poets –Williams, Marianne Moore, Allen Tate and Mark Van Doren in addition to

Stevens. Edelstein C119 and C120. With Williams's response to the three-part survey as well. Wallace C263.

109 The Harvard Advocate. Wallace Stevens issue. CXXVII.3 (December 1940).

4to.; black and white printed wrappers.

A special issue featuring reprints of Stevens's poems as originally published in the Harvard *Advocate* while he was an undergraduate: "Three Poems (1940)" and "Thirteen Poems (1899-1901)." Edelstein C135. Includes Williams's tribute to Stevens in the section headed, "Statements about Wallace Stevens." Wallace C300. The volume also includes reflections on Stevens's work by other literary peers, including Allen Tate, Cleanth Brooks, Harry Levin, F.O. Matthiessen, Marianne Moore and Robert Penn Warren.

A copy from Stevens's collection.

110 View. Vol. II.3 (October 1942).

8vo.; printed wrappers.

Includes Stevens's "Materia Poetica" – which later appeared in *Opus Posthumous* as "Adagia." Edelstein C143. With Williams's "Advice to a Young Poet." Wallace C325.

111 Briarcliff Quarterly. William Carlos Williams issue. III.11 (October 1946).

8vo.; printed wrappers.

The first appearance of the title poem of Williams's 1949 chapbook (see item #186), accompanied by a musical setting of the text done by Celia Thaew, Louis Zukofsky's wife: "Choral: The Pink Church." Wallace C374. Signed "William Carlos Williams" on the cover and on the frontispiece portrait photograph. Includes a reproduction of Stuart Davis's frontispiece drawing in *Kora in Hell: Improvisations*. Mariani asserts that Williams intended this revolutionary poem about Russia, "his own version of Yeats's 'Second Coming,'" to be read as a post-Christian "celebration of the new social order that

was about to dawn."[52] The piece was rejected by *Partisan Review* and *Kenyon Review* before Norman MacLeod at *Briarcliff Quarterly* accepted it. Macleod was then married to Vivienne Koch, author of the first full-length book regarding Williams (see #188), who corresponded with both Williams and Stevens (see items #174 and #54).

When Williams's appointment to serve as Consultant in Poetry to the Library of Congress was rescinded in 1952, it was in large part due to perceived Communist leanings present in poems like "The Pink Church."

This volume also includes "Rubbings of Reality" by Stevens. Edelstein C167.

112　Partisan Review. XIV.3 (May-June 1947).

8vo.; printed wrappers, perfect bound.

First appearance of Stevens's "Three Academic Pieces," comprising one essay and two poems: "The Realm of Resemblance," "Someone Puts a Pineapple Together," and "Of Ideal Time and Choice." Edelstein C172. Signed by Stevens on p. 254 at the close of his piece. With "The Apparition" by Williams. Wallace C386.

Other contributors to this issue include Arthur M. Schlesinger, Jr., Delmore Schwartz, Mary McCarthy and Randall Jarrell.

113　Accent: A Quarterly of New Literature. VIII.1 (Autumn 1947).

8vo.; subscription card; printed wrappers.

With Stevens's poem "In the Element of Antagonisms." Edelstein C176. Williams is listed as a contributor to a previous issue (Spring 1946) in the notes in the back.

114　Quarterly Review of Literature. Marianne Moore issue. IV.2 (Summer 1948).

8vo.; printed wrappers.

Stevens and Williams both contributed essays to this special issue for Marianne Moore. Edelstein C181 and Wallace C393.

In his piece, "About One of Marianne Moore's Poems," Stevens

a philosophy paper titled "On Poetic Truth" by H.D. Lewis, which was published in 1946.

Williams's tribute is much more personal, and reads in part:

> The magic name, Marianne Moore, has been among my most cherished possessions for nearly forty years, synonymous with much that I hold dearest to my heart . . . [she has] talent which diminishes the tom-toming on the hollow men of a wasteland to an irrelevant pitter-patter. Nothing is hollow or waste to the imagination of Marianne Moore . . . I don't think there is a better poet writing in America today.

There is much bound-up in this excerpt. The first part is a fairly well known statement of Williams's regarding his feelings toward Moore. They met through the poet H.D. when Moore was at Bryn Mawr College and Williams, at the University of Pennsylvania. Williams had a deep and not particularly well-hidden antipathy toward T.S. Eliot – known as Tom – and his work and never lost an opportunity to express it. Given the straight-forward allusiveness to Eliot in the rest of the excerpt, the "tom-toming" is probably of a piece with that. And Eliot's well-known 1915 poem, "The Love Song of J. Alfred Prufrock" includes the following lines: "Inside my brain a dull tom-tom begins / Absurdly hammering a prelude of its own . . ." It should be noted that Stevens's *Man With the Blue Guitar* (1937) has the line, "Tom-tom, c'est moi / The blue guitar and I are one . . ." Perhaps he too was responding to Eliot.

115 Modern American Poetry. Focus Five. Edited by B. Rajan. London: Dennis Dobson, 1950.

> 8vo.; green cloth, stamped in blind and black; green topstain; dust-jacket.

First edition; 1500 copies. Prints the following poems by Stevens: "Credences of Summer," "Imago," "Celle Qui Fut Heaulmiette," and "St. John and the Back-Ache," as well as his responses to the four questions in "American and English Poetry: A Questionnaire." Edelstein B44. With these by Williams: "Perpetuum Mobile: The City," "The Pink Church," "The Sea Farer," "The Sound of Waves" and his

150

"The Pink Church," "The Sea Farer," "The Sound of Waves" and his reply to the questionnaire. Wallace B58.

116 Trinity Review. VIII.3 (May 1954).

4to.; printed wrappers.

This special issue celebrating Stevens on the occasion of his 75th birthday includes the first appearances of "Not Ideas about the Thing but the Thing Itself," written specially for this issue, and "The Rock." Edelstein C207. With an essay on Stevens by Williams. Wallace C494. And including work by T.S. Eliot, Marianne Moore and William Empson, among others.

This copy is signed by Stevens, John Malcolm Brinnin and Richard Eberhart at their contributions.

117 The Poet's Voice. Poets reading aloud and commenting upon their works. Selected and edited by Stratis Haviaras. Cambridge, MA: Harvard University Press, 1978.

Six audio cassettes within a 10 x 12" red plastic folder with printed material.

A portfolio set of six audio cassettes containing recordings – each about a half hour – of the following thirteen poets, reading between 1933 and 1970: Stevens, Williams, Marianne Moore, Theodore Roethke; T.S. Eliot, Ezra Pound; W.H. Auden, Robert Frost, John Berryman, Robert Lowell, Randall Jarrell, Sylvia Plath.

Together with a broadside prospectus - offering the set at $60. – and an eleven-page wrapped publication including an introduction by Stratis Haviaras, contextual notes for each poet's contribution and a list of the recorded poems.

Williams opens his 1951 session – which includes eighteen poems – with "Burning the Christmas Greens," and concludes with, "The Birth of Venus," reciting a number of more and less popular selections along the way.

Stevens's poems, recorded in October 1954, less than a year before his death, are "To the One of Fictive Music," "Not Ideas About the Thing but the Thing Itself," and "The Auroras of Autumn." Ste-

for the Woodbury Poetry Room at Harvard, his alma mater:

> I have always disliked the idea of records. And yet on the one oc-
> casion that I visited the Poetry Room in the new library at Cam-
> bridge there were a half dozen people sitting around with tubes
> in their ears taking it all in the most natural way in the world. . . .
> I'm not going to read any more, allowing for an exceptional case
> or two.

Haviaras, in his introduction, writes that "most of the poems ex-
ist in no other recording." He feels this recording project "offers
listeners the chance to hear the poets' own voices and thus to hear
their poetry as it sounded to them. Listening to . . . Williams Car-
los Williams' New Jersey accent . . . and Wallace Stevens' cautious,
businesslike speech, we are forcefully reminded of the importance
of voice in their works." Randall Jarrell had noted the same in his
introduction to the *Selected Poems of Williams Carlos Williams*:

> Williams' poems are full of imperatives, exclamations, trochees
> – the rhythms and dynamics of their speech are being insisted
> upon as they would not be in any prose: it is this insistence upon
> dynamics that is fundamental in Williams' reading of his own
> poems. You've never heard a Williams poem until you've heard
> him read it.

118 "Twentieth-Century Poets." Los Angeles, CA: United States
Postal Service. 2012.

First day covers, color cancels and a complete set of these com-
memorative postage Forever stamps (priced at 45 cents) depicting
ten American poets, among them Williams and Stevens, using
iconic images of each. The image of Stevens is by Sylvia Salmi;
that of Williams is without attribution. The promotional material
states,

> With the issuance of *Twentieth-Century Poets*, the U.S. Postal
> Service honors ten of our nation's most admired poets: Elizabeth
> Bishop, Joseph Brodsky, Gwendolyn Brooks, E. E. Cummings,
> Robert Hayden, Denise Levertov, Sylvia Plath, Theodore
> Roethke, Wallace Stevens and William Carlos Williams. The

many awards won by this illustrious group include numerous Pulitzer Prizes, National Book Awards and honorary degrees. Each stamp features a photograph of one of the ten poets. Text on the back of the stamp sheet includes an excerpt from one poem by each poet. The art director was Derry Noyes.

WILLIAM CARLOS WILLIAMS

NICOLE SEALEY William Carlos Williams:
Still Life with Poet

Language can either include or exclude. I prefer a language, a poetry, that does the former. Poems that preference meaningful communication – everyday speech coupled with common images – over ambiguity are, in my opinion, the most affecting. Such poems are invitations to readers rather than long arms holding us at bay. There's something to be said for simply saying *it* plain. Enter William Carlos Williams, a poet who translates and transforms the material world plainly and accurately.

Williams' work describes life itself, his life as a doctor in a small town, distilling it down to moments made more beautiful and more complex by the attention paid to the singularity of each and by their *everydayness*. As when artists paint still lifes, works of art that feature arrangements of inanimate objects as their immediate subject, Williams *wrote* still lifes – describing the mundane and contrasting the mundanity with unaffected, yet textured, language.

Once considered the lowest genre, the still life is to painting what some might argue *plainspokenness* is to poetry: unadorned and uncomplicated. There is, however, much beauty and much complexity in simplicity. Take, for instance, Pieter Claesz, the Dutch Golden Age artist who painted *vanitas*, still life paintings that suggest mortality, or Jean-Baptiste-Siméon Chardin, the 18th-century French painter who introduced the living thing to the still life, or Paul Cézanne, post-impressionist painter and master of perspective. All of whom painted the ordinary in an effort to examine our shared humanity.

While inanimate objects might lack breath, Williams, like a master painter, introduces life via emotion, via sentiment. As a reader and a writer of poetry, I want to feel deeply. I, however, don't want to be directed when or what to feel. Whereas sentimentality is curated, designed to elicit a specific response at a specific time – like say, the cued

music on live television shows that tells audiences when to clap or cry – sentiment is *real* feeling. When artists attempt to work *against* sentimentality, their work often lacks sentiment altogether. Fortunately, the poems of William Carlos Williams do not have this problem.

Williams embraces sentiment and, in so doing, pursues the truth of things – whether tangible, a wheelbarrow or plums, or abstraction, degradation and loss – with such precision that suggests Williams must have been as good a doctor as he was a poet. Williams admits to this pursuit in his poem "Cezanne," named for/after Paul Cézanne, excerpted below:

> . . . nothing can
> stop the truth of it art is all we
>
> can say to reverse
> the chain of events and make a pileup
> of passion to match the stars

And, make a pileup of passion to match the stars Williams did. Like vanitas, the work of William Carlos Williams speaks to life's transience. His poems are urgent and straightforward, as if to remind us that all things, like the plums referenced in "This is Just to Say," have a shelf life, an expiration date. Williams' "Complete Destruction" also explores loss, albeit in a less roundabout way. The loss of, not only the cat introduced in the second line, but also the fleas that once fed on the cat. While the fleas escaped the particular fate of their onetime host, they cannot escape the certainty of death. The poem reads,

> It was an icy day.
> We buried the cat,
> then took her box
> and set fire to it
> in the back yard.
> Those fleas that escaped
> earth and fire
> died by the cold.

According to Williams, there are "no ideas but in things," meaning ideas must be grounded in the everyday – not only access familiar

158

products of the collective imagination (see still life paintings of flowers, fruit, et cetera) – but also mirror common speech patterns. Even when Williams himself isn't the obvious speaker in the poems, his presence is felt throughout because of the conversational style – void of both artificiality and accoutrements. I'm thinking, specifically, of poems like "From a Window," "A Cold Front," "The Moral," "An Elegy for D. H. Lawrence" and, of course, no essay about Williams would be complete without it: "The Red Wheelbarrow," which reads:

> so much depends
> upon
> a red wheel
> barrow
> glazed with rain
> water
> beside the white
> chickens.

William Carlos Williams' poems manage to find the transcendental moments in daily life. This, I have no doubt, is one of the many reasons we'll return again and again to his work, to his plainspoken still lifes.

From the Library of
William Carlos Williams

"Willie" (who eventually became known to friends and family as Bill) was an introspective, imaginative child who fell in love with language at a young age. Both of his parents were born and raised outside the United States in multilingual, cultivated households. In his *Autobiography*, Williams credits his father, William George Williams, for stimulating his literary imagination by reading Shakespeare out loud to him when he was a little boy. Williams's mother, Elena, had studied art in Paris in the 1870s. Wallace Stevens noted in a letter to Vivienne Koch in early 1947 (item #54) that Williams's mother " . . . seems to account for a great deal in him." The house Williams grew up in contained many books in Spanish, French and English; both his parents were avid readers.

William George traveled often for work, spending long stretches in South America on business. Willie and his younger brother Ed were raised primarily by their mother, Elena, and her mother-in-law, the boys' paternal grandmother, Emily. The copy of Hans Christian Andersen's *Fairy Tales and Stories* inscribed by Elena to the boys seems to have stuck in Williams's mind: In a satirical letter lampooning British authors published in *The New English Weekly* in July 1932, he described Virginia Woolf as "more like some creature from Hans Christian Andersen's fairy tales than a human being."[53]

In 1897, Willie and Ed were enrolled by their mother at Château de Lancy, a boarding school in Geneva, while William George was on a year-long business trip in Buenos Aires. At the international prep school, the Williams brothers found themselves surrounded by boys from Europe, Russia, Asia and South America. The note from one teacher in his spelling textbook ("Finally, a notebook for your scribbles!") suggests that Williams was frequently writing or doodling in his classes (see item #122). He also loved exploring the campus in his free time, taking long walks and collecting flowers, such as

asphodels, the central image in his acclaimed poem "Asphodel, That Greeny Flower."

In the fall of 1898, after a year at Château de Lancy, the Williams boys went to the Lycée Condorcet in Paris, but they were insufficiently fluent. They withdrew from the school after a semester and were tutored privately by Elena's cousin, Alice, for the rest of the school year. The family returned to New Jersey in 1899, and after a dismal year at Rutherford Public High, the boys began commuting to New York to attend the prestigious Horace Mann school. Elena wanted her elder son to follow in the footsteps of her beloved brother Carlos and become a doctor, and so Williams was encouraged to focus on his science courses. Some of the friends Williams made at Horace Mann made lasting impressions, such as his friend Aegeltinger who frequently helped him with his math homework, and whom William remembered fondly in the poem "Aigeltinger."

Although Williams graduated from Horace Mann with a C average, he earned one of his few As from his favorite English teacher, William Abbott. In Abbott's class, Williams got his first real taste of formal poetry, studying Milton and Wordsworth. Williams's book *Selected Essays* is dedicated to Abbott, "the first English teacher who ever gave me an A."[54]

The copy of Alfred Kreymborg's *Mushrooms*, inscribed by Williams to his mother upon its publication in 1916, is significant for several reasons. Kreymborg was among the first to champion Williams's work, publishing his poetry in *Others*, the journal he founded in 1915 and which Williams became instrumental in helping edit and publish. Kreymborg was at the center of a circle of poets that included Stevens, Marianne Moore, H.D. and many others.

Other books included here hint at Williams's interests outside of poetry – for example, Edward Angly's *Oh Yeah?* is a wry critique of capitalism and political corruption. The themes of social justice and the economic hardships of the working class run throughout Williams's career, rising to the fore in such works as *Spring and All, An Early Matryr* and *Paterson II.* William Henry Hudson's memoir of his childhood in Buenos Aires, *Far Away and Long Ago: A History of My Early Life,* reflects Williams's obsession with documenting his own life, which is

an undercurrent in much of his work, from *Kora in Hell*, through to his *Autobiography* and *I Wanted to Write a Poem* (an oral biography comprising conversations he and Flossie had with journalist Edith Heal in the mid-1950s).

Cid Corman's *For Sure*, a presentation copy gifted to Williams and his wife just three years before Williams's death, marks an important literary friendship Williams cultivated late in his life. In the late 1940s, Sidney "Cid" Corman (1924-2004) started "This is Poetry," the first American radio program devoted to poetry. During the 15-minute weekly broadcast, Corman would read poems on air by his favorite living poets, which included Theodore Roethke, Robert Creeley and Marianne Moore. In 1951, after Creeley's failed publishing endeavor, Corman launched *Origin* (see item #194), a literary magazine that featured work by Stevens, Williams, and many others. Each issue was focused on one author, and the journal came to be very highly regarded, enjoying a long print run of 35 years.[55] Corman also started the publishing house Origin Press, which published, among other works, Louis Zukofsky's *"A"* in 1959, with an afterword by Williams (see item #204).

Many critics liken Corman's poetic style to Williams's, particularly his preference for simple idiomatic language and short lines. The two men, who met at Yaddo, corresponded frequently in the 1950s, discussing issues of craft and the purpose of poetry. Williams wrote an essay inspired by one of their lively exchanges: "On Measure – Statement for Cid Corman," which appeared first in *Origin* (Spring 1954) and was reprinted in Williams's *Selected Essays*. According to Paul Mariani, "it is clear that Corman engaged Williams's critical mind in a way that not even [Charles] Olson or Ginsberg did."[56]

119 Andersen, Hans Christian. Fairy Tales and Stories. Boston: Estes
 &Lauriat, 1887.

 8vo.; red cloth; stamped in black and gold; worn.

 First edition. A gift, inscribed by Williams's mother, Elena, on the
 front free endpaper: *For my dear little / children Willie and Edgar / from /
 Mamma.* With childish scrawls on the front endpapers.

120 Charles, Cecil. Honduras: The Land of Great Depths. Chicago
 and New York: Rand, McNally, & Company, 1890.

 12mo.; brown cloth, stamped in black and gold; decorated end-
 papers.

 First edition. A presentation copy, inscribed to Williams's father
 on the front endpaper: *W.G. Williams Esq. / with the compliments of the /
 Publishers. / May 10, 1892.* With his father's ownership stamp ("William
 George Williams / Rutherford / N.J.") on the front free endpaper.

121 Pendlebury, Charles. Examples in Arithmetic. Extracted from
 Arithmetic for Schools. Ninth edition. London: George Bell and
 Sons, 1896.

 12mo.; purple cloth, stamped in blind and gold; yellow endpa-
 pers; bookseller's ticket on front pastedown.

164

First edition. With Williams's ownership signature on the front pastedown: *Willie Williams. / 63.*

In 1897, 14-year-old William and his younger brother Edgar were enrolled at Château de Lancy, a boarding school in Geneva, while their father was on a year-long business trip in Buenos Aires. This math textbook is from this period – Williams put his assigned student number (63) in all of his school books. In 1899, the family returned to New Jersey, and William started school at Horace Mann in New York City as a sophomore.

122 Meiklejohn, J.M.D. The Spelling List: Being Ten Thousand Difficult Words Selected from Civil Service and Other Examination Papers with Fifteen Rules for Spelling. Third edition. London: Alfred M. Holden, 1897.

 12mo.; blue cloth, stamped in black; printed label affixed to cover.

Third edition. Williams's ownership signature ("Willie Williams") on the front endpaper, with a drawing of a hatchet with the numbers "6" and "3" carved into them. The label on the cover reads, "Spelling / Willie Williams / Château de Lancy." With a note from one of his teachers at Château de Lancy laid-in: "No. 63 / Bonheur / un cahier / de bruillon! / A.R. Green / 12.6.98" ("Finally, a notebook for your scribbles!").

123 Irving, Washington. Tales of a Traveler. New York: American Book Company, 1894.

8vo.; paper-covered boards, green cloth spine stamped in black; printed label to cover.

Volume from the Eclectic English Classics series. With Williams's ownership signature in pencil on the front pastedown: "William C. Williams / Desk 18 HIA / Exam." With a page of notes in Williams's hand inserted. The printed label on the cover reads, *William C. Williams / DESK No. 16, H.S.R. / Horace Mann School*.

124 Baker, Franklin T. Baker and Richard Jones. The Sir Roger de Coverley Papers from The Spectator. New York: D. Appleton and Company, 1899.

12mo.; tan paper-covered boards printed in green; olive green cloth spine stamped in gold.

First edition. Williams's ownership signature in pencil on the front endpaper: *W.C. Williams / Desk. 123 H.S.R.* With occasional bracketing of paragraphs and minor markings in the margins of some pages.

125 Coman, Katharine and Elizabeth Kimball Kendell. A History of England for High Schools and Academies. New York and London: The Macmillan Company, 1900.

8vo.; brown quarter-leather over navy cloth, stamped in gold.

First edition, second printing. With Williams's ownership signature: *William C. Williams*. With pencil notes in his hand on the front and rear pastedowns.

126 Kreymborg, Alfred. Mushrooms: A Book of Free Forms. New York: John Marshall, Co., Ltd., 1916.

 12mo.; green paper-covered boards, stamped in black.

First edition. A gift copy, inscribed by Williams to his mother on the front endpaper: *For Mother with love / from her son / Willie. / July 11-1916.* With a bookmark made from the corner of a letter to "Dear Cousin Helene" inserted.

127 Hudson, W. H. Far Away and Long Ago: A History of My Early Life. New York: E.P. Dutton & Company, 1918.

 8vo.; blue cloth, stamped in gold.

First edition, sixth printing. Signed, *William Carlos Williams.*

128 Angly, Edward, ed. Oh Yeah? New York: The Viking Press, 1931.

 12mo.; red cloth, stamped in black; dust jacket.

First edition. With Williams's ownership signature: *W.C. Williams.*

129 Corman, Cid. For Sure. Ashland, MA: Origin Press, 1960.

 16mo.; printed wrappers, sewn.

First edition. A presentation copy, inscribed: *For Bill / & Floss / with love / & respect / always / Cid Corman / Rutherford / October 1960.*

 This copy was given to Williams and his wife during a visit by Corman during which he read to Williams the complete text of Louis Zukofksy's *"A,"* as documented in an exchange of letters between Zukofsky and Williams a few weeks later. That volume, which Corman had published the prior year, contains a foreword by Williams.

By Williams

130 The Tempers. London: Elkin Mathews, 1913.

16mo.; tan paper-covered boards, stamped in gold.

First edition; 1,000 copies, the entire edition. Wallace A2. Signed by Williams on the front endpaper.

Williams's first publication was, in his word, "disastrous." In 1909 he and his father attempted to self-publish and locally distribute a book of poems, using a printer in Rutherford, NJ to produce 100 copies which were riddled with errors, yielding the scarce first "A" item in Wallace's bibliography – fewer than twenty copies survive in institutions, and only one has come to market in forty years (at that, it was sold twice).

Fast-forward four years: Williams's friend Ezra Pound came to the rescue. Elkin Mathews, the London press that had, by 1913, published four volumes of Pound's poetry (including *Ripostes* (1912), which is dedicated to Williams), agreed to publish *The Tempers* upon Pound's recommendation. Pound was very pleased with the end result; in his review for *The New Freewoman*, he praised Williams's authenticity and originality, writing that the poems were "distinguished by the vigor of their emotional colouring . . . the emotions expressed are veritably his own, wherever he shows traces of reading, it would seem to be a snare against which he struggles, rather than a support to lean upon."

The poems in this petite collection strongly reflect Pound's influence on Williams, and the emergence of Imagism in his work. The book is dedicated to his uncle on his mother's side, Carlos Hoheb, a surgeon who practiced in Puerto Rico, Haiti and Panama. Williams's Spanish lineage is further represented here in his translation of "El Romancero," excerpted from *Poesias Selectas Castellanas* (Madrid: Gomez Fuentenebro y Compañia, 1817), part of a four-volume series gifted to Williams by Pound.

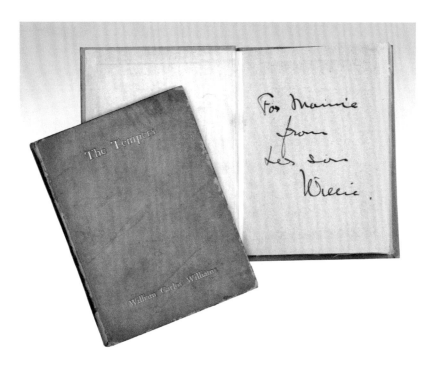

131 The Tempers. London: Elkin Mathews, 1913.

> 16mo.; tan paper-covered boards, stamped in gold; rear endpa-
> per notes ("348. 4cx.cx").

First edition; 1,000 copies, the entire edition. Wallace A2. A presen-
tation copy, inscribed to his mother-in-law on the front endpaper:
For Nannie/ from / her son / Willie.

 The Tempers, Williams's first commercially published book, came
out less than a year after he married Florence "Flossie" Herman; he
first courted her older sister, Charlotte, but she turned him down
and chose instead to be with his brother, Edgar. Williams and
Flossie kept their engagement a secret from Nannie for as long as
possible, knowing she would disapprove of the union. Up until
her death in 1949, Williams's relationship with his mother-in-law
remained strained; Nannie Herman had little respect for poetry and

she actively disliked Williams's friends, especially Ezra Pound. The money-hungry character of Gurlie Stecher, who appears in *White Mule, In the Money* and *The Build-Up*, was loosely based on Nannie.

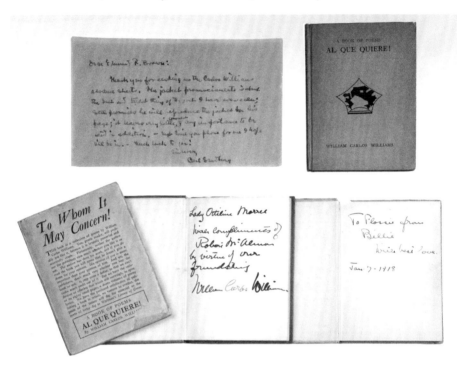

132 Al Que Quiere! Boston: Four Seas Company, 1917.

> 12mo.; yellow paper-covered boards, stamped in black; dust-jacket.

First edition; 1,000 copies, the entire edition. Wallace A3. A presentation copy, inscribed to his wife on the front endpaper: *To Flossie from / Billie / With best love. / Jan. 7 1918.*

Williams did not originally intend to marry Flossie (Florence) Herman, and when he proposed, he admitted he didn't love her; he didn't love anyone, he said, but thought that he and Flossie could be happy together. The marriage took place on December 12, 1912, a date (12/12/12) chosen for good luck. Flossie was only eighteen when she wed Williams and despite very rocky early years marred by his

infidelity, she stayed by him and was a continual source of inspiration – "The Cure," "The House" and "Asphodel, that Greeny Flower" are all dedicated to her.

In a letter to Marianne Moore dated February 21, 1917, Williams translates *Al Que Quiere!* as "To him who wants it," likening the Spanish phrase to "a Chinese image cut out of stone: it is decorative and has a certain integral charm." However, it "does not truly represent the contents of the book." Williams tells Moore he wants to add "The Pleasures of Democracy" as a subtitle, but "my publisher objects – and I shake and wobble."[57] Still, Williams was able to include a rather provocative statement on the dust-jacket, which reads in full:

> To Whom It May Concern! This book is a collection of poems by William Carlos Williams. You, gentle reader, will probably not like it, because it is brutally powerful and scornfully crude. Fortunately, neither the author nor the publisher care much whether you like it or not. The author has done his work, and if you do read the book you will agree that he doesn't give a damn for your opinion . . . And we, the publishers, don't much care whether you buy the book or not. It only costs a dollar, so that we can't make much profit out of it. But we have the satisfaction of offering that which will outweigh, in spite of its eighty small pages, a dozen volumes of pretty lyrics. We have the profound satisfaction of publishing a book in which, we venture to predict, the poets of the future will dig for material as the poets of today dig in Whitman's *Leaves Of Grass*.

Williams contributed $250 of his own money to offset publication costs, as he would for his next two books with the Four Seas Company (*Kora In Hell* and *Sour Grapes*). This provided the publisher with some security and Williams with more editorial control. In his autobiography, *I Wanted to Write a Poem* (Beacon Hill Press, 1958), he expresses slight dissatisfaction with the cover design:

> . . . [it] was taken from a design on a pebble. To me the design looked like a dancer, and the effect of the dancer was very important – a natural, completely individual pattern. The artist made the outline around the design too geometrical; it should have been irregular, as the pebble was."[58]

133 Al Que Quiere! Boston: Four Seas Company, 1917.

12mo.; yellow paper-covered boards, stamped in black; dust-jacket.

First edition; 1000 copies, the entire edition. Wallace A3. A presentation copy, inscribed on the front endpaper: *Lady Ottoline Morrel* [sic] / *With compliments of* / *Robert McAlmon* / *by virtue of our* / *friendship* / *William Carlos Williams.*

Lady Ottoline Morrell (1873-1938) was a well-known patron of literature and the arts who befriended a number of writers including Aldous Huxley, T.S. Eliot, Virginia Woolf and D.H. Lawrence. She was the inspiration for several characters in her friends' novels – not all of them flattering – most notably Lady Chatterley of Lawrence's *Lady Chatterley's Lover*, the plot of which parallels Morrell's affair with a stonemason doing work in her garden (Morrell and her husband had an open marriage).

For more on McAlmon and his significance as a colleague and publisher of Williams's work, see item #106.

134 Al Que Quiere! Boston: Four Seas Company, 1917.

12mo.; yellow paper-covered boards, stamped in black; browned.

First edition; 1,000 copies, the entire edition. Wallace A3. A presentation copy, inscribed on the front endpaper: *Bob Wetterau* / *from* / *Bill* / *(William Carlos Williams)* / *11/14/50.*

At the time of this inscription, Robert Wetterau ran the art book department at Flax in Los Angeles and also contributed a book review column for *Art & Architecture*. After Williams and Wetterau had been corresponding for years, in November of 1950 Williams made his first trip out to California, where he gave a poetry reading at UCLA among other West Coast universities on this trip. On November 16, two days after inscribing this book, Williams attended a party Wetterau threw in his honor. Williams recalled the event fondly in his autobiography: "That was a good party at Flax. I read to five ladies in the corner. Anaïs Nin was there and Man Ray and his wife."[59] Williams inscribed a copy of *A Dream of Love* to Man Ray at that event (see item #176).

135 Sandburg, Carl. Autograph letter to Edmund R. Brown, signed, "Carl Sandburg," ca. 1917.

> Half leaf; one page.

Sandburg acknowledges receipt of advance sheets for *Al Que Quiere!* The undated letter reads in full:

> Thank you for sending me the Carlos Williams advance sheets.
>
> The jacket pronouncement is about the best and truest thing of the sort I have ever seen; Sell promises he will reproduce the jacket on his page; it leaves very little comment of any importance to be said in addition. Next time you phone for me I hope I'll be in. Much luck to you!
>
> Sincerely,
> Carl Sandburg

Three-time Pulitzer Prize-winning poet and editor Carl Sandburg (1878-1967) wrote Imagist poems in the same vein as Williams; his poem "Fog" is often cited along with Williams's "The Red Wheelbarrow" as the prototypical examples of the style. Sandburg and Williams, along with Yeats, Eliot, Kreymborg and Pound, were included in *Catholic Anthology* (Elkin Mathews, 1915), and in *American Decade* (Cummington Press, 1943), which also included poems by Stevens. The most famous connection between the two men, however, is less collegial: Williams famously penned a scathing review of Sandburg's *Complete Poems* that appeared in the September 1951 issue of *Poetry*.

Edmund R. Brown (1888-?) was president of the Four Seas Publishing Company in Boston, which published *Al Que Quiere!*, *Sour Grapes* (1921), and *Kora in Hell* (1920). Brown also served as editor for *Poetry Journal*, which published two poems by Williams in their December 1916 issue.

136 Kora in Hell: Improvisations. Boston: Four Seas Company, 1920.

> 8vo.; gray paper-covered boards stamped in black.

First edition; 1,000 copies, the entire edition. Wallace A4a. A presentation copy, with a lengthy inscription on the front endpaper to choreographer and modern dancer Martha Graham: *Martha Graham*

/ With best wishes / William Carlos Williams / June 8 '38 / I'm afraid this is / rather old stuff now. / I picked it out to give you, / though, because of a feeling / for the dance I seem to / remember in it. / W.

Williams inscribed this copy to Martha Graham (1894-1991), who modeled her provocative 1938 piece "American Document" after *In the American Grain*. Williams gave her permission to use his title, but Graham ultimately decided to come up with her own. Graham, like Williams, was upset by the rise of fascism and felt compelled to politicize her work to promote the ideals of American democracy. During performances of "American Document," a text compiled from various historical sources (including the Declaration of Independence and the Emancipation Proclamation) was recited by a narrator as a large cast of dancers interpreted the words with their bodies. In his review, *New York Times* dance critic John Martin called the production "as successful a combination of speech and movement as any that has yet been made."[60] Williams sent this copy to Graham upon receipt of her address from his friend Eleanor Scully (for the letter in which he requests her address, see item #160).

Dedicated to Flossie, *Kora in Hell: Improvisations* contains a year's worth of Williams's daily musings, which he claimed in his autobiography he did not at all edit (though he did confess to "tear[ing] up some of the stuff").[61] About the cover design, he said that it "represents the ovum in the act of being impregnated, surrounded by spermatozoa, all trying to get in but only one successful." The frontispiece illustration was done by the modernist painter Stuart Davis, and Williams felt his drawing captured "an impressionistic view of the simultaneous."[62]

137　Contact. "St. Francis Einstein of the Daffodils," "The Three Letters," and "Comment," pp. 2-4, 10-13, 18-19. No. 4 (Summer 1921).

8vo.; printed wrappers.

"Advertising Number" of *Contact*, with both Williams and McAlmon listed on the masthead but primarily "advertising" Williams, his work and the role of *Contact* as his agent:

> Henceforth the writings of Williams Carlos Williams will be offered for sale at prices fixed by the author. Prospective purchasers will apply through CONTACT which at present is the sole agent. A minimum price of fifty dollars will be charged for all poems, those of most excellence, as in all commercial exchange, being rated higher in price. Critical essays, imaginative prose and plays will be offered at prices varying according to the length and success of the work. The artist will however continue to contribute his work gratis to whatever publication, in his own opinion, furthers the interests of good writing in the United States. (p. 2)

Including contributions by Williams: "St. Francis Einstein of the Daffodils" (a revised version is in *Literary American*, New York, I.3 (July 1934); "The Three Letters" (preliminary sketch for a chapter of *A Voyage to Pagany*); and "Comment" (an editorial about *Contact* and American art). Wallace C64, C65, C66. Most of this issue, if not by Williams (and one piece by McAlmon), relates to Williams. Marianne Moore reviews at length *Kora in Hell* (pp. 5-8), and an excerpt from John Gould Fletcher's review also appears (albeit with Fletcher's name upside-down) under the heading, "The Italics Are God's."

The issue opens with Ezra Pound's review of *Credit Power and Democracy* by Maj. C. H. Douglas, and also includes a poem by Kenneth Burke ("Ver Renatus Orbis Est") and one by Alva N. Turner ("To Two Motherless Kittens").

138　Sour Grapes: A Book of Poems. Boston: Four Seas Company, 1921.

Small 8vo.; green paper-covered boards; title label pasted to spine; dust-jacket.

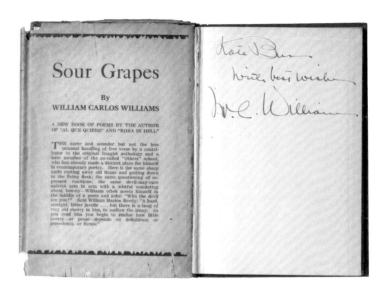

First edition; 1,000 copies, the entire edition. Wallace A5. A presentation copy, inscribed on the front endpaper: *Kate Buss / with best wishes / W.C. Williams.*

In *I Wanted to Write a Poem*, Williams had this to say about *Sour Grapes* to biographer Edith Heal:

> This is definitely a mood book, all of it impromptu. When the mood possessed me, I wrote. Whether it was a tree or a woman or a bird, the mood had to be translated into form. To get the line on paper. To make it euphonious. To fit the words so that they went smoothly and still said exactly what I wanted to say. That is what I struggled for. To me, at that time, a poem was an image, the picture was the important thing. As far as I could, with the material I had, I was lyrical, but I was determined to use the material I knew and much of it did not lend itself to lyricism.[63]

Kate ("Kitty") Buss (1879-1943) became acquainted with Williams through her associations with Gertrude Stein and Alfred Kreymborg, who founded *Others: A Magazine of New Verse*, a Modernist literary journal that published early poems of both Williams and Stevens during its four-year print run (1915-1919). Buss, originally

from Massachusetts, was a journalist for the *Boston Evening Transcript* who spent time with Stein, Hemingway and other expats in Paris in the 1920s.

139 Autograph letter to Kate Buss, signed, "W.C. Williams," Rutherford, NJ, September 5, 1923.

Two leaves of William Carlos Williams, M.D. letterhead, 4 pages.

A lively letter that covers several topics, all related to the experimental Three Mountains Press in Paris. First, Williams hilariously responds to Buss's request to include a photograph of him in the *Boston Evening Transcript*. He writes,

> To have my photo appear in the Boston Transcript would by comparative importance so diminish the value of any scribbling I may have done in my poor life that – no, <u>that</u> must not <u>be</u>. If someone would only do me a portrait bust in trap-rock, yes.

Next, Williams addresses another request from Buss, for copies of some Three Mountains Press titles, apologizing for not being able to provide them. He does, however, offer to let her borrow his personal copies:

> I'll tell you what I'll do: I'll <u>lend</u> you copies of the books (of which in two cases I have only the one copy) for a week or two. But I must first have your word on it that you will promptly return these precious trifles when you have read them two or three times. Will you be so kind as to give me this assurance at once when I will mail the books instantly. Sorry to be so fussy but the God damned custom house is the cause – I guess.

Williams concludes the letter with five numbered items touching on a variety of subjects, including Ford Madox Ford's name change (from Ford Madox Hueffer, which Williams suspects sounded "too foreign"), Pound's role as the "literary godfather" of Three Mountains (but not its financier), and the regrettable fact that Williams's recent book with the Three Mountains Press, *The Great American Novel*, is not being sold in Boston ("... a pity ... mine has the words "Shit" and "Screw" in it").

140 The Great American Novel. Paris: Three Mountains Press, 1923.
 8vo.; bound signatures.

Unnumbered review copy, stamped on the half-title (which stands
in for a cover of this copy); one of surely just a handful of early cop-
ies. Wallace A6.

 In August of 1922, Pound wrote to Williams from Paris about
a limited edition series of prose booklets he was supervising for
Three Mountains Press. He invited Williams to submit work,
something in the vicinity of 50 pages, and Williams sent *The Great
American Novel*, which he described as "[a] satire on the novel form,
in which a little (female) Ford car falls in love with a Mack truck."[64] It
came out the following year, and was later reprinted in the anthol-
ogy *American Short Novels* (Princeton University/Thomas W. Crowell
Co., 1960) along with works of fiction by Gertrude Stein, Herman
Melville, Stephen Crane, Mark Twain and Henry James.

 Three Mountains Press was founded by Bill Bird and intended as
a joint endeavor with Robert McAlmon's Contact Editions: Three
Mountains would handle printing operations, and Contact, the
publishing business. But the distinction was never really solidified,

178

with Bird and McAlmon eventually sharing space in Paris and using both monikers interchangeably. In addition to publishing *The Great American Novel*, they also published Williams's *Spring and All* (1923), Pound's *Indiscretions; or, Une revue de deux mondes* (1923), Hemingway's *Three Stories and Ten Poems* (1923) and *in our time* (1924), and other slim volumes by American writers living abroad.

141 **The Great American Novel.** Paris: Three Mountains Press, 1923.

> Small 4to.; unopened; tan paper-covered boards, green cloth spine; printed title label to spine.

First edition; one of 300 copies printed on handmade paper (this is copy #262). Wallace A6.

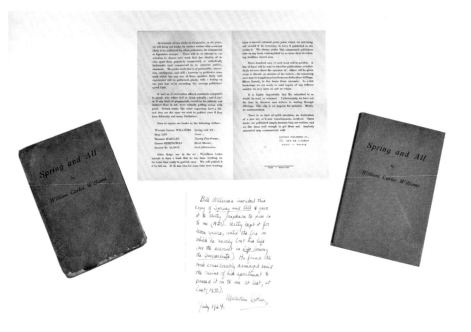

142 **Spring and All.** Paris: Contact Publishing Company, 1923.

> Small 8vo.; printed wrappers with flaps, sewn.

First edition; fewer than 300 copies. Wallace A7. Signed by Williams on the front endpaper.

One of the least disseminated of Williams's major works at the time of its publication; Wallace approximates only 300 copies were printed, but likely fewer were distributed. According to Williams, "Nobody ever saw it – it had no circulation at all – but I had a lot of fun with it."[65]

Like *Kora in Hell: Improvisations*, *Spring and All* blends poetry and prose; the poems were first numbered, then later given titles in brackets, and interspersed with prose passages. Some of the section headings were intentionally printed upside down, and Williams used both roman numerals and Arabic numbers, resulting in a text that is unconventional in its aesthetics as well as its ideas. *Spring and All* is dedicated to Williams's close friend, artist Charles Demuth (1883-1935), whose 1928 painting "I Saw the Figure 5 in Gold" was inspired by Williams's poem "The Great Figure" from *Sour Grapes*. The book also contains the first appearance of one of Williams's most famous poems, "The Red Wheelbarrow."

143 Spring and All. Paris: Contact Publishing Company, 1923.

 8vo.; green printed wrappers with flaps, sewn; considerable charring and fire-damage.

Together with:

Autograph note signed, "Malcolm Cowley," July 1964.

 Bifolium; one page.

First edition; fewer than 300 copies. Wallace A7. A presentation copy, inscribed on the front endpaper: *Malcolm Cowley / from / W.C. Williams / 1923*. With a note from Cowley, detailing the volume's provenance and explaining its condition.

This copy was inscribed six years before Malcolm Cowley (1898-1989) landed the role of assistant editor for *The New Republic*, which published a number of poems by Williams and Stevens in the fifteen years of Cowley's tenure. In 1920, one year after finishing college at Harvard, he moved to Paris for a fellowship, where he spent time with other expatriate writers and scholars. He documented those years in his 1934 book *Exile's Return*, now considered one of the definitive profiles of the "Lost Generation."

After Cowley joined *The New Republic*, his literary friendships became slightly strained because of his influential editorial position. When Philip Horton wrote a negative review in its pages of Williams's *Complete Collected Poems 1906-1938*, Cowley published Williams's caustic response in the Letters to the Editors section of the January 1939 issue, which reads in part: "I'm not important but I'm not insignificant . . . if he hadn't had Stevens to teach him how to look crookedly he wouldn't have had anything at all to say. Tell him to go wipe his nose."[66]

Cowley explains the provenance of this copy in the signed note, dated July 1964, which reads in full:

> Bill Williams inscribed this copy of <u>Spring and All</u> *&* gave it to Matty Josephson to pass on to me (1923). Matty kept it for seven years until the fire in which he nearly lost his life (see the account in <u>Life Among the Surrealists</u>). He found the book considerably damaged amid the ruins of his apartment *&* passed it on to me at last (1930).

144 **Spring and All**. Paris: Contact Publishing Company, 1923.

> Small 8vo.; unopened; printed wrappers with flaps; torn at spine; sewn.

First edition; fewer than 300 copies. Wallace A7. With the Contact Publishing bifolium pamphlet loosely inserted.

145 **Go Go**. New York: Monroe Wheeler, 1923.

> 12mo.; printed wrappers.

First edition; 150 copies, the entire edition; Manikin Number Two. Wallace A8. A presentation copy, inscribed on the front endpaper: *Milton E. [sic] Abernethy / With the greatest / appreciation for / his kindness to / me. / William Carlos Williams.*

Monroe Wheeler (1899-1988) began printing poetry chapbooks under the Manikin Press imprint in 1920. A publisher's note on the verso of the last leaf of *Go Go* explains the imprint's name, metaphorically suggesting that a book of poems reflects the human condition like a mannequin mirrors anatomical form: "MANIKIN

– A model of the human body, showing the tissues, organs and skeleton, commonly in detachable pieces." Manikin Three featured new verse by Marianne Moore. Nine of the ten poems in *Go Go* first appeared in *Spring and All*; the chapbook contained only one new poem: "The Hermaphroditic Telephones."

Milton A. Abernethy (1911-1991) was one of the founding editors of the literary magazine *Contempo*, which published work by Williams, Pound, Faulkner, Joyce and others from 1931 to 1934. The April 1932 issue featured Williams's poem "The Cod Head" as well as his review of cummings's *Viva*; Williams also reviewed Hart Crane's *White Buildings* for the journal for the July 1932 issue, and Nathanael West's *Miss Lonelyhearts* for the July 1933 issue (a review titled "Sordid? Good God!"). While running *Contempo*, Abernethy also operated a bookstore called The Intimate Bookshop in Chapel Hill, and reportedly sold copies of *The Communist Manifesto* for ten cents apiece.

146 In the American Grain. New York: Albert & Charles Boni, 1925.

8vo.; black cloth, stamped in gold; dust-jacket.

First edition; number of copies unknown. Wallace A9. A presentation copy, inscribed on the front endpaper: *Doc Pleasants / From his friend / Doc Williams / American, early / and late.*

"Doc Pleasants," a.k.a. Henry Pleasants (1910-2000), was a music critic who is mentioned in a few of Williams's letters to his friend and fellow poet Louis Zukofsky. The correspondence, from October-November 1934, concerns a project that never came to fruition and strained their friendship: an opera based on George Washington's life, as recounted by Williams in *In the American Grain*.

Zukofsky sought Pleasants's advice after creative differences between Williams and the composer, Tibor Serly, brought the project to a halt. However, Pleasants's input only exacerbated the already tense situation. On November 14, 1934, Williams wrote to Zukofsky, "I'm inclined to think Dr. Pleasants may have a few helpful suggestions to offer if they are offered with proper humility and proper regard for the composition we have in hand. But if we are to have a

new opera now, he'd better write it himself . . . now, if Dr. Pleasants wants to pick out all the operatic characters of the Revolutionary period and scramble them up to make a spectacle, OK with me but to hell with it."[67] Zukofsky and Williams did eventually make amends – Williams dedicated *The Wedge* to him in 1944.

This was Williams's first book with a commercial press. A statement printed on the front of the dust-jacket explains Williams's intention and reads in part:

> In these studies I have sought to rename the things seen, now lost in the chaos of borrowed titles, many of them inappropriate, under which the true character lies hid. In letters, in journals, reports of happenings I have recognized new contours suggested by old words so that new names were constituted. Thus, where I have found noteworthy stuff, bits of writing have been copied into the book for the taste of it . . . it has been my wish to draw from every source one thing, the strange phosphorus of the life, nameless under an old misappellation.

The prose volume is a textual collage that seeks to map out American identity across nearly four centuries, beginning with the discovery of the New World and ending with a chapter on Abraham Lincoln. In a letter to Horace Gregory dated July 22, 1939, Williams reflects on his inspiration for the book, writing that despite being of "mixed ancestry," he "felt from earliest childhood that America was the only home" he could call his own: "I felt that it was expressly founded for me, personally, and that it must be my first business in life to possess it; that only by making it my own from

the beginning to my own day, in detail, should I ever have a basis for knowing where I stood."[68]

In the American Grain garnered admiration from a number of prominent artists – Alfred Stieglitz told Williams the book helped him come up with the name of his Madison Avenue photography gallery (An American Place) and Martha Graham wrote that the text had been instrumental in creating one of her signature choreographed pieces, "American Document." New Directions eventually acquired the distribution rights and issued multiple later printings (1939, 1948, 1956, 1964) as well as a revised edition (1966).

147 A Voyage to Pagany. New York: Macaulay, 1928.

8vo.; brown cloth, stamped in brown and black; dust-jacket.

First edition of Williams's "first serious novel" (*I Wanted* 45); number of copies printed unknown. Wallace A10. Dedicated to Ezra Pound: "To / the first of us all / my old friend / Ezra Pound / this book is affectionately / dedicated."

The protagonist of *A Voyage to Pagany*, Dr. "Dev" Evans, bears a striking resemblance to Williams himself. A New Jersey doctor with poetic sensibilities, Evans travels through Pagany, a region Williams invented to stand in for Europe, in search of inspiration. Williams wrote the book a few years after taking a one-year sabbatical from his medical practice, six months of which were spent touring Italy and France with Flossie. The pictorial dust-jacket was designed by Williams's brother, Edgar.

According to Williams, the publisher felt the manuscript was too long, so Williams cut out a chapter titled "The Venus," which he included in his next collection, *A Novelette and Other Prose.*[69]

148 A Novelette and Other Prose. Toulon: TO Publishers, 1932.

8vo.; green paper-covered boards, stamped in black.

First edition; number of copies unknown. Wallace A12. Includes "January: A Novelette" and thirteen essays and stories, many of which first appeared in periodicals. In a letter to Louis Zukofsky dated January 25, 1929, Williams writes, "While tearing around tend-

ing the sick I've composed a Novelette in praise of my wife whom I have gotten to know again because of being thrown violently into her arms and she in mine by the recent epidemic – though not by illness of either of us, quite the contrary."[70] Williams is referring to the influenza epidemic that killed more than 50,000 people in the U.S. during the winter of 1928-1929.

A group of Objectivist poets living in Paris, including Zukofsky, comprised the curiously named TO Publishers (later known as The Objectivist Press). In a copy of *A Novelette and Other Prose* inscribed to Gertrude Stein, Williams apologized for the numerous typographical errors (including the misspelling of author Logan Clendening, whose book *The Human Body* Williams reviewed – in the book, it is spelled "Clanending"). The volume contains essays on the work of Stein, Joyce and Marianne Moore among others.

149 **The Knife of the Times and Other Stories.** Ithaca: Dragon Press, 1932.

8vo.; teal cloth; title labels to cover and spine; dust-jacket.

First edition; 500 copies, the entire edition. Wallace A13. A presentation copy, inscribed on the front endpaper: *Betty Stedman / good readin' / William Carlos Williams. / 4/29/50.*

This copy belonged to Elizabeth "Betty" Stedman, a nurse and acquaintance of Williams at Passaic General Hospital. Stedman shared a funny letter with Williams written in 1935 or 1936 by Florence Plarey, a neighbor who volunteered to watch the Stedmans' dog while they were away. When they returned, they discovered the dog was pregnant; Plarey was evasive when questioned by Betty, but later admitted a failure of oversight might have resulted in their pooch's delicate condition.[71] This amusing story made its way into a prose passage in *Paterson*. Williams inscribed at least one other book to Stedman: a copy of *Life Along the Passaic River* (see item #162).

The Knife of the Times and Other Stories was published with the help of Angel Flores, whom Williams referred to as "a good friend" in Ithaca in a letter to Marianne Moore dated June 2, 1932.[72] In his biography of Williams, Mariani tells of their brief, somewhat odd, collaboration: Four weeks after Williams sent him the manuscript,

Flores sent him proofs back, promising bound copies within two weeks. This speed made Williams a little uneasy; he described it as "too like lightning for comfort," but the book did come out when Flores said it would, in March of 1932. However, Flores did nothing to promote the book and very few copies were sold. When a colleague contacted Williams in 1935 after coming across a bunch of copies for sale (for fifteen cents apiece) on the boardwalk in Atlantic City, Williams asked him to buy all of them and send them to him.[73]

The volume includes eleven stories, only one of which had been previously published ("The Colored Girls of Passenack, Old and New"). The title story features a compassionate depiction of a lesbian relationship; "the knife of the times" refers to the struggles the two women face in a society that shames them for their sexuality. The final story, "Old Doc Rivers," is, according to Mariani, "a minor masterpiece."

150 The Cod Head. [San Francisco]: Harvest Press, [1932].

 Bifolium; four pages.

Together with:

The Cod Head. [San Francisco]: Harvest Press, [1932].

 8vo.; bifolium; green wrappers, stapled; printed label to cover; Kamin Bookshop label pasted inside rear wrapper.

Proof pull variant and first edition. Wallace A14, for the first edition. The proof pull, which is unsigned and includes neither the city nor year on the cover, bears the following colophon: "100 copies only printed at The Harvest Press for the friends of Milton Arbernethy" [*sic*]. The first edition, signed at the close of the poem, bears the following colophon: "125 copies only printed at The Harvest Press for the friends of Contempo: Chapel Hill, N.C."

In his preface to *Collected Poems 1921-1931*, Stevens mentions *The Cod Head*, published as a standalone poem, as evidence of Williams's interest in the juxtaposition between "the sentimental and the anti-poetic." Williams bristled at this characterization, insisting that he never intentionally tried to be anti-poetic: "I was pleased

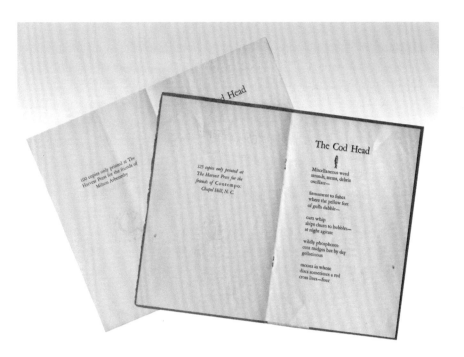

when Stevens agreed to write the Preface but nettled when I read the part where he said I was interested in the anti-poetic. I had never thought consciously of such a thing."[74]

Kenneth Burke, writing in June of 1963 for the *New York Review of Books*, unpacks Stevens's comments about *The Cod Head*, noting that Stevens most likely considered sentimental Williams's tendency to use animal imagery to illustrate human attributes. Burke also speculates that Stevens found the "neat abruptness" of Williams's enjambment anti-poetic, or intentionally unlyrical.[75]

151 Collected Poems 1921-1931. New York: The Objectivist Press, 1934.

8vo.; crimson cloth; printed spine label; dust-jacket.

First edition; 500 copies, the entire edition. Wallace A15. With a preface by Wallace Stevens.

The first book appearance of a number of notable poems, including the iconic "This Is Just to Say" and "Poem (as the cat)." Williams is listed on

the dust-jacket as a member of the Objectivist Press Advisory Board, along with Pound and Zukofsky. All poems were included in *Collected Early Poems*, although some were retitled and "Full Moon" was lengthened by ten lines. The idea of collecting his poems was "a lovely gesture" and Williams said he was "deeply moved by it," though "needless to say, it didn't sell at all."[76]

152 Bunting, Basil. Annotated typescript: "William Carlos Williams's Recent Poetry." 1934.

> Five typescript leaves; author/title in autograph on the first page, with a few minor emendations throughout.

One of the earliest assessments of Williams's work, written by the noted English poet and critic, who at the time of its composition was a disciple of Ezra Pound and was living in Italy in Rapallo to be close to Pound. It appeared in *Westminster Magazine*, XXIII.2 (Summer 1934), 149-54.

Bunting's language is quite extraordinary: "One of the uses of poetry is to give a design to things the gods have left lying about in slovenly piles." He describes Williams's work as "eminently graceful, moving easily, even nimbly, as its arrangement on the page proclaims. It parades no demi-divine authority." He adds, "The self-appointed adjudicators on the New York

York middle class-moron weeklies are not likely to grant it much."

At a point in time when Williams was not widely recognized for his poetry, Bunting asserts that "Nobody else has taken America for a permanent subject," and, "He is like Yeats, a national and nation-making poet.

> None of his poems is long enough to get bewildering. . . . Williams is readily visible: if not at the first glance, at the second or third for sure. . . . the separate poems, or nearly all of them, are ready to unite at the right focus into the unfinished and unfinishable design of their common theme, America.

He concludes, declaring Williams,

> one of the less than a dozen poets now writing who have a reasonable certainty of literary longevity and whose work repays study . . . He is the most direct of the first-class poets now writing and his versification, within its chosen limits, that of an acknowledged master.

153 An Early Martyr and Other Poems. New York: Alcestis Press, 1935.

8vo.; cream printed wrappers; unprinted glassine dust-jacket.

First edition; one of 165 copies signed by Williams at the colophon, this one is signed but unnumbered. Wallace A16.

Dedicated to social activist John Coffey, the "early martyr" who was incarcerated, without due process, in the Matteawan State Hospital for the Criminally Insane. Coffey was arrested in 1920 for stealing from department stores, reselling the goods (mostly fur coats) and giving the proceeds to charities. He received no trial and was not allowed to testify on his own behalf. Williams visited Coffey when he was in the mental institution and tells his story in the five-stanza title poem of this collection, which also includes the frequently anthologized poem, "The Yachts."

Williams first defended Coffey in an article titled "A Man Versus the Law" published in *The Freeman* on June 23, 1920 (Wallace C50). He argued that Coffey was not insane and had been wrongfully imprisoned. Though sentenced for life, Coffey was released into the care of his brother in the mid-1930s due to overcrowding in the hospital. Williams may have written "An Early Martyr" in 1920 when Coffey was first sentenced; in *I Wanted to Write a Poem*, Flossie recalls that *The Freeman* paid Williams for the poem, but then decided it was too risky, and published the article instead.[7]

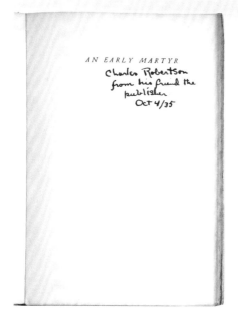 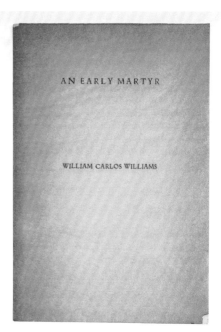

154 An Early Martyr and Other Poems. New York: Alcestis Press, 1935.

 8vo.; cream printed wrappers; unprinted glassine dust-jacket.

First edition; one of 135 copies numbered and signed by Williams (this is #127), 165 copies the entire edition. Wallace A16. Inscribed by the publisher Ronald Lane Latimer on the half-title: *Charles Robertson / from his friend the / publisher / Oct 4/35.*

 An Early Martyr and Other Poems was priced by Latimer at $7.50 – an almost unheard of sum to charge for a book of poetry, but necessary to cover the cost of printing on exquisite handmade Italian paper. In the year it was published, only eight copies were sold, much to Williams's disappointment.

 In corresponding with Williams about Latimer in 1936, Stevens expressed sympathy for Williams's frustrations with the eccentric publisher, agreeing that with Latimer, "there is something wrong in the woodpile." Williams was especially outraged about a sloppy set of galleys in which a missing tilde on a Spanish word (anos instead of años) resulted in an unfortunate error: "Since he had five assholes" instead of "Since he was five

years old."[78] Williams recalled his collaboration with Latimer more kindly in his autobiography, writing that Latimer published *An Early Martyr* "superbly, lavishly" and allowed him to do his next book, *Adam and Eve and the City*.[79]

For more on the Robertson/Latimer relationship, see copies of *Owl's Clover* (item #28) and *Adam and Eve and the City* (item #156) also inscribed to him.

155 Alcestis: A Poetry Quarterly. "Fine Work with Pitch and Copper," p. 15. I.4 (July 1935).

8vo.; printed wrappers.

First appearance of Williams's poem "Fine Work with Pitch and Copper," which appeared in book form a year later in *Adam and Eve and the City*. Wallace C230.

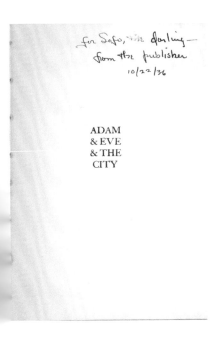
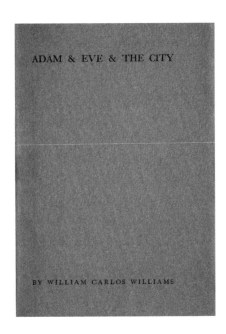

156 Adam and Eve and the City. Peru, VT: Alcestis Press, 1936.

8vo.; olive printed wrappers with flaps; cardboard slipcase.

First edition; one of twenty signed copies numbered in roman numerals (this is copy V); 167 copies, the entire edition. Wallace A17. Another from the collection of Charles Robertson, inscribed to him by the publisher, Latimer, on the half-title: *Ex Libris Charles Robertson - / from his friend / the publisher / 10/23/36.*

For more on the Robertson/Latimer relationship, see copies of *Owl's Clover* (item #28) and *An Early Martyr* (item #154) also inscribed to him.

Dedicated to Flossie Williams ("To my wife"). Williams viewed the book as a companion to *An Early Martyr*, with "Adam" and "Eve" intended as "tributes to my father and mother."[80] Includes the poem "Fine Work with Pitch and Copper," which Latimer had first published in *Alcestis* in July of 1935, and a partial early draft of what would become the epic five-volume *Paterson*, titled "From the Poem 'Patterson' [*sic*]". Of the book, Williams had this to say: " . . . in '36 Latimer brought out my *Adam and Eve and the City*. But still nothing sold. I think Latimer did a Stevens book before he went broke and quit."[81]

It is probably fair to say that Williams knew full well the extent and depth of Stevens's relationship with Latimer.

157 Adam and Eve and the City. Peru, VT: Alcestis Press, 1936.

8vo.; olive printed wrappers with flaps.

First edition; one of 135 numbered signed copies (this is copy #9); 167 copies, the entire edition. Wallace A17. Inscribed by the publisher Ronald Lane Latimer on the half-title: *For Sofo, ["the" rubbed out] darling - / from the publisher / 10/22/36.*

158 White Mule. Norfolk, CT: New Directions, 1937.

8vo.; white cloth, stamped in black; dust-jacket.

First edition; 1,100 copies, the entire edition. Wallace A18. A presentation copy, inscribed on the front endpaper: *Miriam + Kenneth Patchen / With best wishes / William Carlos Williams. / July 19, 1951.*

Williams's first book with New Directions, the publishing house that henceforth handled the majority of his books and whose name is still associated with him. *White Mule* was a critical – and by Williams's standards, commercial – success. Williams was grateful that James Laughlin, the publisher, was willing to cover printing and distribution costs, and to offer

Williams a share of the profits since he had previously had to put up his own money to fund his publications. Williams wrote to Zukofsky on July 18, 1937 that the book was "selling slowly . . . but if it pays for itself I'll get another book and so it has always gone with me. It wouldn't be healthy at my age to burst suddenly into blatant bloom."[82]

A novel about babies (specifiically, Flossie's babyhood) and dedicated "to the Kids," *White Mule* did sell well enough to necessitate a second printing in December of 1937 of an additional 1,000 copies; it was reissued again with *In the Money* in 1945, and clothbound and paperback editions came out in 1967.

Kenneth Patchen (1911-1972) was a poet and novelist who, like Williams, was closely connected to New Directions, which published his second book of poems, *First Will and Testament*, in 1939, as well as several other volumes of his poetry and prose. Laughlin was both a friend and admirer of Patchen, who briefly held a job in the New Directions office.

Patchen's fervent pacifism, a frequent topic in his writing, drew fire from some, and Williams came to Patchen's defense on two separate occasions. In 1940, after Randall Jarrell negatively reviewed Patchen's verse in *Partisan Review*, Williams wrote a Letter to the Editor published in the next issue defending the poet. The following year, Delmore Schwartz convinced Laughlin that it was too risky to publish Patchen's experimental antiwar novel *The Journal of Albion Moonlight*. Patchen was forced to self-publish and to sell a limited number of copies via subscription. Williams wrote a positive essay about the book for the literary journal *Fantasy* in 1942, describing the writing as "well muscled" and "brilliantly clear." Henry Miller and Anaïs Nin also praised the novel, and Laughlin eventually changed his mind – nearly two decades later; New Directions published an edition of the book in 1961.

In 1957, Patchen and his wife Miriam moved to Palo Alto, California, where Patchen became a major figure in the Beat poetry movement. Despite a debilitating spinal injury, he collaborated with artists and jazz musicians on experimental mixed media compositions. Posthumously, Patchen has become more celebrated than he was in his lifetime, with critics calling him a "poet-prophet" and comparing his work to that of Whitman and Blake.[83]

159 Williams, William Carlos and William Zorach. Two Drawings Two Poems. New York: The Stovepipe Press, 1937.

8vo.; two folded leaves laid into green wrappers, with printed label and publisher's device.

First edition; one of 500 copies (430 for sale). Wallace B27. Williams and Zorach came up with the idea to collaborate on a book while they were acting together in a play at the Provincetown Playhouse in 1916 – Lima Beans, a one-act written and produced by Alfred Kreymborg: "That's all it was: we were theatre pals, and somehow it came about that we combined our work, his two drawings, nudes and my two poems 'Advent of Today' and 'The Girl.'"[84] The Dadaist comedy featured Williams and Mina Loy playing husband and wife, and Zorach as a street vendor hocking vegetables.[85] An edited version of "Advent of Today" appears in Collected Early Poems and "The Girl" was concurrently published in The Patroon (May 1937) and included in Collected Later Poems.

Painter, printmaker and sculptor William Zorach (1889-1966) met Williams through their mutual connection to Kreymborg; Zorach's abstract illustrations were featured on the cover of Others, one of the first journals to publish Williams's poetry. He designed the cover for Kreymborg's book Mushrooms (see item #126) but is primarily known for the Modernist bronze and aluminum public sculptures and post office murals commissioned later in his career.

160 Typed letter to Eleanor Scully, signed, "W.C. Williams," Rutherford, NJ, June 6, 1938.

One leaf; one page; two autograph emendations; original envelope.

Williams responds to Scully's letter sent after she saw Martha Graham's "American Document," which drew heavily from his In the American Grain. Williams confesses that he has never seen Graham dance, "partly from lack of opportunity, partly from the difficulties my profession puts in my way during the theatre season and partly from that despicable inertia which even in the best of us makes it hard for us to move our carcasses unless we are caught up in the crowd and pushed ahead." He also ruminates on dance as an artistic medium, unique in its ability "to particularize some of the

things which would interpret us to ourselves and keep us from tripping over our own wedding gowns. We are such bewildered asses – for the most part."

He then asks Scully for Graham's address: "How about letting me have Martha Graham's address? I have a book I wrote in – God knows when! – full of dance motives which I'd like to give her. It's called *Kora in Hell: Improvisations*. I think she might be amused." Presumably Scully gave him Graham's address; the copy of *Kora in Hell* inscribed to her is dated just two days after this letter (see item #136).

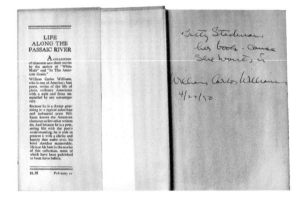

161 Life Along the Passaic River. Norfolk, CT: New Directions, 1938.

 8vo.; white cloth, stamped in black; dust-jacket.

Together with:

New Directions. Typescript carbon invoice, to "Dr. W.C. Williams, 9 Ridge Road, Rutherford, NJ," "10-10-47," Invoice "No. 6748."

One half leaf of New Directions invoice paper.

First edition; 1,006 copies, the entire edition. Wallace A19. Together with an invoice from New Directions to Williams, charging him $2.17 total for 2 copies of *Life Along the Passaic River* (40% of retail, plus $.07 "trans").

All nineteen of these stories are included in Williams's 1961 collection, *The Farmers' Daughters* (Wallace A46) and all but five first appeared in periodicals, the earliest dating back to 1920 ("Danse Pseudomacabre"). Williams intended the book as a follow-up to *The Knife of the Times and Other Stories*. Williams was "still obsessed with the plight of the poor" and the words came easily – "I would come home from my practice and sit down and write until the story was finished, ten to twelve pages. I seldom revised at all."[86]

162　Life Along the Passaic River. Norfolk, CT: New Directions, 1938.

8vo.; white cloth, stamped in black; dust-jacket.

First edition; 1,006 copies, the entire edition. Wallace A19. A presentation copy, inscribed on the front endpaper: *Betty Stedman / her book – cause / she wants it / William Carlos Williams / 4/29/50.*
Another charming inscription for Betty Stedman, a nurse and acquaintance of Williams at Passaic General Hospital. (For a copy of *The Knife of the Times and Other Stories* inscribed to Stedman, see item #149).

163　The Complete Collected Poems 1906-1938. Norfolk, CT: New Directions, 1938.

8vo.; blue cloth, stamped in gold.

First edition; one of 50 signed copies (this is #33). Wallace A20b.
At Williams's request, this comprehensive collection was organized chronologically into sections titled after the books in which the poems first appeared, plus two final sections of "Recent Verse" and "Longer Poems." Williams made slight revisions to a few poems and left out a handful "for lack of value," as he put it in a letter to Laughlin dated February 11, 1938. His experience editing the collection was illuminating in terms of craft; as he explains in *I Wanted to Write a Poem*, "The *Collected Poems* gave me the

whole picture, all I had gone through technically to learn about the making of a poem." He describes his early work as "too conventional, too academic ... the greatest problem was that I didn't know how to divide a poem into what perhaps my lyrical sense wanted," referring to revision as a process of "concentrating the poem."[87]

164 The Complete Collected Poems 1906-1938. Norfolk, CT: New Directions, 1938.

 8vo.; blue cloth, stamped in gold; dust-jacket.

First edition; "about 1,500 copies," this one in the third of four bindings. Wallace A20a. A presentation copy for the wife of Pulitzer Prize-winning poet Theodore Roethke, inscribed on the front endpaper: *Beatrice / with love / from / William Carlos Williams / May 17/55.*

 Williams and Roethke (1908-1963) first met in 1940, and exchanged letters, poems and even gifts (Roethke sent Williams smoked fish and cheese on a number of occasions) over the next decade. In a letter dated November 11, 1942, Roethke called Williams his "toughest mentor," for Williams often pushed the younger poet to use more idiomatic language in his work, to access his authentic voice. *Praise to the End* (Doubleday, 1951), Roethke's third book, is dedicated to Williams and Kenneth Burke.[88]

 Beatrice O'Connell had been a student of Roethke's at Bennington College, and they married in 1953. A year later, Roethke was awarded the Pulitzer Prize, an honor which Williams would only receive posthumously in 1963, two months after his death. Though 25 years his senior, Williams preceded Roethke in death by just five months.

165 Ford, Charles Henri. The Garden of Disorder and Other Poems. Introduction by William Carlos Williams: "The Tortuous Straightness of Charles Henri Ford." London: Europa Press, 1938.

 8vo.; marbled paper and gray quarter cloth, stamped in green; pencil notes and later owner's inscription on front endpaper.

First edition, including "The Tortuous Straightness of Charles Henri Ford," Williams's introduction dated "5th June 1937"; this essay was included in *Selected Essays* (Random House, 1954) but with an incorrect date (1939); one of 30 copies numbered in roman numerals (this is copy XXIII) and signed by

the author; 500 copies, the entire edition. Wallace B30.

Ford (1908-2002) was the editor and publisher of *View*, which was published from 1940-1949. Ford was a major force behind Surrealism in the U.S., using *View* as a platform.

Williams's support of younger poets extended throughout his life, from Louis Zukofsky and Charles Henri Ford in the 1930s, through Allen Ginsberg and Denise Levertov in the 1950s and through his death. He was generous with his reading and criticism of their work as well as generous in lending his support to get them published.

166 Typed letter to John Crowe Ransom, signed, "W.C. Williams,"
Rutherford, NJ, December 11, 1938.

 One leaf; one page.

A buoyant letter to John Crowe Ransom (1888-1974), fellow poet and founding editor of *Kenyon Review*, written after he accepted a "short treatise" Williams wrote about Federico García Lorca. Williams's piece appeared in the same issue as two poems by the Spanish poet, translated into English posthumously (Lorca was executed in 1936 at the start of the Spanish Civil War). The letter begins:

Dear Mr. Ransom,

Your letter, about the Lorca article, put me right back on my feet again, where I haven't been for a year or more. To say that I'm delighted at your acceptance of it doesn't half tell the story. Of more importance is that you've taken it just as I could have wished that you'd take it. It isn't easy to get what I was after but you got it perfectly. That, whatever the final merits of the article may be, is the certification of its complete success which is most satisfying. Spanish literature, aside from one book, is an almost unknown quantity in the United States. But I wanted only one thing out of it. I had to begin in Kindergarten. The effect sought, however, was not elementary. How in God's name could I explain that to anyone?

Williams goes on to recommend a translator for the Lorca poems: Rolfe Humphries. He also offers Ransom some reassurance: "Don't be afraid they won't be appreciated by our audience. Look at the Lorca translations of [Humphries] that appeared in a recent number of the New Republic. They were well received." Williams notes that one of the poems had been previ-

198

ously translated ("into English by an Englishman") and published by The Oxford University Press, but he still believes "Humphries should get the break" and do a new translation for the journal. The letter concludes with a joke: "Well, if you don't get me into the Spring issue I'll try to bear up under it though why not put a little heavy cream on my gellatine [*sic*] and give me the whole thrill? Huh?"

Williams got his wish – his ten-page essay and the Lorca poems, translated by Humphries, were published in the Spring 1939 issue of *Kenyon Review*.

167 **Charles Sheeler: Paintings, Drawings, Photographs.** With an introduction by William Carlos Williams. New York: Museum of Modern Art, 1939.

Small 4to.; gray paper, stamped in black; dust-jacket.

First edition; 5,500 copies, the entire edition. Wallace B35. Charles Sheeler (1883-1965) and Williams were first introduced by a mutual friend in 1923 and both had work published in the same issues of *Broom* and *Aesthete* later that year and again in 1925. Williams was fond of writing introductions for books featuring work by his artist friends, and his remarks about Sheeler here are still used by curators in exhibitions. From Williams's introduction:

> Charles Sheeler has lived in a mechanical age . . . [with] a realization on the part of the artist, of man's pitiful weakness and at the same time his fate in the world. These themes are for the major artist. These are the themes which under the cover of his art Sheeler has celebrated.

168 **The Broken Span.** Norfolk, CT: New Directions, 1941.

Slim 8vo.; pale gray wrappers, printed in black and pink.

First edition of the first volume in New Directions' "Poet of the Month" series in one of three bindings distributed across 2,000 copies. Wallace A22. A presentation copy, lovingly inscribed to his wife on the front endpaper: *To / Floss – with my love. / If there is any love in me / it has thriven on that with which / you, Floss, have surrounded / me from the beginning / – without you I could never / have had the faith and / courage to adventure and / work as I have done. So / that when and if I succeed / in anything you always / have a large responsibility / there. / Bill.*

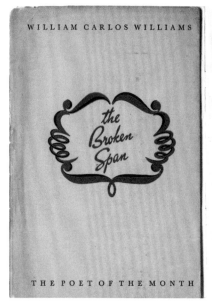
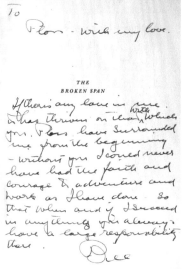

In his biography of Williams, Mariani documents the rocky start of his marriage to Flossie, largely in part due to his infidelity, making this inscription written a year before their 30th wedding anniversary even more poignant.

The Broken Span contains the beginning of what would become Williams's epic five-volume poem *Paterson*. The preface to the fifteen poems grouped under the title "For the Poem Patterson" [*sic*] reads:

> A man like a city and a woman like a flower – who are in love. Two women. Three women. Innumerable women, each like a flower. But only one man – like a city.

169 The Wedge. Cummington, MA: Cummington Press, 1944.

12mo.; marbled endpapers; top edge gilt; full red calf, stamped in gold.

First edition; 380 copies, the entire edition. Wallace A23. Williams's specially bound personal copy of this book dedicated to his longtime friend Louis Zukofsky, signed on the last free front blank: *W.C. Williams / Florence H Williams / Sept. 27, 1944.*

Williams struggled to find a publisher for *The Wedge*; as he explained to Zukofsky in a letter dated September 11, 1944, it was "plain hell to get it print-

ed and bound." A number of publishers, including Laughlin at New Directions, cited lack of paper as their reason for rejecting the manuscript. Finally, much to Williams's relief, Harry Duncan and Paul Williams of the Cummington Press agreed to take on the project.

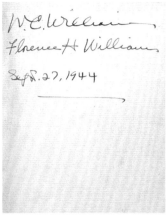

Originally titled "The lang(Wedge)," these poems and Williams's impassioned introduction to the book represent his attempt to reconcile poetry with wartime politics. Poetry is not an escape from action, Williams argued, but is action "in a different sector of the field." Giving a talk at the New York Public Library just after *The Wedge* came out, Williams said he hoped the poems would "serve as a wedge to drive open consciousness."[89]

170 Goll, Yvan. Jean Sana Terre. Landless John. Translated by Lionel Abel, William Carlos Williams, Clark Mills, John Gould Fletcher. Preface by Allen Tate. With two original drawings by Eugene Berman. San Francisco: The Grabhorn Press, 1944.

> 4to.; illustrated; marbled paper-covered boards, cloth spine; printed label to spine.

First edition of these translations of Yvan Goll's series of *Jean Sans Terre* poems, including a contribution by Williams: "Jean sans terre à borde au dernier port à 'Claire sans Lune'" – Landless John at the Final Port / to Claire sans Lune (p. 27). One of 175 copies printed at the Grabhorn Press, between September 1943 and February 1944. Wallace B45.

The Grabhorn Press was a small press based in San Francisco which operated from the mid-1920s through the mid-1960s. Its output of over 650 fine books was the subject of a Grolier Club exhibit in the spring of 2015. Allen Tate, who provided the preface to this volume, had his first book of poems published by the Alcestis Press, publisher of Stevens's *Ideas of Order* and *Owl's Clover* and Williams's *An Early Martyr and Other Stories* and *Adam and Eve and the City*. By the time of the publication of *Landless John* he

had become the editor of the *Sewanee Review*. See items #43 and #44 for correspondence Tate had with Wallace Stevens in 1944 and 1945, shortly after the publication of *Landless John*.

Williams had translated poems from Spanish throughout his career but there are few examples of his having done translations from French. He did not regularly contribute to compilations such as this, despite his voluminous contributions to literary journals.

171 **The Harvard Wake**. "Lower Case Cummings" and "The Peacock's Eyes," pp. 20-23 and 80-82. No. 5. E.E. Cummings issue. (Spring 1946).

8vo.; printed wrappers.

Wallace C364 and C365. This special E.E. Cummings issue was guest-edited by José García Villa, and includes an essay by Williams and nine brief poems. In "Lower Case Cummings," Williams defends Cummings's trademark typographical oddities, admiring his work as performative and even acrobatic: " . . . he can't be imitated . . . you've got to learn the basis for his trapeze tricks." The nine other poems – "The Manoeuvre," "The Banner Bearer," "The Thing," "The Act," "Hey Red!" "The Night Rider," "The Brilliance," "Death by Radio (For F.D.R.)," and "The Birdsong" – are all in either *Collected Early Poems* or *Collected Later Poems*.

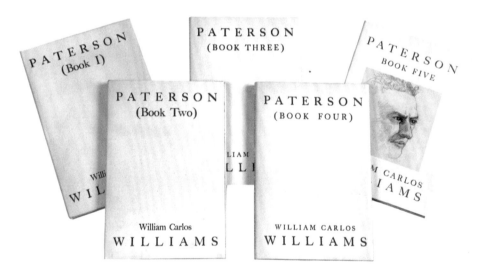

172 Paterson (Book One). New York: New Directions, 1946.

8vo.; tan cloth, stamped in black and gold; dust-jacket.

First edition; 1,063 copies printed (the colophon calls for 1,000). Wallace A24. Signed by Williams on the front endpaper.

Williams spent eight years writing *Paterson*. It had been germinating in his mind and in his gradually amassed collection of notes for over twenty years – the time elapsing between *The Dial*'s 1926 publication of his initial, significantly shorter "Patterson" [*sic*] and the publication of Volume One in 1946. Over the next ten years Williams brought out each part as it was completed, "inventing" his form to accommodate the material: "I was aware that it wasn't a finished form, yet I knew it was not formless . . . I respected the rules but I decided I must define the traditional in terms of my own world."[90] It was vital to Williams that *Paterson* carve out a new idiom for poetry in both its structure and style.

Until *Paterson*, Williams was arguably more known for his prose and political writings, but this masterpiece solidified his place as one of the foremost voices in 20th-century American poetry. Many critics have compared the work to Pound's *Cantos* and Eliot's *The Waste Land* in its scope and ambition – yet *Paterson* is a distinctly American response to industrialization. Poets effusively praised the work; Randall Jarrell called Book One "the best thing William Carlos Williams has ever written . . . There has never been a poem more American"[91] and Robert Lowell wrote that Williams's verse possessed "a richness that makes almost all other contemporary poetry look a little secondhand."[92]

Williams personifies the city of Paterson through the central persona in the poem, a doctor-poet named Paterson who also lives in Paterson. The image of the Great Falls of the Passaic River, one of the largest waterfalls in North America, figures prominently; Williams uses the history of the region (and the feat of civil engineering that transformed the Falls into a lucrative energy source) as a metaphor for progress as well as the negative byproducts of mechanization. Paterson's rapid rise leads to inevitable decay: a civilization "brutalized by inequality, disorganized by industrial chaos, and faced with annihilation," according to Lowell. However, the poem does not end with the collapse of Paterson and the polluted Passaic – the

later books sow seeds of hope that the city (and man) might once again be revitalized.

Book One expands upon ideas Williams had laid out in much earlier poems and stories – he specifically refers to "The Wanderer" (1917), "The Folded Skyscraper" (1927), and "Four Bottles of Beer" (1930) as precursors for *Paterson*, or "abortive beginnings" in comments he sent to John C. Thirlwall in 1959 for a forthcoming New Directions anthology. Williams always intended the longform poem to be his magnum opus, "a true Inferno" as he wrote in a letter to Robert McAlmon in July of 1939.[93]

173 "Dr. Williams's Double Life." In *Medical Economics*. June 1950, pp. 52-53, 146.

Together with:

Official Timetable - Rutherford / Carlton Hill and New York. Effective Mar. 1, 1947 to Mar. 31, 1947, Incl. 1947.

Together with:

Printed Christmas card with a Williams poem, signed, "Best wishes, Florence Williams." 1967.

A small grouping of biographical items, from the family of Edgar Williams. Edgar's daughter has labeled the copy of *Medical Economics*, UNCLE WILL - P.52 on the cover. The train schedule for Williams's trips from New Jersey to New York is in mint condition. A posthumous Christmas card signed by Florence Williams with "Best wishes" prints Williams's poem, "At the thick of the dark . . . " – a selection from his "Burning the Christmas Green" (1967). Also present are an obituary clipping, neatly torn in two, and a black and white portrait photograph.

174 Typed letter to Vivienne Koch, signed "Bill," January 29, 1947.
 One leaf; one page, with autograph postscript.

Together with:

Typescript poem: "A Place (any place) to Transcend all Places," signed, "William Carlos Williams."

 4 leaves; 4 pages.

Williams responds to Koch's request for a poem and asks for help recalling the name of someone who solicited Williams to write a piece about Norman Macleod. The letter reads in full:

Dear Vivienne:

Why not use The Visit? If that isn't long enough I can add another -- the one Partisan R. has comes to about 15 lines. Or something else. But I like The Visit.

 I enclose the one I spoke of from Kenyon Review, Winter '46. It sems [*sic*] to me to be about as characteristic as anything I have.

 Something that has upset me during the past week is that I rec'd a letter from someone asking me to write something for an issue of some magazine which is planning to issue a Norman Macleod number and I have lost the letter and can't remember the name of the man who sent it to me or the name of the magazine or anything more specific of the matter than I have already mentioned above. Do you know anything of this? It is not to be mentioned to Norman in any way. But if you can give me a hint as to who the person might be who wrote me so that I may communicate with him, I'd be a thousand times obliged.

 Yrs,
 Bill

The autograph postscript contains another clue as to the man's identity: "It was, I think, at the bookstore party – [] or something like that."

Koch was married to the poet Norman Macleod (1906-1985) from 1935 to 1946, which is likely why Williams queried her about the special issue. Koch wrote the New Directions volume on Williams in 1950 (see item #188). The Golden Goose devoted an entire issue to Macleod in May 1952, publishing nine of his poems and an excerpt from his unpublished auto-biography along with Williams's "A Poem for Norman Macleod." Koch and *Others* editor Alfred Kreymborg also contributed to the tribute issue.[94]

The Golden Goose had a strong connection to Macleod: He served as editor from 1944 to 1947 back when it was known as the *Maryland Quarterly* and then the *Briarcliff Quarterly*, which published work by both Stevens and Williams (see item #111). After Macleod left, the journal was rechristened *Cronos* and taken over by Richard Wirtz Emerson and Frederick Eckman (who were based out of Ohio State University in Columbus), and then re-named again, *Golden Goose*, in 1948.[95] The Golden Goose Press, also run by Emerson and Eckman, published Williams's *The Pink Church* in 1949 (see item #186).

175 Autograph letter to Ralph Ross, signed, "Williams," December 18, 1947.

> One leaf of "Dr. W.C. Williams" letterhead, with his printed address of 9 Ridge Road, Rutherford, NJ; two pages; with original 9 x 12" envelope addressed to Ross.

Together with:

Typescript: A Trial Horse No. 1 (Many Loves), Act III Scene I: "Talk." 1942.

> 7 typescript leaves; paper-clipped; with 7 typescript carbon leaves; paper-clipped; pages 1-3 hand-numbered on each.

Together with:

A Trial Horse No. 1 (Many Loves). An entertainment in three acts and six scenes. Excised from *New Directions 7* (1942), pp. 233-305.

> 8vo.; excised signatures; spine taped.

Together with:

Typescript carbon: A Dream of Love (Innocent Blackguard). A play in three acts and six scenes. 1946.

> 117 typescript carbon leaves; manuscript note initialed by WCW at the head of the first leaf of Act I; docketed on the title page and signed inside the lower wrapper; brad-bound; green wrappers; tattered; typing service label to cover.

A letter to Dr. Ralph Ross, at the NYU Division of General Education on Washington Square East, enclosing the excised, typescript and carbon material of both *A Trial Horse No. 1 (Many Loves)* and *A Dream of Love*:

> Thanks for the tolerant words – I hope some sort of production – even if only a partial one can be arranged. The 2nd play enclosed – it has certain possibilities but – but – but – who's got the but? – the theatre ain't flexible enough I fear. Williams.

Williams's enclosures include the typescript and typescript carbon of the first of two scenes of the final act of the 1942 play that would later be published as the title piece in *Many Loves and Other Plays* (1961), published by James Laughlin at New Directions. Together with the first appearance of these "prose playlets," all on the theme of "love – of a sort" (Synopsis), as excised from *New Directions 7*. Wallace C311. These are "accompanied," as further stated, "by a counter-play, in modern verse which binds them together": a typescript carbon of Williams's three-act play, *A Dream of Love*, with his name and address in his hand inside the rear cover, his address in his hand on the title page; and this important alteration noted in his hand at the head of the first page of Act I: "In the final arrangement Act I – Scene I becomes Act I – Scene II & Scene II becomes Scene I. W.C.W." The printed label of the Anne Meyerson Author's Manuscript Typing Service, on Park Avenue, New York, is on the front cover.

In "Notes on William Carlos Williams as Playwright," an essay included in Williams's 1961 anthology of plays, *Many Loves*, John C. Thirlwall recounts Williams's efforts over the course of two years to get *A Dream of Love* produced. Thirlwall writes,

> To one agent who delicately refused the play as not fully dramatic, Williams wrote: "There are plays less dramatic in movement that are well capable of holding audience interest for two hours of an evening – an

intelligent interest which is quite legitimate. The drama in *A Dream of Love* lies in this sector, not so much in conflict (there is very little conflict in *The Cherry Orchard*) as in revelation."[96]

176 A Dream of Love. A play in three acts and eight scenes. *Direction* 6. New York: New Directions, 1948.

8vo.; printed wrappers.

First edition; issued as "Direction Six" in the noted series; 1700 copies. Wallace A27. A presentation copy, inscribed on the half-title: *Man Ray / from Ridgefield, N.J. / – via Paris (France) to / – Hollywood: an / inversion (?) / Best luck, / William Carlos Williams. / 11/16/50.*

Artist Man Ray (1890-1976) and Williams had a long association dating back to 1915, when they were both involved with a New York collective of artists and writers who called themselves "The Others" (which became the name of the literary journal Ray founded with Alfred Kreymborg which published work by Stevens and Williams – see item #105). Williams's mother had studied painting in Paris, and Williams dabbled in his youth, painting mostly self-portraits and New Jersey landscapes. He maintained close ties

208

with the artistic community throughout his life, contributing introductions for some of his friends' exhibitions and books (for example, Charles Sheeler, see item #167). In 1978-79 the Whitney Museum of American Art honored Williams's "efforts ... to participate in the creation of a unique American art" (see item #211). Man Ray's 1924 photograph of Williams was included in the Smithsonian's 2012 exhibit "Poetic Likeness" at the National Portrait Gallery.

Ridgefield, New Jersey, referenced in the inscription, was the location of an artist and writers colony established by the Others crowd in 1915 which lasted several years. Williams and his wife hosted several parties for them at their home in Rutherford, New Jersey.

177 A Dream of Love. A play in three acts and eight scenes. *Direction* 6. New York: New Directions, 1948.

 8vo.; printed wrappers.

First edition. Wallace A27. This copy belonged to director Fred Stewart of the Manhattan Theatre Club, who staged a reading of the play at the National Arts Club in 1961. With Stewart's name and address in pencil on the half-title, and his copious pencil annotations for the 1961 reading.

Stewart removes several paragraphs of dialogue (see pages 54, 82-84 and 88-89); inserts speech cues (see pages 18-19); and adds words or alters dialogue; for example, he adds to the stage direction for the character Myra on page 67: "and begins to pace about the room like a caged animal who cannot escape the four walls that keep her here, waiting for her husband's return," and adds to the description that begins Act III: "In the background, throughout this scene, we see – dimly – Myra still pacing the small cage of the kitchen, which she cannot break out of" (68). In the final paragraph of dialogue, Stewart alters Myra's dialogue from: "I'm sorry, the doctor's dead. He's been dead for a week. I'm sorry you haven't heard about it, he's nevertheless dead," to read "I'm sorry, the doctor's dead. He died a week ago. I'm sorry you haven't heard about it, but it's true." Stewart also indicates in the stage directions that "(the milkman remains on the back porch to the end)" (107).

Before this 1961 reading, *A Dream of Love* had been staged by the Hudson Guild Playhouse in July of 1949 – William Saroyan of the *New York Herald Tribune* wrote a glowing review of the production, but it closed after only two weeks, most likely due to the lack of air-conditioning in the theatre.[97]

178 Typed letter to Arioste Londechard [pseud. of James Finley], signed, "Williams," January 25, 1948.

> One leaf; one page.

A dark letter written during a particularly brutal New England winter – one of the worst of the century – when Williams was struggling with depression and fatigue as he continued to work on *Paterson* after being promoted to Chief of Pediatrics at Passaic General Hospital. The brief letter reads in full:

> Dear Londechard,
>
> I don't know how you do it, though there was a time, I suppose, when I too had what it takes to go on and on and on with what might have passed for a warm and happy heart. This is no sob story. Right now my uterus is hanging out.
>
> I've received your letters but I could not answer them, I had nothing to say. The work strangles me but I have no heart to go beyond it. I simply have to work. I have to work literally until it kills me, I can't be happy any other way.
>
> I'm physically tired from driving this snow, day after day. But my mind is more tired than that.
>
> I have received your letters but could not answer them because I had nothing to say.
>
> Yours,
> Williams

Williams was not exaggerating; a week after writing this letter, he suffered the first of a series of severe heart attacks while trying to dig his car out of a snowbank on his drive home from the hospital after working a late night shift.

Arioste Londechard was the pseudonym of James Finley, a protégé of Pound from New York who wrote poetry and was acquainted with Williams and Cummings.

179 Autograph letter to E.J. Rutan, signed, "Williams," Rutherford, NJ, March 23, 1948.

> One 6 x 8" leaf of Williams's letterhead; two pages; with original envelope.

210

In this letter to his friend E.J. Rutan, a professor at Rutgers, Williams thanks him for voting for him for an unnamed literary prize and muses on what it takes to win awards: "Maybe I'll yet win the award if I last that long. I doubt it seriously however." Williams claims the only way "to win any respect" is to attend literary conferences, which he often does not. He does, however, share the news of a recent honor bestowed upon him – his appointment by the Library of Congress to be "Custodian of Poetry" for the next year ("if I last that long"). He confides in Rutan about his recent health issues, writing "by way of private information, I am at the moment recovering (I hope) from an attack of angina pectoris: a fine opportunity for thought!" Williams hopes Rutan will like *Paterson II*, describing it as "ammunition for your gun."

His words to Rutan proved prophetic: Williams deferred the Library of Congress post due to health reasons, only to have it revoked, likely on political grounds (see item #181).

180 **Paterson (Book Two)**. New York: New Directions, 1948.

 8vo.; tan cloth, stamped in green and gold; dust-jacket.

First edition; 1,009 copies printed (the colophon calls for 1,000), 1,002 of which were bound. Wallace A25. Signed by Williams on the front endpaper.

In Book Two of *Paterson*, Williams shifts focus to the social and economic manifestations of decline. In a letter to his friend and fellow poet Babette Deutsch, he wrote that in the second installment, "there will be . . . much more relating to the economic distress occasioned by human greed and blindness . . . but still, there will be little treating directly of the rise of labor as a named force. I am not a Marxian" (July 28, 1947).[98]

181 **The Clouds, Aigeltinger, Russia and other verse**. Published jointly by the Wells College Press and the Cummington Press, 1948.

 8vo.; gray cloth, title label to spine; publisher's cardboard slipcase.

First edition; one of forty copies numbered in roman numerals (this is copy v) signed by Williams; 310 copies, the entire edition. Wallace A26. Signed by Williams at colophon.

Duncan and Williams were able to use the Wells College Press (instead of Cummington's hand press) to create *The Clouds*. . . . Kenneth Burke de-

scribed the four-part title poem, placed last in the collection, as "gorgeous
. . . at times almost ferocious" in his *New York Review of Books* tribute pub-
lished just after Williams's death in 1963.[99] *The New Yorker* proclaimed the
book "beautifully bound" and the poems "musical, unexpected, and wittily
varied as ever."[100]

One of the poems in *The Clouds*, however, stirred up controversy and
may have cost Williams professionally. "Russia" was believed by some to
be sympathetic to communism, and this was most likely the reason the
Library of Congress rescinded its invitation to Williams to become the
Chair of Poetry. Williams was appointed in 1949, the year after *The Clouds*
was published, but postponed his duties for health reasons. When he was
ready to accept the position in 1952, after reports of his supposed Commu-
nist Party ties had appeared in a few newspapers, he was informed that his
appointment had been revoked.

182 Selected Poems: Working Material. [New York: New Directions, 1949.]
8vo.; three sections of disbound text cannibalized from *The Complete Poems*
by the author, totalling just over 70 leaves (and partial leaves), used in pre-
paring the text for *Selected Poems*.

Williams's working material towards his *Selected Poems*, using a torn-up
copy of *The Complete Poems* and then adding checkmarks to poems for inclu-
sion, ignoring or physically cutting out poems to omit, and signing printed
page 216 along the left margin, "William Carlos Williams."

Williams made a gift of this hodge-podge to Don Paquette, inscribing it
on the section half-title for *Adam and Eve and the City: Don Paquette – the best /
reader of poems that / I can think of – / William Carlos Williams / 9/9/50.*

Donald J. Paquette (1899-1969) was a minor poet who was acquainted
with Williams and Pound. His name comes up in a letter from Robert
Creeley to Williams dated April 24, 1950. Creeley had received poems from
Paquette and was interested in using them in the first issue of *Lititz Review*, a
journal of poetry and criticism he was launching which would also include
a reprint of Williams's attack on Eliot, "With Rude Fingers Forced." Howev-
er, due to a variety of circumstances, including fundraising problems and
his hired printer's broken wrist, the magazine never came out and Creeley
eventually abandoned the project.

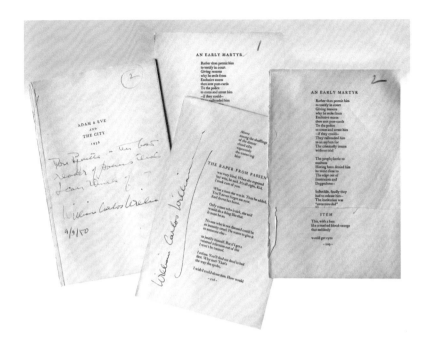

Paquette had two poems in the September 1934 issue of *Poetry* and published one collection, *Detour to Destiny: Poems* (James A. Decker Press, 1940). A review of *Detour to Destiny* from a 1941 issue of *Voices* begins, "It is unfortunate that this volume is badly printed, for Mr. Paquette is a contemporary poet with considerable attainments, concerned with social problems, America and people in general."

183 **Selected Poems.** With an introduction by Randall Jarrell. The New Classics Series. New York: New Directions, 1949.

Small 8vo.; gray cloth; brown and black dust-jacket.

First edition; 3591 copies. Jarrell was tapped to write the introduction, in which he characterizes the language of Williams's poems as "absolutely unaffected and in a metric pure, spontaneous, dancelike." Wallace A28a. A presentation copy, inscribed on the title page: *Isabel Wyckoff / best luck / William Carlos Williams. / July 25 / 51.*

Williams was awarded the National Book Award for Poetry in 1950 for *Selected Poems* and *Paterson: Book III.*

213

See "Ghosts in the Collection," page 123, for further information about this inscription.

184 Selected Poems. With an introduction by Randall Jarrell. Norfolk, CT: New Directions, 1949.

> 8vo.; light brown cloth, stamped in dark brown.

First edition, later printing. Williams's personal copy, with an autograph note in pencil by him on the front endpaper: *"It is the way we read that's the thing. Open the book anywhere and begin."* With his ownership signature in ink to the title page as well as holograph notes to the poem "Botticellian Trees." Additionally, tipped-in to the rear endpaper is an index card bearing pasted columns cut from a newspaper article – "Not the Age of Atoms But of Welfare for All" by Arnold J. Toynbee – that has been annotated briefly by Williams. He has crossed out two paragraphs and noted in holograph on the notecard: *Only when the arts thrive can man stand up and say 'I am'.* He continues directly on the endpaper: *This inequality is perpetuated in the various immortal inheritances which constitute our arts and its form.*

185 Selected Poems. Edited with an introduction by Charles Tomlinson. New York: New Directions, 1985.

> 8vo.; wrappers.

New edition, third printing. Wallace A28c. Harold Bloom's copy, signed on the half-title ("Harold Bloom").

214

In 1985, New Directions reissued *Selected Poems* with a new introduction and additional poems published after the 1963 edition. This expanded volume was edited by Charles Tomlinson, a British postwar poet whose lively correspondence with Williams is the subject of *William Carlos Williams and Charles Tomlinson: A Transatlantic Connection* (Peter Lang, 1999).

186 **The Pink Church.** Columbus, OH: Golden Goose Press, 1949.

8vo.; blue printed wrappers with flaps, sewn.

First edition; one of twenty-five numbered copies (this is copy #13) signed by Williams; 400 copies, the entire edition. Wallace A29.

The Pink Church was the first book published by Golden Goose Press, founded by Richard Wirtz Emerson and Frederick Eckman; for an overview of their interesting history and background with Williams, see the discussion of Norman Macleod in item #174.

A note at the top of the front flap reads in full:

> The publishers are proud to begin their series of chap books [sic] with this group of poems by one of the three finest poets writing in the English language in this century. The title poem stands out as one of the best poems in Dr. Williams' full writing career, and the others in the collection demonstrate the diversity that marks a major poet.

After relocating from Ohio to northern California, the press went on to publish work by Cummings, Pound and Robert Penn Warren.

Dedicated to James Laughlin, *The Pink Church* is an allegory for Christianity, with Williams representing Christ "as a socialistic figure, related to a generous feeling toward the poor."[101] The first appearance of the title poem ("Choral: The Pink Church") was in the October 1946 issue of the *Briarcliff Quarterly*, where it was published alongside a musical setting of the text composed by Louis Zukofsky's wife, Celia Thaew (see item #111).

187 **Paterson (Book Three).** New York: New Directions, 1949.

8vo.; gray cloth, stamped in blue and gold; dust-jacket.

First edition; 1000 copies printed, 999 copies of which were bound. Wallace A30. Signed by Williams on the front endpaper.

Upon turning 65 in 1948, Williams retired from Passaic General Hospital

and had more time to write. He devoted most of that time planning and writing Book Three of *Paterson*. In a letter to his friend Norman Holmes Pearson, he describes the act of composition as "a sickness . . . like ambergris in the whale's belly, the lump will be formed and finally spewed forth" (February 3, 1949).[102]

188 Koch, Vivienne. **William Carlos Williams.** The Makers of Modern Literature series. Norfolk, CT: New Directions, 1950.

Small 8vo.; tan cloth, stamped in black; dust-jacket.

First edition; 2721 copies. Wallace B57. Signed by Williams beneath the frontispiece photograph portrait of him, which was taken by Charles Sheeler in 1926.

Koch's "critical estimate" of Williams's oeuvre through 1949, with sections devoted to his poems, plays, fiction and nonfiction prose, interspersed with notes by Williams and quotations from some of his unpublished manuscripts, was the first book-length appreciation of Williams's work.

189 **Make Light of It.** Collected Stories. New York: Random House, 1950.

8vo.; gray cloth, stamped in black, white and gold; dust-jacket.

First editon; 5000 copies. Wallace A32. Marianne Moore's annotated review copy, with the publisher's slip and compliments card loosely inserted. With Moore's light pencil annotations to the first rear blank indicating perhaps pages of interest – she lists a few numbers (9, 13, 14, 16) followed by fragmented phrases ("a well-fitted suit," "one of those Amer. hybrids," "deeds of mercy").

This compilation includes pieces from *The Knife of the Times* and *Life Along the Passaic River*, and a final section titled "Beer and Cold Cuts" featuring stories that had been published previously in periodicals but not in book form. *Make Light of It* is not the title of a story, but refers to Williams's attempts to put the Library of Congress debacle behind him: "Whenever I have chosen a title it has interested me to find one with more than one meaning . . . *Make Light of It* followed the disheartening Library of Congress affair, could be saying, make light of the whole thing, or perhaps; make *light* of it."[103]

190 Williams, William Carlos. **Autograph letter to Edward Parone, signed, "Williams,"** Portland, OR, November 7, 1950.

> One leaf of The Portland letterhead; two pages.; with original franked envelope addressed in ink.

In the fall of 1950, Williams and Flossie traveled to the west coast for five weeks. Williams gave several readings and lectures, and met with students and faculty from the English departments at the University of Washington in Seattle, Reed College in Portland, and the University of Oregon in Eugene. This letter is a response to one Williams received from Ed Parone, a young poet he met at his table at the first ever National Book Awards dinner on March 16, 1950 (Williams was a recipient for *Selected Poems* and *Paterson III*). Williams writes that he has recommended him for a Yaddo fellowship:

> I have written to Elizabeth Ames at Yaddo strongly recommending you for a fellowship, if such it is called, there this winter. Hope she comes through. As I understand it, they do not take many for residence at Yaddo during the winter months, but I am sure you will hear, one way or another, of this within a short time.

Williams mentions his trip with Flossie briefly, then concludes with "best of luck – and I've enjoyed reading your stuff." Beneath his signature he provides his Rutherford address, where he can be reached "after November 25th."

Edward Parone (1925-2016) published four poems in *The New Yorker* in 1954-1956 before switching gears and pursuing a career as a theater director. He is credited with discovering Edward Albee and helping him get his 1958 play *The Zoo Story* produced in New York. He also mentored playwrights including Amiri Baraka, Lanford Wilson, Tom Stoppard and Sam Shepard. In the late 1960s, Parone moved to L.A. where he began working in film and television in addition to directing experimental plays at the Taper Theater.

191 Kavita. "Sonnet in Search of an Author," "Illegitimate Things," pp. 4, 42-43. XVI.1, Series 67. (December 1950).

> 8vo.; printed wrappers.

First appearance of "Sonnet in Search of an Author" printed opposite Marianne Moore's "Armor's Undermining Modesty," in this special bilingual issue of *Kavita*. Together with a later appearance of "Illegitimate Things." Wallace C451. "Sonnet in Search of an Author" would not appear in print again for several years – it was published once more in the April 14, 1956, issue of *The Nation* and then finally in book form in *Pictures From Brueghel and Other Poems* (New Directions, 1962). "Illegitimate Things" was first published in the September 1939 issue of *Poetry* and then included in *The Broken Span* (New Directions, 1941).

192 Paterson (Book Four). New York: New Directions, 1951.

 8vo.; tan cloth, stamped in red and gold; dust-jacket.

First edition; 1000 copies, 995 of which were bound. Wallace A34. Signed by Williams on the front endpaper.

 Williams finished Book Four during the summer of 1950 which he spent at Yaddo, the artists' and writers' colony in upstate New York. He winnowed more than a hundred pages of notes down to "a scant twenty-two," working "seven days a week from right after breakfast until noon, and from one to four P.M. without a break" for several weeks straight until the manuscript was completed.[104]

193 Autobiography of William Carlos Williams. New York: Random House, 1951.

 8vo.; ownership signature ("K. Carter") on the front pastedown; blue cloth, stamped in white and gold; dust-jacket.

First edition, second printing; 5,000 copies. Wallace A35b. A presentation copy with a lengthy inscription on the front endpaper:

 For / Katherine Davis / – as much as I have used / words and thought of them / and their contours and / the stresses we put upon / them, I can't find a single / reference to them, a single / major reference to them in my poems as / objects worthy of major / consideration – and yet I / think of them always. I suppose / they are so much part of my / thought, so close to me, that / I can't get far enough away / from them to see them. / William Carlos Williams / 5/17/52.

Williams made this generous inscription during a trip to Indiana for a symposium at Hanover College on May 16, 1952.

Poetry published the first 25 pages of this book in August 1948 and May 1949, titled "Some Notes Toward an Autobiography: The Childish Background." In a letter to Marianne Moore, Williams attributes his 1948 heart attack to stress from working on the project: "It was from overwork on my *Autobiography* that I went under. I might have died" (June 23, 1951).[105] Williams regretted not sharing drafts with Flossie or close friends, and admitted he "trusted to memory too many things" and "didn't edit," which resulted in "some inaccuracies about dates, places."[106] After publishing two impressions of the first edition, Random House sold the rights to New Directions in June of 1965, who issued a third printing in both hardcover and paperback in 1967.

194 Origin: A Quarterly for the Creative. "The Desert Music," pp. 65-75. I.6 (Summer 1952).

8vo.; gray printed wrappers.

The first of several poems by Williams published by Origin editor Cid Corman. Wallace C453. This issue also includes work by Robert Creeley, Robert Duncan and Denise Levertov. "The Desert Music" is a long poem that Williams first read aloud at Harvard for the Phi Beta Kappa Annual Literary Celebration in the summer of 1951. In a letter to Norman MacLeod, he wrote, "It has taken me a month or more to write it, transcribe it, have it typed, correct it, and polish. That took about all the drive I had" (June 11, 1951).[107] It was the first poem he composed after suffering a stroke in March of 1951. The poem became the title poem and centerpiece of Williams's next book of poetry, *The Desert Music and Other Poems.*

195 The Desert Music and Other Poems. New York: Random House, 1954.

8vo.; green paper-covered boards, tan cloth spine; title label to spine; original publisher's slipcase.

First edition; one of 100 copies signed (this is copy #49). Wallace A38b.

Williams started writing the title poem of *The Desert Music* upon receiving an invitation to read at Harvard's Phi Beta Kappa commencement exercises in 1951. He had been traveling around El Paso and was inspired by the desert landscape. He read the poem on June 18, 1951, and apparently some of the

faculty were shocked by its references to Juarez prostitutes. In 1952, Williams suffered the first of a series of strokes (which he refers to as "cerebral accidents" and "cerebral attacks" in *I Wanted to Write a Poem*), which kept him from publishing another book until 1954. In this collection, he writes almost exclusively in the form he invented when writing *Paterson*: the variable foot, or triadic/stepped line that is broken into three descending, indented parts.

196 Typed letter to John Crowe Ransom, signed, "Williams," Rutherford, NJ, February 23, 1955.

> One 6 x 7" leaf of Williams's letterhead; one page.

When Williams wrote this note promising to send him more work soon, Ransom was still editor of *Kenyon Review*. He mentions that Dave McDowell – who at the time was an editor at Random House, though he quit to start his own press with Ivan Obolensky in 1957 – is publishing a book of poems by him in the summer (*Journey to Love*), but might be willing to postpone if Ransom is interested in using anything for the journal.

197 Ginsberg, Allen. Howl. Introduction by William Carlos Williams. The Pocket Poets Series: Number Four. San Francisco: The City Lights Pocket Bookshop, 1956.

> 4to.; printed wrappers.

First edition; 1,000 copies. Wallace B71. Denise Levertov's copy, with an ownership sticker on the inner front flap.

Allen Ginsberg (1926-1997) believed Williams to be William Blake's successor, and thought of him as a mentor. In college at Columbia he got the impression from his professors that Williams "was some kind of awkward crude provincial from New Jersey," but upon rereading him and speaking with him about poetry, he had an epiphany. As he explained to an interviewer, "I went over my prose writings and I took out little four-or-five line fragments that were absolutely accurate to somebody's speak-talk-thinking and rearranged them in lines, according to the breath, according to how you'd break it up if you were actually to talk it out, and then I sent 'em over to Williams. He sent me back a note, almost immediately, and he said 'These are it! Do you have any more of these?'"[108]

In his stunning introduction, Williams confesses that as a younger man, Ginsberg "disturbed" him and he "never thought he'd live to grow up and write a book of poems." *Howl* is "an arresting poem," all the more powerful because of what Ginsberg experienced (incarceration in a mental institution) prior to writing it. Williams writes:

> It is the poet, Allen Ginsberg, who has gone, in his own body, through the horrifying experiences described from life in these pages. The wonder of the thing is not that he has survived but that he, from the very depths, has found a fellow whom he can love, a love he celebrates without looking aside in these poems. Say what you will, he proves to us, in spite of the most debasing experiences that life can offer a man, the spirit of love survives to ennoble our lives if we have the wit and the courage and the faith – and the art! to persist.
>
> It is the belief in the art of poetry that has gone hand in hand with this man into his Golgotha, from that charnel house, similar in every way, to that of the Jews in the past war. But this is in our country, our own fondest purlieus. We are blind and live our blind lives out in blindness. Poets are damned but they are not blind, they see with the eyes of the angels. This poet sees through and all around the horrors he partakes of in the very intimate details of his poem. He avoids nothing but experiences it to the hilt. He contains it. Claims it as his own – and, we believe, laughs at it and has the time and effrontery to love a fellow of his choice and record that love in a well-made poem.
>
> Hold back the edges of your gowns, Ladies, we are going through hell.

Denise Levertov (1923-1997) was born and raised in England and did not move to the United States until she was 25; however, many critics commented that her poetry seemed inspired by the American idiom and she was frequently compared to both Stevens and Williams. Reviewer Julian Gitzen commented that Levertov's "attention to physical details [permitted her] to develop a considerable range of poetic subject, for, like Williams, she [was] often inspired by the humble, the commonplace, or the small, and she [composed] remarkably perceptive poems about a single flower, a man walking two dogs in the rain, and even sunlight glittering on rubbish in a street."[109]

A selection of the correspondence between Williams and Levertov was published in 1998 by New Directions. On October 25, 1956, Levertov wrote to Williams from Mexico, where she was then living, saying "*Howl* arrived a week or so ago – there's something I can accept unconditionally . . ."

Williams was a major influence on Levertov, and one she acknowledged in a series of four essays included in her *New and Selected Essays* (New Directions, 1992): "On Williams' Triadic Line," "Williams and the Duende," "The Ideas in the Things" and "Williams and Eliot." Williams's good friend Cid Corman was among the first to publish her work, in his journal *Origin*, and City Lights Pocket Bookshop issued her collection *Here and Now* as the sixth installment in their Pocket Poet Series in 1956. James Laughlin was similarly enthusiastic, and Levertov became a New Directions author in 1959. Levertov and Williams became close friends at the end of his life – she visited him in Rutherford on a number of occasions, seeking feedback on her poems, which he happily gave. She wrote both nonfiction prose and poetry till her death at age 74.

198 Typed letter to Geraldine Lust, signed, "W.C. Williams," Rutherford, NJ, March 9, 1957.

> One 6 x 7" leaf of Williams's letterhead; one page.

A brief note in which Williams declines Lust's invitation to help reignite interest in Pound's work, specifically his Modernist translation of Sophocles's tragedy *Women in Trachis*, which was published in 1956. "You are right I have been Pound's friend for years and still wish to be considered so," he writes, "but I am not as young as I was and cannot take part in any active campaign to bring his works to public attention."

199 "The Gift." Loosely inserted inside a printed Christmas card which is signed, "Dr. and Mrs. Williams." December 1957.

> 4 x 7 ½" bifolium signed on interior page; 3¾ x 7¼" bifolium printed with Williams's "The Gift" inserted.

Bifolium poem for Christmas, 2500 copies printed by Peter Beilenson at the Walpole Printing Office: Mt. Vernon, NY; 100 copies printed with "Bill and Floss," 200 with "Fuji and John," 500 with "Ann and J Laughlin," 1700 printed with "New Directions." For more on the Thirwills, see item #200. Wallace D16.

200 The Selected Letters of William Carlos Williams. Edited with an introduction by John C. Thirlwall. New York: McDowell, Obolensky, 1957.

> 8vo.; maroon cloth, stamped in gold; dust-jacket.

222

First edition; ordinary issue; over 2000 copies. Wallace A42a. A dual presentation copy, inscribed twice to Williams's wife on the front endpaper, by Williams and Thirlwall: *Flossy dear / from / Bill / July 31, 1957;* and *Also for Floss. From the editor / Jack Thirlwall.*

John C. Thirlwall (1904-1971) was a professor of English at City College, and in addition to this book also compiled and edited "The Lost Poems of William Carlos Williams" for *New Directions 16* (New Directions, 1957). Williams and Thirlwall first met in 1953 and remained in close contact until Williams's death a decade later.

Dedicated "To Floss and Fuji" (Fuji Yanase was Thirlwall's wife). Thirlwall includes in his introduction a quotation from a letter he received from Williams in which he insists, "you must let the letters speak for themselves ... [the book] should really be a portrait of my gallery of friends." With letters spanning 54 years from Williams to literary luminaries including Stevens, Pound, Stein, Moore, Cummings, Burke and many others, as well as personal missives to Flossie and his elder son, Dr. Bill, Jr., written while he was overseas fighting in World War II.

201 **The Selected Letters of William Carlos Williams.** Edited with an introduction by John C. Thirlwall. New York: McDowell, Obolensky, 1957.

8vo.; red and white cloth, stamped in gold; publisher's cardboard slipcase.

First edition, signed issue; one of 75 copies (this is #35) specially bound and signed by Williams at the colophon. Wallace A42b.

202 **I Wanted to Write a Poem: The Autobiography of the Works of a Poet.** Reported and Edited by Edith Heal. Boston: Beacon Press, 1958.

8vo.; brown cloth, stamped in white; dust-jacket.

First edition; 3543 copies. Wallace A43a.

In the introduction, Heal explains how this book was written: "For five months I met with the poet and his wife, the Bill and Floss you will hear talking in these pages. The interviewer seldom asked a question because the poet did his own searching. I simply took notes. And Floss's acute observations were an important part of these notes."[110]

203 **Paterson (Book Five).** New York: New Directions, 1958.

> 8vo.; tan cloth, stamped in orange and gold; dust-jacket.

First edition; 3000 copies. Wallace A44.

Ten years elapsed between Book Four and Book Five, the final installment of *Paterson*. Williams is quoted on the dust-jacket:

> I have come to understand not only that many changes have occurred in me and the world, but I have been forced to recognize that there can be no end to such a story I have envisioned with the terms I had laid down for myself. I had to take the world of Paterson into a new dimension if I wanted to give it imaginative validity . . . the composition began to assume a form which you see in the present poem, keeping, I fondly hope, a unity directly continuous with the Paterson of *Pat. 1 to 4*.

Williams's association with another poet from Paterson, NJ – Allen Ginsberg – is reflected in Book Five (and Book Four, to a lesser extent). Ginsberg saw Williams as a mentor and sent him work after hearing him read. Though the two poets disagreed over craft issues such as line length (in an interview, Williams once referred to Ginsberg's long lines as "disgusting"[111]), they corresponded off and on and a number of Ginsberg's letters are incorporated into Book Five. Williams told Ginsberg, in a letter dated February 27, 1952, that he would "be the center" of the final chapter of the epic poem, for Ginsberg had come to personify that place in his mind.[112]

Williams wrote introductions for the City Lights Books editions of Ginsberg's first two collections, *Howl and Other Poems* (see item #197) and *Kaddish and Other Poems*, and City Lights Books reissued Williams's *Kora in Hell* in 1957.

204 **"Zukofsky."** In *"A" 1-12* by Louis Zukofsky. With an essay on Poetry by the author and a final note by William Carlos Williams. NP: Origin Press, 1959.

> 12mo.; title page printed in red and black; red cloth, stamped in gold.

First edition of this volume published by Cid Corman, with an essay by Williams entitled, "Zukofsky," dated "Rutherford, New Jersey, 1957," on pages 291-96; 200 copies printed by the Genichido Printing Company in Kyoto Japan, the entire edition. The essay was reprinted in *Agenda*, London, III.6, special issue edited by Charles Tomlinson (December 1964), 1-4, with a permissions acknowledgement to Florence Williams, Zukofsky and Cid Corman and Origin Press. Wallace B83.

A presentation copy, inscribed on the front endpaper: *To / Lew and Sally Feldman / and theirs / always / Louis Zukofsky / May 5, 1931*.

205 Typed letter to Henry Sturtz, signed, "William C. Williams," Rutherford, NJ, December 14, 1959.

 One 6 x 7" leaf of Williams's letterhead.

Williams muses on art, intelligence and the human condition in this brilliant letter to a fan, who wrote asking about the 1921 poem "St. Francis Einstein of the Daffodils." He explains his inspiration:

> Einstein was a saint to me, his intelligence must lead the race to truth which he worshipped. We musn't let the modern materialists kid us that they know anything more than the human mind leads us to believe. The rhythmic beauty of truth which we cannot escape is a mystical entity much allied to art. It sometimes amuses me to think that Einstein was a bum violinist and loved to fiddle when among his friends. All part of the same set up.

Williams decries "the lies which the offcial church blesses and sanctions" and says "if it were not for the Einsteins among us we should all be lost." He recommends "a wonderful novel" to Sturtz (*The Native Moment* by Anthony C. West) and thanks him for contacting him about his poem, joking that "poems are too often lost in the printing. Nothing we can do about that."

206 Typed letter to Gladys Thompson, signed, "W.C.W.," with an autograph postscript by his wife Florence ("F. H.W"), Rutherford, NJ, July 7, 1961.

 One leaf; one page.

Together with:

Autograph note to Gladys Thompson, signed, "F.H.W.," July 8, 1961.

One leaf of Williams's letterhead (with "Mrs." added by hand); one page; with original envelope.

A remarkable letter written when Williams was 78 and in poor health after suffering multiple heart attacks and strokes. He is still lucid and able to offer some thoughts on writing, spirituality and his marriage, though his handwriting has suffered even in his signature.

The numerous typos and errors in this letter are explained by Flossie's note at the bottom of the page: "Dr. W. has recently had a severe stroke – but he insists on carrying on a correspondence so – read between the lines, where you can – Good luck –."

Flossie also emphatically asks – in a handwritten note along the lefthand margin of the letter – that Ms. Thomson send a copy of Williams's letter back to her; in her follow-up note sent the next day she reiterates this request: "Again may I ask that you send me a copy of what W.C.W. sent – he is not able any more to communicate –."

226

207 Levine, David. **Portrait Illustration Print of William Carlos Williams.** From the *New York Review of Books,* June 1, 1963.

> Print; black and white; matted to 7 ½ x 11";
> framed.

Levine's illustration of Williams accompanied the tribute penned by Kenneth Burke in the *New York Review of Books* three months after Williams's death in 1963. He subsequently drew Wallace Stevens in 1966, to accompany Denis Donghue's review of *Letters of Wallace Stevens.* (For more on Levine, see item #86.)

208 Pictures from Brueghel. And other poems.
Including The Desert Music and Journey to Love. London: MacGibbon and Kee, 1963.

> Small 8vo.; tied signatures; unopened; black and white paper-covered
> boards.

Advance copy of the first UK edition. Wallace A48.

MacGibbon and Kee published this edition one year after the first edition was put out by New Directions. *Pictures from Brueghel* was Williams's final book of poetry, for which he was posthumously awarded the Pulitzer Prize in 1963.

209 Program for the American Academy of Arts and Letters and The National Institute of Arts and Letters Ceremonial. Wednesday afternoon May 22, 1963 at three o'clock. Academy Auditorium 632 West 156 Street New York, New York: 1963.

> 4to.; wrappers; with an annotated seating plan for the stage (checkmarks next to a dozen names) and directions for reaching the terrace after the ceremonial loosely inserted.

The program for the ceremony during which Williams was posthumously awarded the Gold Medal for Poetry by Robert Penn Warren. The event took place on May 22, 1963, in New York just two and a half months after

Williams had passed away. Flossie attended the ceremony, and was seated in the front row next to Malcolm Cowley. Other members of the Academy were seated on stage as well, many of whom knew Williams well: Marianne Moore, William Zorach and Babette Deutsch. Architect Mies van der Rohe was honored with the Gold Medal for Architecture at the ceremony, and fourteen grants were awarded in literature and art.

210 Agenda. "Asphodel, That Greeny Flower," pp. 1-24. III.2 (October-November 1963).

8vo.; printed wrappers.

Wallace C509. Also includes "An Introduction to Williams's Poetry" by Peter Whigham.

211 William Carlos Williams and the American Scene 1920-1940. Whitney Museum of American Art. December 12, 1978 – February 4, 1979. Poems by William Carlos Williams selected by Dickran Tashjian. Reprinted by permission of New Directions Publishing Corporation.

Slim 8vo.; printed wrappers.

Together with:

Everything is a picture William Carlos Williams and the American Scene, 1920-1940.

9½ x 14" leaf; tri-fold; six pages; illustrated.

Together with:

Guide to New York City Murals. Prepared in conjunction with "William Carlos Williams and the American Scene, 1920-1940."

9 x 16" leaf; mimeographed; two pages; illustrated.

A mini-archive documenting this posthumous exhibition at the Whitney Museum of American Art exploring Williams's role in the aesthetic evolution of pre-war America. Dickran Tashjian (Professor, Program in Comparative Culture at the University of California, Irvine), selected poems of Williams that relate to movements in the arts and/or specific art works during the two decades covered by the show. Tashjian states: "Williams' ideas and poetry allow us to understand the concerns of the 1920s and 1930s not

simply as an aspect of American art history, but more properly as a cultural phenomenon."

The illustrated Whitney exhibition brochure further explains, "This exhibition is organized around the efforts of William Carlos Williams, physician and poet, to participate in the creation of a unique American art during the turbulent period between the two world wars." Work by visual artists "who were his friends and acquaintances" is present, along with "poems, little magazines, pamphlets, books and other printed material which reveal Williams' interest in the visual arts. They accentuate the interplay

between visual and literary artists, and they provide both social and cultural contexts for the works of art in the exhibition . . . "

The accompanying Guide to New York City Murals highlights "murals by American and foreign artists in the five boroughs of New York" created throughout the 1930s. The guide notes, "Although some murals have been destroyed, or lost through negligence, insensitivity, or ignorance, many fine works are still extant and available to the public." The guide pictures one such mural: "America at Work, 1939," by Ben Shahn and Bernarda Bryson, at the Bronx Central Post Office.

From the Library of Ezra Pound

No other poet had more of an impact on Williams than Ezra Pound – in *I Wanted to Write a Poem*, Williams claimed "before meeting Ezra Pound is like B.C. and A.D."[113] The two men met as students at the University of Pennsylvania in 1902, and Williams humorously recalled that Pound was not impressed when he first showed him his work: "He was impressed with his own poetry; but then, I was impressed with my own poetry, too, so we got along all right."[114] Both poets paid out of pocket for the publication of their first books, which came out within a year of each other (Pound's *A Lume Spento* in 1908 and Williams's *Poems* in 1909, which was privately published by Williams's father).

In the years following Williams's failed first book, when Pound was living in Europe, his influence on Williams was particularly formative – he helped arrange a deal with his London publisher Elkin Mathews, who published Williams's next book (*The Tempers*) and encouraged Harriet Monroe to include four of Williams's poems in the June 1913 issue of the newly launched *Poetry*. These introductions arguably jumpstarted the young poet's career.

But it wasn't just Pound's connections that proved invaluable – his modernist approach to verse, in terms of both theory and practice, showed Williams an alternative to writing in the highly structured modes of Keats and Whitman, his early heroes. Pound also encouraged Williams to read more widely, recommending poetry by Yeats and Rossetti, and books like *On the Sublime*, an ancient Greek treatise on poetics by Longinus, and Brooks Adams's *The Law of Civilisation and Decay* (Macmillan, 1895).[115]

However, Williams himself believed Pound was most useful in helping him understand early on in his career "the problems faced by a writer." Despite disagreeing on many things, the two remained lifelong friends who exchanged lively letters and always provided each other with honest feedback. In "Letter to an Australian Editor," written in 1946 after Pound had been arrested for treason for his support of Mussolini during World War II and incarcerated in a mental institution, Williams described himself as "deeply indebted" to Pound, whom he called a "great genius."[116]

The following books from Pound's library were variously inscribed to him by Williams, bear the signature of one, the other or both, and bear the blind-stamp of Pound's castle library in the Italian Tyrol: "Brunnenburg / Tirolo (Merano) / Italia." All show the wear and tear of active reading, further evidenced by Pound's notes and annotations in some of the volumes.

212 Kora in Hell: Improvisations. Boston: The Four Seas Company, 1920.

> 8vo.; gray paper-covered boards, stamped in black; orange printed dust-jacket.

First edition; 1,000 copies, the entire edition. Wallace A4a. With Pound's library blindstamp on the the title page. Docketed in pencil on the front endpaper: "EP's."

213 In the American Grain. New York: Albert & Charles Boni, 1925.

> 8vo.; black cloth, stamped in gold.

First edition; number of copies unknown. Wallace A9. Signed *William Carlos Williams* on the front endpaper, with Pound's ownership signature (*E. Pound*) directly beneath it, and his blind stamp to the title page.

Pound intended *In the American Grain* to be the third installment in Charles Nott's "Ideogramic Series" which he was editing, but Nott ran out of money before that could happen. This copy was annotated most likely in preparation for that project. In the Table of Contents, Pound put checkmarks by half a dozen entries and inserted the title of a missing section ("Descent" on pg. 212). Throughout the volume are light editorial notes by Pound – usually only a word or two – and brackets in the margins of approximately two dozen pages. On the rear endpaper, Pound wrote: "149 / 150 imports" followed by "Montezuma / Mayflower / Pere S.R. / G.W. / Burr" (there are no annotations to pages 149-50).

214 The Cod Head. San Francisco: Harvest Press, 1932.

> 8vo.; bifolium; green wrappers, stapled; printed label to cover.

First edition; 125 copies. Wallace A14. Signed "William Carlos Williams" at the end of the poem. With his ink emendation to the second stanza at the top of the same page, deleting the word "darkly" in the phrase, "wavering rocks darkly." And with Pound's blindstamp to the title page.

215 *An Early Martyr and Other Poems.* New York: Alcestis Press, 1935.

> 8vo.; cream printed wrappers; unprinted glassine dust-jacket; original cardboard slipcase, lacking spine panel.

First edition; one of 135 signed numbered copies (this is copy #125); 165 copies, the entire edition. Wallace A16. A presentation copy, inscribed to Ezra Pound's wife, Dorothy Shakespear: *Dorothy / with love from / Bill.* With Pound's library blindstamp.

Williams was fond of Pound's wife, describing her in a letter to Viola Baxter as "a beautiful English girl" soon after the couple married in 1914. *An Early Martyr* was published during a period when the two poets were at odds, after Pound accused Williams of having "pissed" his life away. As Mariani recounts in his biography of Williams, he sent the book to Dorothy just after Christmas with a note to Ezra saying that the last poem, titled "You Have Pissed Your Life," was dedicated to him.[117]

216 White Mule. Norfolk, CT: New Directions, 1937.

> 8vo.; white cloth, stamped in black; white dust-jacket, printed in red.

First edition; 1,100 copies, the entire edition. Wallace A18. With Pound's bold signature in ink on the front endpaper: *E. Pound.*

217 Laughlin, James, ed. **New Directions in Prose and Poetry 1937.** "Patterson [*sic*]: Episode 17." Norfolk, CT: New Directions, 1937.

> 8vo.; illustrated paper-covered boards; illustrated dust-jacket.

First edition of the second installment of the New Directions annual anthology of experimental creative writing, which Laughlin started in 1936 with Pound's enthusiastic support. With Williams's "Patterson [*sic*]: Episode 17" which begins "And the guys from Paterson beat up the guys from New York . . . ". These excerpts of the poem later appeared in Book Three of *Paterson.* Wallace C245. Signed *EP* in red pencil on the front endpaper.

218 Life Along the Passaic River. Norfolk, CT: New Directions, 1938.

> 8vo.; white cloth, stamped in black; dust-jacket.

First edition; 1,006 copies, the entire edition. Wallace A19. With Pound's pencil signature, *E. Pound,* on the front endpaper, and his library blindstamp to the title page.

219 Paterson (Book Three). New York: New
Directions, 1949.

> Slim 8vo.; tan cloth, stamped in gold
> and navy blue; cream printed dust-
> jacket.

First edition. Wallace A30a. A presentation
copy, inscribed by the publisher, James
Laughlin, to Pound on the front endpaper:
Merry Xmas / to Ez Pound / from JAS. / 1949.
Docketed by Pound in pencil on the same
page: *recd / 13 Dec.*

220 The Selected Letters of William Carlos Williams. Edited with an
introduction by John C. Thirlwall. New York: McDowell, Obolensky, 1957.

> 8vo.; maroon cloth, stamped in gold.

First edition. Wallace A42a. With Pound's notes covering the front endpa-
pers; and a few page numbers in a tidy, discreet, non-Poundian hand on the
rear endpaper.

221 The William Carlos Williams Reader. Edited with an introduction by
M. L. Rosenthal. New York: New Directions, 1966.

> 8vo.; yellow cloth, stamped in black.

First edition. Wallace A50. With discreet occasional marginal lines and
underlining throughout.

Inscribed to his son, Paul Williams

Paul Herman Williams (1917-2003) – the second of Williams's two sons – married Virginia Carnes ("Jinny") in 1941 and they had three children: Paul, Jr., Raymond and Suzanne. From September 1944 to March 1946, while Paul was serving in the Navy during WWII, Jinny and the children moved into 9 Ridge Road in Rutherford with Flossie and Bill. In letters to Pound and Zukofsky from this period, Williams speaks fondly of life with his daughter-in-law and young grandchildren, and was pleased that upon Paul's return, the family settled nearby. Later on Paul and Jinny separated and, after a trial reunification, ultimately divorced, which accounts for Williams's shift from joint inscriptions to individual presentations.

222 **In the American Grain.** New York: Albert & Charles Boni, 1925.

> 8vo.; tan cloth, spine stamped in red.

First edition, third printing; 2200 copies. Wallace A9. A presentation copy, inscribed on the front endpaper: *Paul / with love from / Dad.*

223 **The Complete Collected Poems 1906-1938.** Norfolk, CT: New Directions, 1938.

> Tall 8vo.; top edge gilt; dark blue cloth, stamped in gold.

First edition; 1500 copies, the entire edition. Wallace A20. A presentation copy, inscribed on the front endpaper: *Paul & Virginia / with love from / Dad.*

224 **Paterson.** Norfolk, CT and New York, NY: New Directions, 1946-1958.

> 5 vols., 8vo.; volumes 3, 4 and 5 in dust-jacket.

First editions. Wallace A24, A25, A30, A34, A44. A complete set of presentation copies, inscribed on the front endpapers as follows:

> Book 1: *"Paul and Jinny - with love / Dad / 6/1/46."*
> Book 2: *"Jinny and Paul / with much love / from Dad."*
> Book 3: *"Virginia, with love / from / Bill, Sr."*
> Book 4, first blank: *"Jinny / with love from / grandpop / William Carlos*

> Williams. / April 21, 1951."
> Book 5: "Paul / from / Dad."

225 The Build-Up. New York: Random House, 1952.

> 8vo.; orange paper-covered boards; black cloth spine, stamped in blue; cream printed dust-jacket.

First edition. Wallace A37. Signed on the half-title page: *W.C. Williams*. With Jinny's ownership signature below, in pencil: *Xmas – 1952 / New York Hospital / Virginia C. Williams.*

Like *White Mule* and *In the Money*, *The Build-Up* is a novel with a family-focused narrative, and Williams once again used Flossie's family for inspiration. Williams struggled with fictionalizing the experiences of his in-laws, setting this in Rutherford: "I had trouble. I found much of what I was writing was too personal."

Kirkus Reviews described *The Build-Up* as a "pleasant family novel . . . enjoyable for those who like literate, quiet entertainment given by one who seems to delight in mankind and who invites the reader to rest happily while observing his people" (October 17, 1952). The novel was nominated for the National Book Award for Fiction in 1953, but lost to Ralph Ellison's *Invisible Man.*

226 The Desert Music and Other Poems. New York: Random House, 1954.

> 8vo.; pale green cloth, stamped in red and black; cream printed dust-jacket.

First edition, signed issue, in the special binding reserved for 111 copies published simultaneously with the ordinary copies. Wallace A38b. A presentation copy, inscribed on the half-title: *– for Virginia & Paul –.*

227 Selected Essays. New York: Random House, 1954.

> 8vo.; green cloth, stamped in gold and white; cream printed dust-jacket.

First edition. Wallace A40. A presentation copy, inscribed on the front endpaper: *For Jinny & Paul from Dad Nov. 15/54.*

A compilation of Williams's previously published prose criticism and five new essays, including "The Poem as a Field of Action" in which he

argues that poetry is not passive and can be an effective tool for activism and stimulating social change.

228 **The Selected Letters of William Carlos Williams.** Edited with an introduction by John C. Thirlwall. New York: McDowell, Obolensky, 1957.

8vo.; maroon cloth, stamped in gold; dust-jacket.

First edition. Wallace A42a. Dedicated "To Floss and Fuji" (Fuji Yanase was Thirlwall's wife). This volume contains letters spanning 54 years from Williams to literary luminaries including Stevens, Pound, Stein, Moore, Cummings, Burke and many others, as well as personal missives to Flossie and his elder son, Dr. Bill, Jr., written while he was overseas fighting in World War II. The introduction includes a quotation from a letter from Williams to Thirlwall in which he insists, "you must let the letters speak for themselves . . . [the book] should really be a portrait of my gallery of friends."

A presentation copy, inscribed on the front endpaper: *Paul & Jinny from Dad.*

Bibliography

Anderson, Jack. "Words of Beauty and Terror Inform a Graham Classic." *New York Times*, Oct. 1, 1989.

Berry, Wendell. *The Poetry of William Carlos Williams of Rutherford*. Berkeley: Counterpoint, 2011.

Bloom, Harold. "The Central Man: Emerson, Whitman, Wallace Stevens." *Massachusetts Review* 7, no. 1 (Winter 1966): 23-42.

Bloom, Harold. *Wallace Stevens: The Poems of Our Climate*. Ithaca and London: Cornell University Press, 1976.

Boozer, William. "Late Talks with Allen Tate." *New York Times*, Apr. 8, 1979.

"Briefly Noted." *The New Yorker*, Jan. 29, 1949.

Brazeau, Peter. *Parts of a World: Wallace Stevens Remembered*. New York: Random House Books, 1983. First published 1977.

Bryant, Jen. *A River of Words: The Story of William Carlos Williams*. Grand Rapids: Eerdmans Books for Young Readers, 2008.

Burke, Kenneth. "William Carlos Williams, 1883-1963." *New York Review of Books*, June 1, 1963.

Carlson, Michael. "Obituary: Cid Corman." *Guardian*, Apr. 14, 2004.

Coles, Roberts. *House Calls with William Carlos Williams, MD*. With photographs by Thomas Roma. Brooklyn: Powerhouse Books, 2008.

Coles, Robert. *William Carlos Williams: The Knack of Survival in America*. New Brunswick: Rutgers University Press, 1983. First published 1975.

Cook, Eleanor. *A Reader's Guide to Wallace Stevens*. Princeton: Princeton University Press, 2007.

Daugherty, James M. "Ivan S. Daugherty's 'Memorandum' on Wallace Stevens." *Wallace Stevens Journal* 31, no. 1 (Spring 2007): 3-13.

Dillon, George. "A Blue Phenomenon." *Poetry* 68, no. 2 (May 1946): 97.

Edelstein, J.M. *Wallace Stevens: A Descriptive Bibliography*. Pittsburgh: University of Pittsburgh Press, 1973.

Egan, Mary Jo. "Thomas McGreevy and Wallace Stevens: A Correspondence." *Wallace Stevens Journal* 18, no. 2 (Fall 1994): 127.

Filreis, Alan. *Modernism from Right to Left: Wallace Stevens, the Thirties, and Literary Radicalism*. Cambridge: Cambridge University Press, 1994.

Furioso Papers. Yale Collection of American Literature, Beinecke Rare Book and Manuscript Library.

Gitzen, Julian. "From Reverence to Attention: The Poetry of Denise Levertov." *Midwest Quarterly* 16 (1975): 328-341.

Graham, Ruth. "Mystery Man," Poetry Foundation, Sept. 24, 2013. https://www.poetryfoundation.org/articles/70053/mystery-man.

Hellman, Geoffrey T. "Publisher II: Flair is the World." *The New Yorker*, Nov. 27, 1948.

Holsapple, Bruce. *The Birth of the Imagination: William Carlos Williams On Form.* Albuquerque: University of New Mexico Press, 2016.

Jarrell, Randall. "The Poet and His Public." *Partisan Review* 13, no. 4 (Sept-Oct 1946): 493-498.

Jarrell, Randall. "Reflections on Wallace Stevens." *Partisan Review* 17 (May-June 1951): 341-342.

Lappen, Alyssa A. "Wallace Stevens: A Daughter's Memory." *New York Times*, Mar. 19, 1978.

Laughlin, James and William Carlos Williams. *William Carlos Williams and James Laughlin: Selected Letters.* Edited by Hugh Witemeyer. New York: W. W. Norton & Company, 1989.

Kusch, Robert. *My Toughest Mentor: Theodore Roethke and William Carlos Williams 1940-1948.* Lewisburg, PA: Bucknell University Press, 1999.

Leibowitz, Herbert. *"Something Urgent I Have to Say to You:" The Life and Works of William Carlos Williams.* New York: Farrar, Straus and Giroux, 2011.

Lensing, George S. *Wallace Stevens: A Poet's Growth.* Baton Rouge: LSU Press, 1986.

Levertov, Denise and William Carlos Williams. *The Letters of Denise Levertov and Williams Carlos Williams.* Edited by Christopher MacGowan. New York: New Directions, 1998.

Lowell, Robert. "Thomas, Bishop, and Williams." *Sewanee Review* 55, no. 3 (Summer 1947): 500-503.

Mariani, Paul. *Epitaphs for the Journey: New, Selected, and Revised Poems.* Eugene: Cascade Books, 2012.

Mariani, Paul. *The Whole Harmonium: The Life of Wallace Stevens.* New York: Simon & Schuster, 2016.

Mariani, Paul. *William Carlos Williams: A New World Naked.* New York: McGraw-Hill, 1981.

Meyer, Gerard Previn. "Immortality in a Footnote." *The Journal of the Long Island Book Collector*, No. 3. 1975.

Miller, Philip. *The Guide to Long-Playing Records: Vocal Music.* New York: Alfred A. Knopf, 1955.

Nassar, Eugene Paul. *Wallace Stevens: An Anatomy of Figuration.* Philadelphia: University of Pennsylvania Press, 1965.

The Oxford Critical and Cultural History of Modernist Magazines: Vol. II. Edited by Peter Brooker and Andrew Thacker. Oxford: Oxford University Press, 2009.

Pecile, Jordon. "An Appreciation of Wallace Stevens." *New York Times*, Sept. 30, 1979.

Pound, Ezra and William Carlos Williams. *Pound Williams: Selected Letters of Ezra Pound and William Carlos Williams.* Edited by Hugh Witemeyer. New York: New Directions, 1996.

Pritchard, William. "The Man Who Wore a Four-Piece Suit." *New York Times*, Nov. 20, 1983.

Richardson, Joan. *Wallace Stevens, A Biography: The Early Years, 1879-1923.* New York: Beech Tree Books, William Morrow, 1986.

Richardson, Joan. *Wallace Stevens, A Biography: The Later Years: 1923-1955.* New York: Beech Tree Books, William Morrow, 1988.

Robertson, Charles A. "Communications." *Wallace Stevens Journal* 1, no. 2 (Summer 1977): 81.

Richardson, Joan. *How to Live, What to Do: Thirteen Ways of Looking at Wallace Stevens.* Iowa City: University of Iowa Press, 2018.

Schmidt, Peter. *William Carlos Williams, The Arts, and Literary Tradition.* Baton Rouge: Louisiana State University Press, 1988.

Schulze, Robin G. *The Web of Friendship: Marianne Moore and Wallace Stevens.* Ann Arbor: The University of Michigan Press, 1995.

Sharpe, Tony. *Wallace Stevens: A Literary Life.* New York: St. Martin's Press, 2000.

Smith, L.R. *Kenneth Patchen: Rebel Poet in America.* Huron, OH: Bottom Dog Press, 2000.

Spontaneous Mind: Selected Interviews 1958-1996. Edited by David Carter. New York: Harper Collins, 2001.

Stevens, Wallace. *The Collected Poems of Wallace Stevens.* New York: Alfred A. Knopf, 1967. First published 1954.

Stevens, Wallace. *The Collected Poems of Wallace Stevens: The Corrected Edition.* Edited by John N. Serio and Chris Beyers. New York: Vintage Books, a Division of Penguin Random House LLC, 2015.

Stevens, Wallace. *Letters of Wallace Stevens*. Edited by Holly Stevens. New York: Alfred A. Knopf, 1966.

Stevens, Wallace. *Opus Posthumous: Poems, Plays, Prose by Wallace Stevens*. Edited and with introduction by Samuel French Morse. New York: Alfred A. Knopf, 1957.

Stevens, Wallace. *The Palm at the End of the Mind: Selected Poems and a Play*. Edited by Holly Stevens. New York: Vintage Books, A Division of Random House, 1972. First published 1967.

Stevens, Wallace. *Stevens: Collected Poetry and Prose*. Edited by Frank Kermode and Joan Richardson. New York: Library of America, 1997.

Stevens, Wallace. *Sur Plusieurs Beaux Sujects: Wallace Stevens' Commonplace Book: A Facsimile and Transcription*. Edited and with introductions by Milton J. Bates. Stanford: Stanford University Press, 1989.

Strange, Jonathan. "Six Stevens Letters." *Wallace Stevens Journal* 18, no. 1 (Spring 1994): 19.

Sutton, William. "A Visit with William Carlos Williams." *Minnesota Review* 1 (April 1961): 321-322.

Thirlwall, John C. "Notes on William Carlos Williams as Playwright." In *Many Loves*. Norfolk, CT: New Directions, 1961.

Vendler, Helen. *On Extended Wings: Wallace Stevens' Longer Poems*. Cambridge: Harvard University Press, 1969.

Vendler, Helen. "Stevens' 'Like Decorations in a Nigger Cemetery.'" *Massachusetts Review* 7, no. 1 (Winter 1966): 136-146.

Vendler, Helen. *Wallace Stevens: Words Chosen Out of Desire*. Knoxville: The University of Tennessee Press, 1984.

Wallace, Emily. *A Bibliography of William Carlos Williams*. Middletown, CT: Wesleyan University Press, 1968.

The Wallace Stevens-Cummington Press Correspondence 1941-1951. Edited by Carolyn Masel. Wakefield: Microform Academic Publishers, 1992.

Wallace Stevens: A Celebration. Edited by Robert Buttel and Frank Doggett. Princeton: Princeton University Press, 1980.

Wallace Stevens: The Poetics of Modernism. Edited by Albert Gelpi. Cambridge: Cambridge University Press, 2008. First published 1985.

Wallace Stevens in Context. Edited by Glen MacLeod. Cambridge: Cambridge University Press, 2017.

Whittemore, Reed. *William Carlos Williams: Poet from Jersey*. Boston: Houghton Mifflin Company, 1975.

William Carlos Williams. Edited and with an Introduction by Harold Bloom. New Haven: Chelsea House Publishers, 1986.

William Carlos Williams: The Critical Heritage. Edited by Charles Doyle. London: Routledge and Kegan Paul, 1980.

William Carlos Williams: Selected Poems. Edited by Robert Pinsky. New York: American Poets Project, The Library of America, 2004.

Williams, William Carlos. *The Autobiography of William Carlos Williams*. New York: Random House, 1951.

Williams, William Carlos. *A Book of Poems: Al Que Quiere!*. Edited and with an introduction by Jonathan Cohen. New York: New Directions, 2017.

Williams, William Carlos and Louis Zukofsky. *The Correspondence of William Carlos Williams and Louis Zukofsky*. Edited by Barry Ahearn. Middletown, CT: Wesleyan University Press, 2003.

Williams, William Carlos. *Imaginations*. Edited and introductions by Webster Schott. New York: New Directions, 1970.

Williams, William Carlos. *I Wanted to Write a Poem: The Autobiography of the Works of a Poet*. Reported and edited by Edith Heal. New York: New Directions, 1967. First published by Beacon Press in 1958.

Williams, William Carlos. "Letter to an Australian Editor." *William Carlos Williams Review* 17, no. 2 (1991): 8-12.

Williams, William Carlos. "On Wallace Stevens." *New Republic* LXXXXIII, no. 1198, Nov. 17, 1937.

Williams, William Carlos. *Paterson*. Revised edition prepared by Christopher MacGowan. Norfolk, CT: New Directions, 1995.

Williams, William Carlos. *The Selected Letters of William Carlos Williams*. Edited by John C. Thirlwall. New York: New Directions, 1984. First published by McDowell, Obolensky, 1957.

Williams, William Carlos. *Selected Poems*. Edited and with an introduction by Charles Tomlinson. New York: New Directions, 1985.

Williams, William Carlos. *Something to Say: William Carlos Williams on Younger Poets*. Edited by James E.B. Breslin. New York: New Directions, 1985.

Williams, William Carlos. *Yes, Mrs. Williams: A Personal Record of my Mother*. New York: McDowell, Obolensky, 1959.

NOTES

1 Geoffrey T. Hellman, "Publisher II: Flair is the World," *The New Yorker*, Nov. 27, 1948.

2 Wallace Stevens, *Letters of Wallace Stevens*, ed. Holly Stevens (New York: Alfred A. Knopf, 1966), 193-194.

3 George S. Lensing, *Wallace Stevens: A Poet's Growth* (Baton Rouge: LSU Press, 1986), 248-250.

4 Stevens, *Letters*, 291.

5 Lensing, *Wallace Stevens*, 255.

6 Stevens, *Letters*, 214.

7 Ibid., 231-237.

8 Joan Richardson, *Wallace Stevens, A Biography: The Later Years: 1923-1955* (New York: Beech Tree Books, William Morrow, 1988), 72, 89.

9 Stevens, *Letters*, 262.

10 Paul Mariani, *The Whole Harmonium: The Life of Wallace Stevens* (New York: Simon and Schuster, 2016), 184.

11 Alan Filreis, *Modernism from Right to Left: Wallace Stevens, the Thirties, and Literary Radicalism* (Cambridge: Cambridge University Press, 1994), 113.

12 Stevens, *Letters*, 276.

13 William Carlos Williams, "On Wallace Stevens," *The New Republic* LXXXXIII, no. 1198, Nov. 17, 1937.

14 Stevens, *Letters*, 283-284.

15 James M. Daugherty, "Ivan S. Daugherty's 'Memorandum' on Wallace Stevens," *Wallace Stevens Journal* 31, no. 1 (Spring 2007): 3-13.

16 Stevens, *Letters*, 272.

17 Helen Vendler, "Stevens' 'Like Decorations in a Nigger Cemetery,'" *Massachusetts Review* 7:1 (Winter 1966): 136-46.

18 Stevens, *Letters*, p. 541.

19 Mariani, *The Whole Harmonium*, 146-147.

20 Stevens, *Letters*, 311-312.

21 Charles A. Robertson, "Communications," *Wallace Stevens Journal* 1, no. 2 (Summer 1977): 81.

22 Harold Bloom, *Wallace Stevens: The Poems of Our Climate* (Ithaca and London: Cornell University Press, 1976), 115, 135.

23 Guide to the Furioso Papers YCAL MSS 75, Yale University Library

24 Furioso Papers. Yale Collection of American Literature, Beinecke Rare Book and Manuscript Library.

25 Stevens, *Letters*, 420.

26 Ibid., 408.

27 *The Wallace Stevens-Cummington Press Correspondence 1941-1951*, ed. Carolyn Masel (Wakefield: Microform Academic Publishers, 1992), 8.

28 Bloom, *Wallace Stevens*, 226.

29 Randall Jarrell, "Reflections on Wallace Stevens," *Partisan Review* 17 (May-June 1951): 341-342.

30 George Dillon, "A Blue Phenomenon," *Poetry* 68, no. 2 (May 1946): 97.

31 William Boozer, "Late Talks with Allen Tate," *New York Times*, Apr. 8, 1979.

32 Richardson, Vol 2, 248-249.

33 Mariani, *The Whole Harmonium*, p. 295

34 Jonathan Strange, "Six Stevens Letters," Wallace Stevens Journal 18, no. 1 (Spring 1994): 19.

35 Stevens, *Letters*, 536.

36 J.M. Edelstein, *Wallace Stevens: A Descriptive Bibliography* (Pittsburgh: University of Pittsburgh Press, 1973), 78.

37 Stevens, *Letters*, 581.

38 Ibid., 686.

39 Ibid., 685.

40 Ibid., 586.

41 Mary Jo Egan, "Thomas McGreevy and Wallace Stevens: A Correspondence," *Wallace Stevens Journal* 18, no. 2 (Fall 1994): 127.

42 Stevens, *Letters*, 811.

43 Ibid., 724.

44 Ibid., 705.

45 Jordon Pecile, "An Appreciation of Wallace Stevens," *New York Times*, Sept. 30, 1979.

46 Edelstein, *Wallace Stevens*, 99.

47 Stevens, *Letters*, 760.

48 Philip Miller, *The Guide to Long-Playing Records: Vocal Music* (New York: Alfred A. Knopf, 1955), 103.

49 William Pritchard, "The Man Who Wore a Four-Piece Suit," *New York Times*, Nov. 20, 1983.

50 Harold Bloom, "The Central Man: Emerson, Whitman, and Wallace Stevens," *Massachusetts Review* 7, no. 1 (Winter 1966): 23-42.

51 Stevens, *Letters*, 276.

52 Paul Mariani, *William Carlos Williams: A New World Naked* (New York: McGraw-Hill, 1981), 524-525.

53 Ibid., 331.

54 Ibid., 1-32.

55 Michael Carlson, "Obituary: Cid Corman," *Guardian*, Apr. 14, 2004.

56 Mariani, *William Carlos Williams*, 707.

57 William Carlos Williams, *The Selected Letters of William Carlos Williams*, ed. John C. Thirlwall (New York: McDowell, Obolensky, 1957; New York: New Directions, 1984), 40. Citations refer to the New Directions edition.

58 William Carlos Williams, *I Wanted to Write a Poem: The Autobiography of the Works of a Poet*, ed. Edith Heal (Boston: Beacon Press, 1958), 18.

59 William Carlos Williams, *The Autobiography of William Carlos Williams* (New York: Random House, 1951), 387.

60 Jack Anderson, "Words of Beauty and Terror Inform a Graham Classic," *New York Times*, Oct. 1, 1989.

61 Williams, *Autobiography*, 158.

62 Williams, *I Wanted*, 28-29.

63 Ibid., 34-35.

64 Williams, *Autobiography*, 237.

65 Williams, *I Wanted*, 36.

66 Mariani, *William Carlos Williams*, 423.

67 William Carlos Williams and Louis Zukofsky, *The Correspondence of William Carlos Williams and Louis Zukofsky*, ed. Barry Ahearn (Middletown, CT: Wesleyan University Press, 2003), 203-204.

68 Williams, *Selected Letters*, 185.

69 Williams, *I Wanted*, 45.

70 Emily Wallace, *A Bibliography of William Carlos Williams* (Middletown, CT: Wesleyan University Press, 1968), 30.

71 William Carlos Williams, *Paterson*, revised ed. prepared by Christopher MacGowan (Norfolk, CT: New Directions, 1995), 270.

72 Williams, *Selected Letters*, 124.

73 Mariani, *William Carlos Williams*, 324.

74 Williams, *I Wanted*, 52.

75 Kenneth Burke, "William Carlos Williams, 1883-1963," *New York Review of Books*, June 1, 1963.

76 Williams, *I Wanted*, 51-52.

77 Ibid., 56.

78 Graham, "Mystery Man."

79 Williams, *Autobiography*, 299.

80 Williams, *I Wanted*, 57.

81 Williams, *Autobiography*, 299.

82 Wallace, *Bibliography*, 41.

83 L.R. Smith, *Kenneth Patchen: Rebel Poet in America* (Huron, OH: Bottom Dog Press, 2000), 67-81.

84 Williams, *I Wanted*, 59.

85 Mariani, *William Carlos Williams*, 140.

86 Williams, *I Wanted*, 63.

87 Ibid., 55-56.

88 Robert Kusch, *My Toughest Mentor: Theodore Roethke and William Carlos Williams 1940-1948* (Lewisburg, PA: Bucknell University Press, 1999), 11-12.

89 Mariani, *William Carlos Williams*, 483.

90 Williams, *I Wanted*, 74.

91 Randall Jarrell, "The Poet and His Public," *Partisan Review* 13, no. 4 (Sept-Oct 1946): 493-498.

92 Robert Lowell, "Thomas, Bishop, and Williams," *Sewanee Review* 55, no. 3 (Summer 1947): 500-503.

93 Wallace, *Bibliography*, 56.

94 William Carlos Williams, *Something to Say: William Carlos Williams on Younger Poets*, ed. James E.B. Breslin (New York: New Directions, 1985), 191.

95 *The Oxford Critical and Cultural History of Modernist Magazines: Vol. II*, ed. Peter Brooker and Andrew Thacker (Oxford: Oxford University Press, 2009), 981.

96 John C. Thirlwall, "Notes on William Carlos Williams as Playwright," in *Many Loves* (Norfolk, CT: New Directions, 1961), 433-434.

97 Thirlwall, "Notes," 433-434.

98 Williams, *Selected Letters*, 259.

99 Burke, "William Carlos Williams, 1883-1963."

100 "Briefly Noted," *The New Yorker*, Jan. 29, 1949.

101 Williams, *I Wanted*, 76.

102 Wallace, *Bibliography*, 66.

103 Williams, *I Wanted*, 84.

104 Williams, *Autobiography*, 347.

105 Williams, *Selected Letters*, 304-305.

106 Williams, *I Wanted*, 78.

107 Williams, *Selected Letters*, 301.

108 *Spontaneous Mind: Selected Interviews 1958-1996*, ed. David Carter (New York: Harper Collins, 2001), 266.

109 Julian Gitzen, "From Reverence to Attention: The Poetry of Denise Levertov," *Midwest Quarterly* 16 (1975): 328-41.

110 Williams, *I Wanted*, v-vi.

111 William Sutton, "A Visit with William Carlos Williams," *Minnesota Review* 1 (April 1961): 321-322.

112 Wallace, *Bibliography*, 95.

113 Williams, *I Wanted*, 5.

114 Ibid., 5.

115 *William Carlos Williams: The Critical Heritage*, ed. Charles Doyle (London: Routledge and Kegan Paul, 1980), 2-4.

116 William Carlos Williams, "Letter to an Australian Editor." *William Carlos Williams Review* 17, no. 2 (1991).

117 Mariani, *William Carlos Williams,* 372.

Printed on Cougar Opaque paper.
Designed by Jerry Kelly and
set in his Rilke types.